IN MY VIEW

PERSONAL REFLECTIONS ON ART
BY TODAY'S LEADING ARTISTS

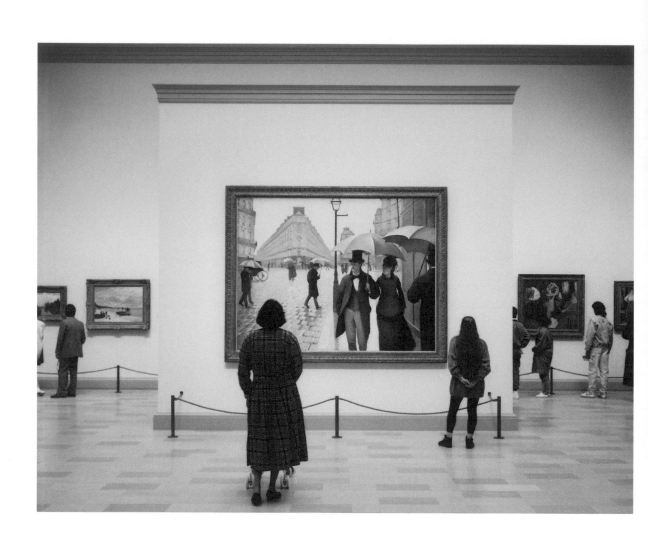

IN MY VIEW

PERSONAL REFLECTIONS ON ART BY TODAY'S LEADING ARTISTS

EDITED BY SIMON GRANT

152 illustrations, 135 in color

Thames & Hudson

My love and thanks to my wife Charlotte for her encouragement, support
and humour throughout, and to my parents who first lit the spark, and to
whom this book is dedicated.

Frontispiece image page 2:
Thomas Struth
Art Institute of Chicago 2
Chicago 1990
1990
Chromogenic print
184 × 219 cm framed (72 ½ × 86 ¼ in.)
The Art Institute of Chicago

The text by Gregory Crewdson is an edited version of
a text that originally appeared in *Tate Etc.* Issue 1, 2004.
The text by Katarina Fritsch is an edited version of a text
that originally appeared in *Tate Etc.* Issue 9, 2007.
The text by Ed Ruscha is an edited version of a text that
originally appeared in *Tate Etc.* Issue 21, 2011.
The text by Mark Wallinger was originally published in
the *Guardian*, 3 July 1995.

First published in 2012 in hardcover in the United States of America by
Thames & Hudson Inc., 500 Fifth Avenue, New York, New York 10110

thamesandhudsonusa.com

Library of Congress Catalog Card Number 2012932513

ISBN 978-0-500-23896-7

Printed and bound in China by Toppan Leefung Printing Limited

CONTENTS

ON

ON

ON

THE LUMINOUS WAY

In his installation (opposite), Ryan
Gander pays homage to an irreconcilable
ideological split between Theo van
Doesburg and Piet Mondrian. Gander
discusses van Doesburg's painting
Counter Composition XV on page 91.

RYAN GANDER

*Ftt, Ft, Ftt, Ftt, Ffttt, Ftt, or somewhere
between a modern representation of how a
contemporary gesture came into being, an
illustration of the physicality of an argument
between Theo and Piet regarding the dynamic
aspect of the diagonal line and attempting
to produce a chroma-key set for a hundred
cinematic scenes*
2010
Black archery arrows
Installation at Lisson Gallery,
London, 2010

In My View is not an ordinary art book. It does not survey the most
glorious pictures painted in the last 1,000 years. Nor does it list the top
100 iconic works from around the world that you must see before you die.
It is a selection by more than seventy-five contemporary artists of their
favoured works from the past – in some cases the distant past, for others,
artists who are still with us. These are artworks that have inspired or have
triggered a memory, works that they find beautiful or that resonate with
their own artistic practices, or simply, art that they find hard to get out
of their minds. The result is a wonderfully eclectic mix of artworks from
around the world that provide an alternative history of art, from the
fifteenth century through to the 1960s.

Quite a few of the works that you will read about in this book are not
part of the traditional art historical canon, and in this, the book is full of
surprises and unlikely artistic affinities, many revealed here for the first
time. How many of us, for example, have previously encountered the
work of John Bock's artist of choice, the obscure Swiss artist Armand
Schulthess, whose 'philosophic garden' now exists only in photographs
because his family destroyed the work after the artist's death? And how
intriguing Victor Hugo's mesmerizing drawings become when seen
through the eyes of Raymond Pettibon, who enthusiastically embraces
his hero.

Here too we get a chance to read about such artists as the
Venezuelan modernist Armando Reverón (the choice of Allora &
Calzadilla), the eighteenth-century German Philipp Otto Runge (chosen
by John Stezaker), paintings by the seventeenth-century Chinese artist
Chen Hongshou (chosen by Zhang Xiaogang), and the relatively little-
known Danish artist Poul Gernes (courtesy of Erwin Wurm).

Often these entries are not simple adulations of an historic work.
I like the fact, for example, that Urs Fischer chose a black-and-white
photograph of a lost sculpture by the nineteenth-century Italian artist
Medardo Rosso. I was amused to learn that Julião Sarmento doesn't care
about the skill of Delacroix's brushstrokes in *Louis d'Orleans Showing His
Mistress* (1825–26), yet is so moved by the work that he wishes he had
painted it himself.

I hope that *In My View* will prove to be as much a revelation to read
as it has been for me to edit. The inspirational – and often unexpected
– selections of artworks and artists unearth intimate connections that
the contemporary artists in this book have with art from the past. Many
of the artists I have talked to during the compilation of the book spoke
with great passion about their choices, and consistently expressed a deep
knowledge of art history right across the centuries. (They also found it
incredibly difficult to restrict themselves to one artist or one artwork.) So
what does *In My View* tell us about the artists and the works that they have
chosen? Most notably, it tells us that these private passions are surprisingly
strong and enduring, and can feed into their way of looking at the world
today. Ed Ruscha puts it beautifully when he writes about the 'little silver
thread' that runs between his own paintings and his choice of artwork –
Millais's *Ophelia* (1851–52), a painting that has, remarkably, had a profound
influence on his art ever since he first saw it at the Tate Gallery in 1961.

It became, Ruscha says, 'a trigger in my art; an inspiration for what I'm doing'. Who would have imagined that the king of Los Angeles cool has been inspired by a sentimental Pre-Raphaelite?

Of course, one of the constants throughout the history of art is how artists can be influenced, seduced and captivated by their predecessors. Michelangelo's Sistine Chapel was in part influenced by Masaccio's frescoes, and in turn Masaccio looked back to Donatello. In the twentieth century, Joan Miró based his hallucinatory *Self-Portrait* (1937–38) on William Blake's curious work *The Man who Taught Blake Painting in his Dreams* (c. 1819–20). A few decades later Alberto Giacometti noted how his sculpture *Grande Tête* (1960) was modelled on the colossal marble head of the Emperor Constantine, which Giacometti saw in the Capitoline Museum in Rome in 1958. More recently, we know that Philip Guston (here chosen by Vija Celmins) was entranced by the intensity of Rembrandt's portraits, and Carl Andre has expressed an admiration for the work of Honoré Daumier, describing Daumier's oil sketch *Man on a Rope* (c. 1858) as 'almost like a Futurist work'.

However, one of the tenets of modernism has been an ambiguous relationship with this past, characterized by a passionate willingness, or even necessity, to break with previous styles and modes of thinking. The art critic and champion of the Bloomsbury Group, Clive Bell,

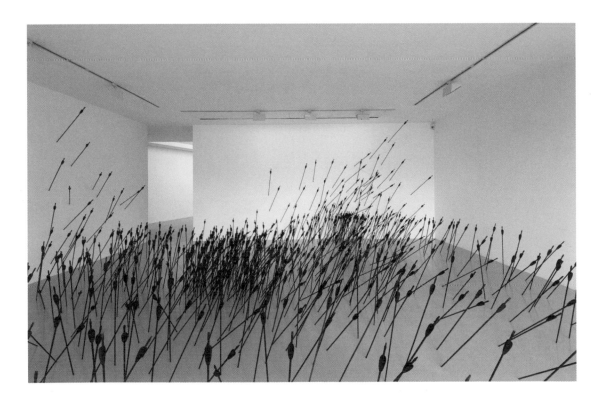

This snapshot, taken by artist Lucy Skaer, shows images that the surrealist painter Leonora Carrington had pinned up in her kitchen, including postcards of two paintings in the Tate Collection: the anonymous British School *Cholmondeley Ladies* (*c.* 1600–10) hangs alongside J. M. W. Turner's *Light and Colour (Goethe's Theory)* (exhibited 1843).

viewed the Victorians as 'intolerable' and saw their art as 'stinking mackerel'. A few years later, Kazimir Malevich pursued a more radical and godless abstraction, epitomized in his painting *Black Square* (1915), by forcefully repudiating the Russian social realism that he grew up with. And is it possible to regard the emergence of Minimal Art without seeing it as a reaction to the frantic energy of Abstract Expressionism?

Despite this history, what we find in *In My View* is not aggressive posturing or any fierce desire to define oneself in opposition to past masters. Instead there is a generosity of spirit towards fellow practitioners. Some of these homages are personal. John Baldessari has written about his late friend Sigmar Polke – and in turn Simon Patterson has written about Baldessari, reflecting his enormous influence on a younger generation of contemporary artists.

Almost half of the artists have chosen works from the twentieth century. And many of these artists, such as Patterson, have selected predecessors who are only a generation apart. Additionally, many of the artworks are from the modernist canon, and several contributions speak of the powerful visceral and optical experience they have had with these works. Arguably, some of the most striking connections are with those artists who first encountered the artist of choice in their childhood. When the American artist Susan Hiller was eight or nine years old, her mother would drop her off at the Cleveland Museum of Art every Saturday morning for her weekly art class. It was on one of those Saturdays that she discovered Albert Pinkham Ryder's painting *The Race Track* (*c.* 1896–1913). Hiller remembers that the painting gave her a 'shivery feeling…a feeling of dread'. The image has stayed with her ever since, and Hiller's own work explores the intangible world of memory, of fear of the unknown. Similarly, Dr Lakra recounts how he first saw a poster of Hieronymus Bosch's *The Garden of Earthly Delights* as at child at his grandfather's house. He would spend hours looking at the gory

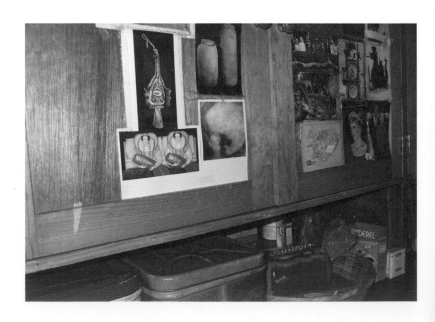

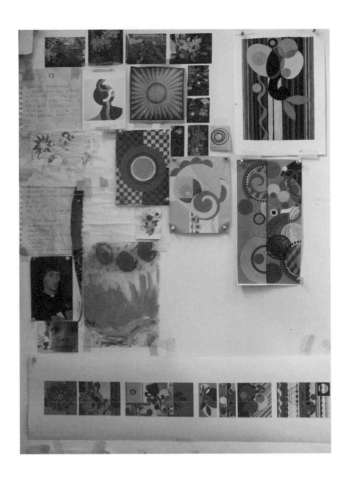

details, which he believes have given way to his adult 'obsession with the
grotesque, the irreverent and the scatological'. (He later learned that his
parents named him 'Jerónimo' after the artist.)

Many artists here express a powerful affinity with another artist's work.
For example, in the work of Victor Hugo, Raymond Pettibon recognizes
an artist who 'had the "bug" of the ink'. Pettibon writes: 'I know what
that is like – it can become an extension of you. It is in your blood.'
These close connections lie at the heart of *In My View*. In looking at the
landscapes of Paul Nash, Tacita Dean feels as if she is joining Nash in the
settings that he depicts, 'as if I had known them myself and recognized
them'. Similarly, Gillian Wearing is united by a love of disguises and
changing identities with the Belgian artist James Ensor, finding a 'kindred
spirit…an artist who I would place within my spiritual family'. John
Baldessari might speak for all the contributors to this book when he says
that such relationships reveal that 'art is a conversation with other artists'.

These relationships, sometimes spanning generations and cultures,
will, of course, often influence the work of the contemporary artists.
Occasionally these influences can be clearly seen. Elmgreen & Dragset's
Powerless Structures (2000) consists of two closed doors linked by a chain.
The work feels, certainly in spirit, very similar to Hammershøi's bleak
paintings of interiors, which often contain empty rooms and blank doors.

'Just add a Bang & Olufsen stereo set to a Hammershøi scenario and the image becomes wholly contemporary', say Elmgreen & Dragset. For the artists, Hammershøi's influence has been definitive. In the same vein, Gregory Crewdson declares that the filmic paintings of Edward Hopper have had a huge influence on his photography. Crewdson recognizes in Hopper's paintings a similar American sensibility that deals with ideas of beauty, theatricality, rootlessness and desire, a sensibility that has influenced several generations of filmmakers, many of whom Crewdson also draws upon for inspiration. For some artists the connections can be less apparent. Hiroshi Sugimoto likens the minute painterly details in Petrus Christus's painting *Portrait of a Young Lady* (c. 1470) to his photographs of seascapes in which 'the human eye strains to discern even finer silver particles'. Rachel Whiteread is fascinated by the 'quiet symmetry' of Piero della Francesca's *Baptism of Christ* (1450s), a quality that she found useful when making her best-known sculpture, *Ghost* (1990). In fact, during construction of *Ghost*, Whiteread kept a postcard of *The Baptism of Christ* with her – not as an intentional guide, but because it helped her to follow 'some notion of solidity that existed in Piero's picture'.

Postcards, posters and reproductions in art books serve as introductions to or reminders of an artist's work. And it is always fascinating to know what postcards artists have close to them. The Italian artist Alighiero e Boetti apparently kept a postcard of Vermeer's *Art of Painting* (1665–66), possibly as it features a large map, and maps became an important strand within Boetti's own work. The Brazilian artist Beatriz Milhazes has postcards of paintings by Matisse and the Brazilian artist Tarsila do Amaral on view in her studio to provide a 'constant source of stimulation and research'. Milhazes also keeps two postcards of Hans Memling's painting *Portrait of a Man with a Carnation* (c. 1475–80) – one in her studio and another in her home.

In editing *In My View*, I was struck by how many artists described having little epiphanies in front of works of art in museums and art galleries – and memories of these moments have remained with them throughout their lives. When Vik Muniz came across Rubens's *Portrait of Clara Serena Rubens* (c. 1616), quite by chance in a loan exhibition at the Metropolitan Museum of Art, New York, he was transfixed by what he saw. So intense was his experience of standing in front of this painting that Muniz knew he would become an artist. He writes of the perfection he saw in the painting as 'that tense moment of transformation when the ball has left the hands of the basketball player and hasn't yet reached the rim, the second before a first kiss – the appearance of a new form, the pure sublime'.

On the other hand, however, there are a few artists in this book who have written about an artwork that they have never seen in the flesh, or first saw as a reproduction. Miroslaw Balka actually prefers looking at the black-and-white photograph of Michelangelo's 'dirty, grey' *Rondanini Pietà* (c. 1564) in his book than the real sculpture. Likewise, Wilhelm Sasnal thinks that Seurat's *Bathers at Asnières* (1884) is 'more magical when you see [it] in a book'. Fred Tomaselli has only ever seen the seventeenth-century Tibetan depiction of Yama (a Buddhist god of the dead) in a colour reproduction in a book. And yet he writes eloquently and movingly about the painting and its influence on his work.

Thomas Scheibitz became fascinated by El Greco's multiple interpretations of Mary Magdalene, and brought together reproductions of these paintings in this photograph. Some of these he has seen in the flesh, and others only in colour reproductions. Numerous artists in *In My View* write about artworks that they saw first (or only) in books, and it becomes clear in reading through their different experiences that a reproduction discovered in a book can easily feed the artistic imagination. Scheibitz writes about El Greco on page 148.

The idea of authenticity and the notion of the original versus the photographic representation is partly what attracted Urs Fischer to Medardo Rosso's lost sculpture. Fischer likes the fact that his relationship to Rosso's work is of a 'fictional nature'; Fischer will never experience the real work, but he derives enjoyment from the suggestive power of the image rather than the thing itself – 'the sweetness of the imagined'.

Artists in this book have all expressed an inspiring faith in the art that they have chosen to write about. They have shown an affection for and a closeness to the artworks and the artists that have got under their skin. As Susan Hiller writes, 'there are some images that once seen are part of one's imagination forever'. And it is this sense of the potential of an artwork to change and affect us that holds such power over us. It is a sentiment that resonates with Francesco Clemente, who perhaps can speak for many when he says that his chosen work of art is one that 'strengthen[s] my resolve as an artist to prove that other, more luminous ways to see are still possible'.

TOMMA ABTS

German, b. 1967

ON

ITŌ JAKUCHŪ

Japanese, 1716–1800

ITŌ JAKUCHŪ

Birds, Animals and Flowering Plants in Imaginary Scene
Edo period, eighteenth century
Pair of 6-panel folding screens,
ink and colour on paper
168.7 × 374.4 cm (66 ½ × 147 ⅜ in.)
The Etsuko and Joe Price Collection,
Los Angeles

I saw *Birds, Animals and Flowering Plants in Imaginary Scene* by Itō Jakuchū in an exhibition titled 'Japanese Masterworks from the Price Collection' at the Los Angeles County Museum of Art in 2008. I am not a connoisseur of Japanese art, and I am not specialized in any particular period in art history, nor do I have general preferences regarding medium or subject matter. Rather, I tend to fall in love with single works for their individual characteristics.

The exhibition presented many extraordinarily beautiful pieces, mostly in familiar forms, such as ink paintings on paper scrolls or silk, and several paintings on folding screens. But when I came across Itō Jakuchū's pair of screens, I felt that I hadn't seen anything like this before. In the context of the more traditional-looking paintings in the exhibition, the modern appearance of the screens was extremely surprising – I could hardly believe that they dated from the eighteenth century.

From afar the screens looked as if they were made of mosaic, as the image seemed to be pixilated. But on closer inspection I could see that the grid was drawn onto the white primed paper surface of the screen, dividing each screen into approximately 43,000 squares, each measuring 1.2 cm, every one of which was filled in separately with ink. The paintings were comprised of many little abstract paintings!

The landscape depicted on the screens seems to be of an invented place. The arrangement of figures appears staged and cinematic. Two fruit-bearing trees, at the edges of the screens, frame the scene. They reveal a clearing full of animals in front of a background of small white islands drifting in the bright blue sea, which at first I thought were clouds floating in the sky.

The collection of various animals in the landscape is beautifully peculiar. The left screen features a variety of small and large birds assembled around a phoenix. The animals on the right screen are altogether more fabulous. Some are recognizable and some seem to be entirely made up, each of them depicted in a cartoonish style. Every one is engaged in a different activity: playing, eating, walking, swimming, fooling around in the water, hanging out on the islands, flying, screaming, looking up, looking down, hiding. A few are looking directly out at the viewer. I am being watched by a goose with a silly expression, by a shy white hare peeking out from behind a tree, by a monkey seemingly high on drugs with big rotating red eyes, and, from behind a black donkey, an unidentifiable creature with long white hair and a single blue horn. The most immediately striking feature of the painting is a massive white elephant. He provides ample white space in the centre of the right screen, a focal point of calm and volume.

When I looked at this picture, I was completely immersed in the act of seeing: on the one hand I was taking in the whole image, while on the other I was becoming lost in the details of each square. Some squares are filled in with a single colour, some with fur or feather patterns, others

show a small square of one colour within one of another colour, and I can even spot areas where the squares are divided into four smaller ones. The lines separating these patterns within patterns either ignore or follow the structure of the grid, thereby creating zigzagged pixilated effects. The wild rhythm of the succession of animals is matched by this changeable use of the squares. I was astonished by this oscillation between figuration and abstraction, stepping back to admire the funny, otherworldly creatures, and then leaning forward again to study the optical patterns up close.

The work of Itō Jakuchū belongs to a time during the Edo period (1603–1867) referred to as the period of the 'eccentrics'. The author of the short text on this work in the exhibition catalogue speculates that the painting could have been produced as an under drawing for a textile design. But whatever the explanation for this unusual pair of screens might be, Jakuchū clearly became deeply absorbed in the process of painting, getting lost in inventing the abstractions of each square as he went along. As a result, he transcended whatever his initial design purpose might have been and created a psychedelic painting.

Tomma Abts lives and works in London.

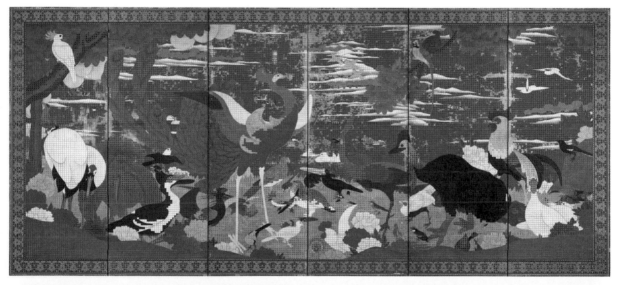

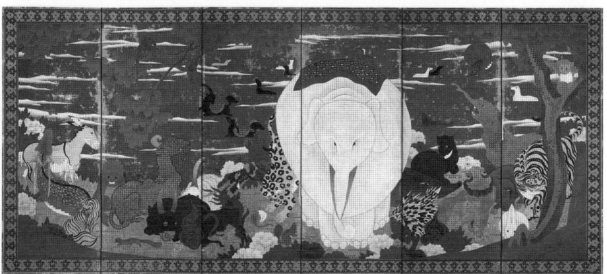

EIJA-LIISA AHTILA

Finnish, b. 1959

ON

PABLO PICASSO

Spanish, 1881–1973

Femme à l'oreiller was painted by Picasso late in his career, in 1969. However, it was not this particular painting that got me interested in Picasso at first, but rather an exhibition that took place at Ateneum Art Museum in Helsinki in 2009. The exhibition was a touring show called 'Masterpieces from the Musée National Picasso in Paris'. It showed his work from 1899 onwards, and brought forward the development of his ideas, the rise of Cubism and how he influenced the ways we are accustomed to perceiving things.

I had never been a fan of Picasso's art before that exhibition. Unfortunately, my feelings about his work had been buried under the commercial and populist stir, and distanced by the myth of his genius. However, I found it very interesting to see how Picasso, after the winter of 1907, started to portray nudes and, in particular, how he abandoned a static point of view. For a long time there had been two things in the visual arts that had stayed intact: the point of view, and the centrality and solidity of the human figure. Picasso questioned both. When he drew or painted a figure he broke the known rules of using light and perspective and made the previously overrated, and thus isolated, human figure an element of its surroundings. With his amazing oeuvre of over 70,000 works, and his popularity, he managed to incorporate abstraction as an existing part of our visual perception, and in so doing changed our visual understanding. Several simultaneous perspectives became a familiar and accepted way of seeing.

Composition in visual arts means setting a frame to a certain place, defining the relations of things inside the frame and giving emphasis to certain things. We could argue that dramaturgy in moving image and film equals the function of composition in art. When Picasso and others were questioning the perspective, point of view and composition, film was taking its early steps. It took influences from theatre, got trapped with naturalistic illusion in narrative and became a machine for commercial purposes. It grew to be a powerful medium working with the real – representing it, creating it, manipulating it and, first and foremost, putting an emphasis on establishing a unique relation to it among arts.

Today, approximately a hundred years after Picasso introduced his ideas, I would like to see abstraction – experimental dramaturgy, multiple points of view and decentralization of the human figure – become more popular in films and moving image. I would like to see people being encouraged to accept several viewpoints and active interpretations instead of closed narratives propagating traditional ways of reading and incorporating affirmative messages. I would like to see narratives that open up their relation to reality and nature and, instead of comprehending and representing, stand by and perceive.

Picasso was almost ninety when he painted *Femme à l'oreiller*. He painted nudes all of his life. In this composition the figure seems to be looking

at the observer. The eyes are a bit mismatched. Maybe it is a self-portrait. When we were shooting my film *The Annunciation* in 2010, I spent long days observing the actors. After looking intensely at someone for ten hours, the image, the person and the gestures invaded me, the viewer. Perhaps Picasso let the nude paint him once again.

Eija-Liisa Ahtila lives and works in Helsinki.

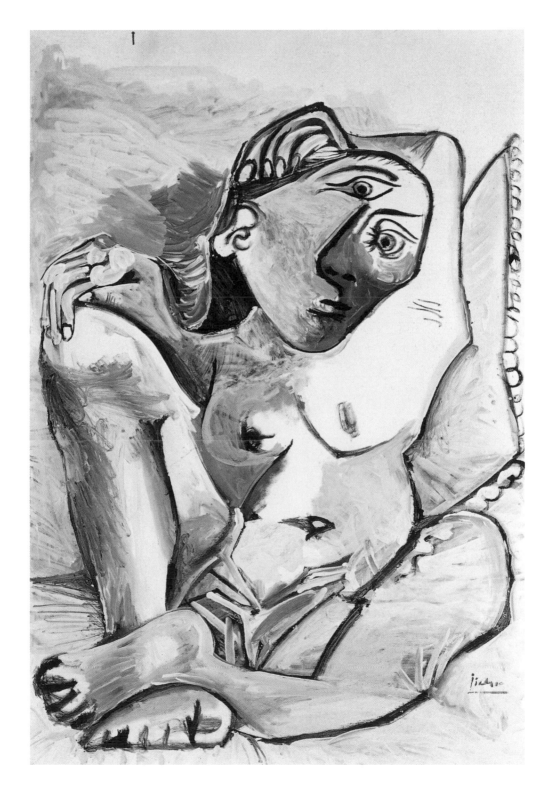

ALLORA & CALZADILLA

American/Cuban, b. 1974/1971

ON

ARMANDO REVERÓN

Venezuelan, 1889–1954

ARMANDO REVERÓN

White Landscape
1934
Oil on canvas
62 × 80 cm (24 ½ × 31 ½ in.)
Private collection

We don't remember where we first saw Armando Reverón's *White Landscape*, but the impression it left on us is indelible. Perhaps it has to do with the tropics, where we live, and the special kind of delirium the sun provokes, especially at the height of its power, midday, when the usual markers of what appears before one's eyes seem to give way to a latent ether.

A landscape bleached in the intense blinding light of the sun, this painting is something we know intimately. It reminds us immediately of *The Noon Complex* (1936), a text by Roger Callois, a French intellectual who had strong ties to Latin America. Callois says of this bewitched hour:

This is the moment when the sun, at its zenith, divides the day into equal parts, each governed by the opposing signs of rise and decline. This, then, is the moment when the forces of life and light yield to the powers of death and darkness.[1]

In Reverón's case, the rupture of noon, when the sun's force is most fiercely felt, was echoed in other fissures that were political, social and personal. Upon visiting an exhibition of Reverón's work organized by the Museum of Modern Art, New York, in 2007, we learned more about the biographical underpinnings of his painterly discoveries. For Reverón, the day was divided in 1917 when Venezuela's repressive government cracked down on artists as enemies of the state. Reverón's response was to flee, moving from place to place, until 1921, when he settled in a fishing village called Macuto on the Caribbean coast. There he built a humble retreat, el Castillete, a private world where he dedicated himself to studying the magical conditions of the tropical sun and finding ways to translate his observations into painting. The result was an inspired body of work, of which *White Landscape* is a part.

Looking further into the solar landscape of Reverón, possessed by the luminous violence of the sun, our thoughts continue to drift along with Callois, in the monstrous resonances of solar mythologies. He says:

Noon is also the time when shade is at a low point, and thus when the exposed soul is most vulnerable to dangers of all kinds. For similar reasons, noon is generally the hour when the dead make their appearance – *they who cast no shadow*. On the most elementary level, these are the reasons noon is preordained to witness the apparition of ghosts. Clearly, they require only those fantasies of the human imagination that are the most general and ancient: sympathetic magic and the principle of correspondence, the identification of the soul with the body's shadow.[2]

Reverón's *White Landscape* shows us an exposed coastal scene under the shadowless siege of the sun. Its pale-coloured palette does not palliate. No. This is the raging heat of the tropical sun asphyxiating all in its path. This is the excess of the sun's rays that cannot be contained or consumed by the defenceless landscape. 'Light is blinding', Reverón once said. 'It maddens and torments, for light cannot be seen.'

Macuto is just north of the equator, the line that divides the world into equal parts. It also faces the Caribbean Sea. The luminous sky and its reflection seem to liquefy everything into light. It is in this context that Reverón produced these intriguing works, the Caribbean landscapes. These paintings for us function as ripe sun stains on the history of monochromatic abstract art.

Allora & Calzadilla (Jennifer Allora and Guillermo Calzadilla) live and work in San Juan, Puerto Rico.

1. Callois, Roger, *The Edge of Surrealism: A Roger Callois Reader* (Durham: Duke University Press, 2003), p. 125.
2. Ibid., p. 126.

PAWEL ALTHAMER
Polish, b. 1967

ON

JERZY STAJUDA
Polish, 1936–1992

JERZY STAJUDA

Briareus
1967
Oil on canvas
63.5 × 103 cm (25 × 41 in.)
The National Museum in Warsaw

In the late 1980s I was a student at the Warsaw Academy of Fine Arts. In my third year my diploma supervisor was the critic and educator Grzegorz Kowalski. At one point in the year, Kowalski invited the artist Jerzy Stajuda to conduct drawing classes for students. I remember that Stajuda arrived wearing stained overalls, like a tramp, and delivered a lecture about drawing as a means of recording emotions and thoughts. This happened while we were still at the stage of drawing nudes.

Stajuda was already an accomplished artist by then. Though he trained as an architect, he didn't design much. He preferred art criticism and being a practising artist. He nurtured our desire to record and to talk. He would organize reviews of students' drawings in his apartment, arranging the works on the floor. For a professional critic (which he was in the 1950s and 60s), he didn't seem too preoccupied with criticizing. We had been used to receiving plenty of feedback. Stajuda would send students off to other professors for traditional assessments. Meanwhile, he focused on identifying the potential and the creative will in the works, seeing this method as an homage to our youth and its possibilities. The most important aspect, he said, was discovering oneself through the practice. He had an amazing skill in picking out intriguing elements of our art, even in inferior works.

Stajuda's own work was an *art informel* style of abstract painting, and he came to be known as the author of surrealist-influenced abstract works. The paintings were usually monochromatic, done in series, and often resembled airy luminous spatial constructions. On closer inspection, however, you noticed raw, unfinished sections next to painstakingly applied layers of glaze. Some of the paintings had gaps, as if the bare surface were waiting to be filled with one's own presence. I saw these works as the painterly equivalent of John Cage's music.

I remember when, during visits to Stajuda's apartment, I would see cracks on the walls, and these would then appear in the works that he did. I realized that these painterly images were in fact a meticulous rendering of drawings he had made in watercolour, ink and pencil. Executed within a few minutes, these hypnotic drawings filled countless folders crammed all over his apartment, among the furniture and his models of battleships and aircraft. Stajuda stopped dating his work in the 1960s, marking only the day and month on some of his drawings, and leaving an unidentified symbol resembling a Chinese character in the lower-right corner.

Looking back at my time at the Warsaw Academy, you could say that if the architect and theorist Oskar Hansen (1922–2005), whose concept of 'Open Form' we all indirectly adopted, represented rational rules and

logical thinking, Stajuda was his opposite, introducing the element of the unconscious. He claimed that our drawings and sculptures were recordings, much the same as writing on walls, or park benches.

Stajuda was definitely among those few whose work as a professor had the exceptional quality of stimulating not only the hand and the eye, but also one's general view of the world. I like to think of my own practice, in which I conduct sculpture classes with people suffering from physical disabilities, in a similar way. To some extent the Nowolipie Group, an organization in Warsaw for adults with multiple sclerosis and other disabilities, to which I contribute, repeats Stajuda's model with daring non-professional artists who bravely disregard boundaries without being too focused on the final results. This ability for self-reflection is what I consider the most rewarding gift I received from Stajuda.

Pawel Althamer lives and works in Warsaw.

ELEANOR ANTIN
American, b. 1935

ON

MAX ERNST
German, 1891–1976

MAX ERNST

*Two Children Are Threatened
by a Nightingale*
1924
Oil on wood with painted wood
elements and frame
69.8 × 57.1 × 11.4 cm (27 ½ × 22
½ × 4 ½ in.)
The Museum of Modern Art,
New York

When I was a kid, my mother often took me to museums on Saturdays, after my art classes or ballet classes were over, a breather before we had to take the long subway trek from Manhattan back to the West Bronx, where we lived. We always went to the Museum of Modern Art (MoMA) or the Metropolitan Museum of Art. Later I found out there was another museum, the Whitney, which used to be on Eighth Street, close to Fifth Avenue. There was a large George Bellows painting of two struggling prize fighters on the wall opposite the entrance door. Maybe that's why my mother never took me there – all that bloody meat was not her idea of class. Besides, being kind of dinky and easily overlooked, the early Whitney didn't have the grandeur of the Met or, in those days, believe it or not, the clean elegant intimacy of MoMA.

In the Met I spent my time with the Greek and Roman sculptures, madly in love with the poor broken cripples meditating on their lost world in that cool light streaming in through the high windows. The vases bored me and still do. The sculptures were my friends and lovers. At MoMA, I got into the habit of choosing a single painting and spending most of my time standing in front of it, trying to unlock its secrets. It could take as much as an hour, then I'd drift off to say hello to works I had studied intimately on earlier Saturdays. I remember Dalí's *Persistence of Memory* was one of my paintings, and so was Pavel Tchelitchew's *Hide-and-Seek*.

I don't now remember the others except for what was my favourite of all my favourites. A very small painting by Max Ernst tucked into a large wooden frame, mysteriously titled *Two Children Are Threatened by a Nightingale*. Even then I hated frames, and this dark brown, moulded wood frame would surely have killed any other painting, but this one seemed to enclose and lovingly protect the work. Indeed, it became part of the painting, giving the painted people a way out of their hallucinatory world into the real one. But would they take it?

The actual wooden gate in the foreground is wide open, leaning against the frame. I think the girl is trying to escape the confines of the painting, or maybe she's trying to kill the nightingale because he opened the gate. She does have a club in her hand and she's looking up at him. But maybe she's not, maybe she's looking out of the open gate at me standing out here shamelessly looking at her. (One girl didn't make it. She's dead on the ground.) But is the nightingale trying to lead the running girl out? Is he offering her freedom or danger? Run out onto that frame and then leap out into what? Life? Or death? Is it safer to stay in a painting that has been home to you for years? Do you really want to grow up?

To the running girl's right, there's a little house without doors or windows, only a large painted sign tacked onto it. I have no idea what that uninteresting object painted on the sign is supposed to be. Or that house.

Is it a doghouse? Or an outhouse? The roof may be real wood like the gate. What is very clear is that a little girl, maybe the sister of the running girl, is being kidnapped by a running man reaching for a large wooden doorknob situated on the frame. Will he open the door to the picture and steal the little girl into the world? She doesn't look scared, indeed she looks calm and mildly interested. Perhaps she's thinking she is still half asleep in the bed from which the thief stole her. Maybe the running girl is trying to get her back, but she's running to the left, rather than the right. They're at cross purposes. For that matter, where is my kid sister in these museum visits? Why don't I have any recollection of *her* at all?

In the painted world, the sun is coming up in the distance over the city, over what looks like the Arc de Triomphe. Do they live in Paris? I wish I knew what the ugly symbol was on the little house wall. Maybe it's a nipple stuck over a bat. Or a horn. Maybe it's an object that doesn't exist anymore, but did back in 1924 when Max Ernst made this painting, which no longer ironically deconstructs the world like a good Dada painting should, but is bursting through into the new ecstatic world of dream reality that will be known as surrealism. A style of art I do not, with some exceptions, care for at all.

Eleanor Antin lives and works in San Diego.

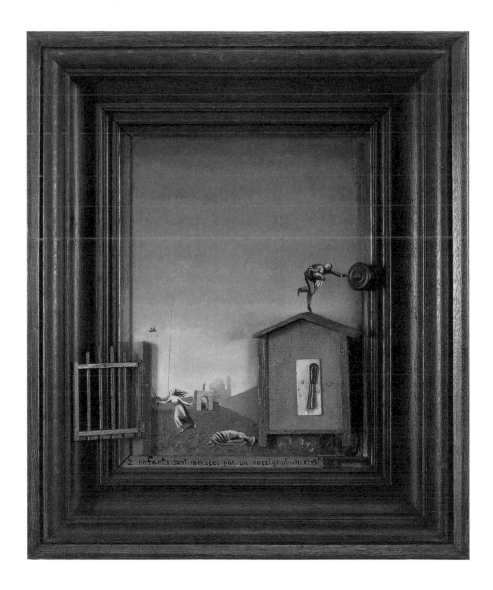

RASHEED ARAEEN

British, b. 1935

ON

ANTHONY CARO

British, b. 1924

ANTHONY CARO

Lock
1962
Steel, painted blue
88 × 536 × 305 cm (34 ⅝ ×
211 × 120 in.)
Private collection

It was early 1985 when I found myself in the Museum of Modern Art (MoMA) in New York. After seeing an exhibition, I wandered around the objects scattered about in the back garden. The garden was full of small, loose, dusty pebbles. I almost tripped over a steel structure resembling box girders. I realized, however, that these were not discarded bits of metal, but the work of the British sculptor Anthony Caro.

Later, as I sipped a coffee in the museum café, I began to think, not only about what I had just seen – the piece is called *Lock* – but about Caro's work in general. When I first saw his work in 1965 it fascinated me so much that I abandoned painting in favour of sculpture. I had been used to seeing Caro's work in clean galleries and museum spaces, but seeing it in the MoMA

garden was different. However, it was more than the environment, it was the work itself, and it gave me a new understanding of Caro's achievement.

I looked for reproductions of *Lock* in books and catalogues and eventually came across an old black-and-white illustration in Herbert Read's book *A Concise History of Modern Sculpture* (1964). There was no discussion of the piece though. Why had art historians ignored this important work?

Critics have often described Caro's work as being influenced by, but also a departure from, the sculpture of David Smith. In my view, this interpretation is wrong. Smith's influence is limited only to the technological language of welded construction. In fact, Caro's work opposes and defies the fundamental aspect of Smith's sculpture, whose rising verticality is entangled with the notion of America as post-war imperial power. The importance of Caro's work, however, is more about what he inherited from Henry Moore. *Lock*'s two metal structures lying flat on the ground, for example, allude to Moore's wartime drawings of reclining figures in the London Underground.

Caro's sculpture is also often taken to represent a more picturesque quality of the British landscape. Again, I disagree with this. Instead, I see the various parts that are formed together compositionally, not only echoing the fragmented body in Moore's work – a body that was subjected to the brutality of both World Wars – but also seeming to reflect its fragmentation, an expression perhaps of the collapse of the British Empire. The fact that the work lies low on the ground, and wants to rise from it, produces a tension between the existential reality of post-war Britain and the desire that seeks an escape from that reality. This, in my view, is what makes Caro's work historically significant.

Caro's sculptures, however, do display a quality that can be attributed to *some* notion of the picturesque, a quality that perhaps has created its admirers, particularly in the bright colourfulness of some other works. But even when there may appear to be a celebration of some sort, perhaps the optimism of the 1960s, it cannot disguise a pervasive sense of post-war anguish.

What is extraordinary about Caro's sculpture is its multi-layered formal complexity, which seems to reflect not only the inheritance of Moore but also of Marcel Duchamp. If *Lock* were, say, left in the street, it would look like a leftover fragment of a demolished factory, waiting for the recycling lorry. The significance of this work therefore lies in its two opposing aspects: a Duchampian conundrum – existing as both art and as anti-art. This is what I saw in the MoMA garden.

My understanding of Caro's work has been important for my own practice. Was it not Caro's art which made me do what I did in 1965? Should I then not pay homage to him in recognition of the fact that he enabled me to find my own place as an artist?

Rasheed Araeen lives and works in London.

KADER ATTIA

French, b. 1970

ON

PIETER BRUEGEL THE ELDER

Netherlandish, c. 1525–1569

PIETER BRUEGEL THE ELDER

Winter Landscape with a Bird Trap
1565
Oil on wood
37 × 55.5 cm (14 ½ × 22 in.)
Musées Royaux des Beaux-Arts
de Belgique, Brussels

I like to look at other artists' work. I particularly like artists who wander through their own universe, and sometimes, if we get lucky, emerge to give us a glimpse of their inner world. Even if I have never liked painting myself, it has always fascinated me. Be it from Prehistory, the Middle Ages, the Renaissance, modern or contemporary periods, painting is an art that I breathe in as much as I look at.

There is one specific painter who sweeps me into the intimate and personal universe that I am looking for. He is someone who tells me about life itself, more than any other artistic or philosophical discourse. He is Pieter Bruegel the Elder. Almost everyone knows his work, but few who know me can imagine how it could influence work like mine.

Firstly, Bruegel knows how to show the polar opposites that exist in human behaviour: the kind and the unkind, the good and bad. He does this in his scenes of local dances and landscapes of the snowy countryside. He shows all walks of life – groups of men, women, children, old, maimed and

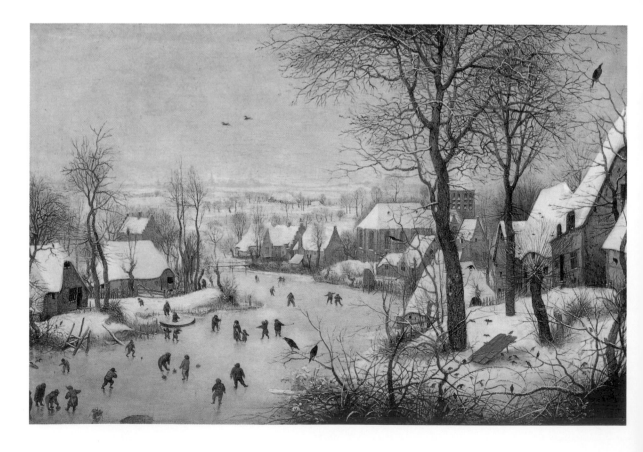

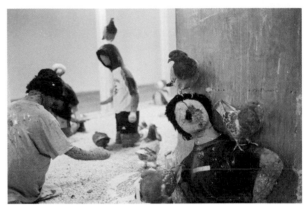

KADER ATTIA

Flying Rats
2005
Birdseed, 250 pigeons
and various materials
Variable dimensions
Installation view at the
Biennale de Lyon, 2005

*Kader Attia lives and
works in Paris.*

crippled people. Some people are hugging each other or laughing, while others wallow on the floor, vomit, or are even in the act of killing someone. They seem surrounded by demons and gargoyles that will take them away to a dark place.

This art speaks to me, because it inspires me in the continuity of its legacy, which stands up firmly against mediocrity, banality and kitsch. One can feel Bruegel's influence on some of my works, such as *Flying Rats* (2005), twenty life-size sculptures of children made of birdseed and subsequently eaten by 250 pigeons. And my piece *Oil and Sugar* (2007), in which oil is poured onto a square block made of sugar that disintegrates. Many of my works are like echoes of the world that Bruegel left us. To me, that world is simply called life.

When I compare the work of this silent master with the vocabulary I try to invent, numerous colours, sounds, rhythms and shapes come to my mind. (Bruegel's colours are intoxicating.) However, there is another thing that we share. We are both witnesses to one of the most important concepts in life: the paradox. As in his paradoxical works, in which Death sits close to a jubilant crowd of people partying and eating, the issue of balance and imbalance between these two opposite sides remains a core issue of our times. It will always be. Mankind itself is a paradox. Because of our intelligence, above all other living organisms, man will end up destroying his environment. This will be our end. As Thomas Hobbes wrote in *The Leviathan*, 'Man is a wolf to Man'.

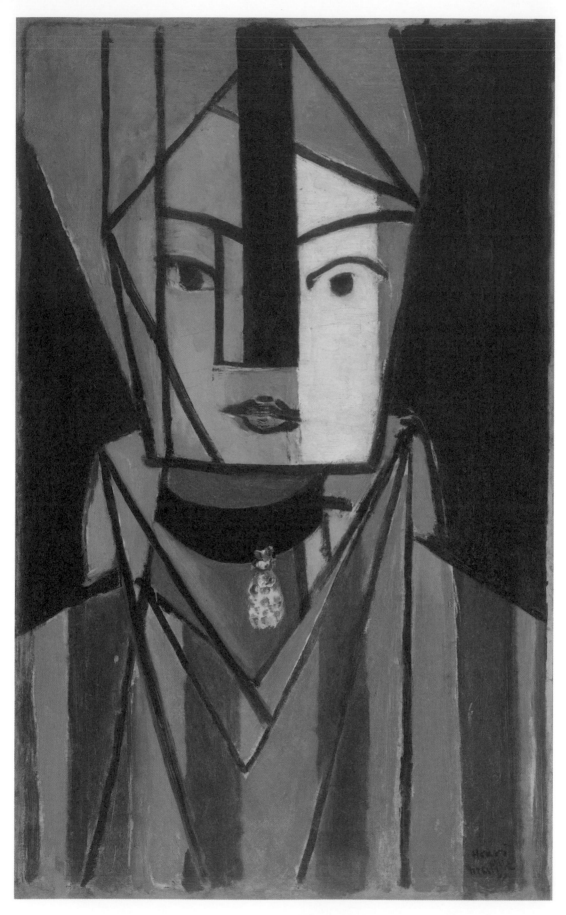

FRANK AUERBACH

British, b. 1931

ON

HENRI MATISSE

French, 1869–1954

HENRI MATISSE

White and Pink Head
1914–15
Oil on canvas
75 × 47 cm (29 ½ × 18 ½ in.)
Musée National d'Art Moderne,
Centre Georges Pompidou, Paris

Frank Auerbach lives and
works in London.

I have looked at many postcards and reproductions of *White and Pink Head* by Matisse over the years. While not as immediate as Picasso's heads of Dora Maar from the 1930s and early 1940s, which I have always loved, this painting has a character that is more educational for me.

White and Pink Head is a tautly organized image, which makes every inch of the paint part of one dynamic entity, coherent as a whole thing, but continually surprising as to placing and proportion. Although laid on in blatant, uninflected areas, it evokes a delicate apprehension of real matter in real space. Although it seems to be brutally geometrical, it resolves itself into a tender image of a specific, loved young woman – it depicts Matisse's remarkable daughter Marguerite, who looks back at us with a gaze as direct and human as the gaze of Rembrandt in his self-portraits.

To miraculously hold together contradictions and incompatibilities is a good definition of art. Next to the *White and Pink Head* on my wall is a photograph of Dürer's marvellous *Portrait of Conrad Merkel* (1508). The parts of this work have much more character, but the whole has less of a thrust than Matisse's painting.

JOHN BALDESSARI

American, b. 1931

ON

SIGMAR POLKE

German, 1941–2010

SIGMAR POLKE

The Sausage Eater
1963
Dispersion on canvas
200 × 150 cm (78 ¾ × 59 in.)
Private collection

I first met Sigmar Polke in 1972 at Documenta V (the large exhibition that takes place every five years in Kassel, Germany). We really hit it off. I spent a lot of time in bars with him, along with other German artists. They loved to drink and laugh and make fun of things. I never found the same kind of spirit among American artists.

I was a real fan of Polke's and always considered him the best living artist. He was like a soulmate in some ways.

When you look at Polke's work, you see that he constantly evolved and continually re-invented himself, taking chances as well as taking liberties. With other artists you have an idea what they're going to do, but with Polke, I was never able to anticipate that. He exemplifies a definition of art I believe in. When somebody asks me 'What is art?', I always say, 'Art is what you can get away with'. Looking at Polke's work now I often think: How did he think he would get away with *that*? But he did, and he seemed to feel no restraints at all. In that respect he was a real role model for me.

There are a number of Polke's works that are good examples of what I mean. In *The Higher Powers Command: Paint the Upper Right Hand Corner Black!* (1969), a black triangle sits at the top right of the image. At the bottom reads the instruction '*The Higher Powers Command: Paint the Upper Right Hand Corner Black!*'. I don't know if Polke was being ironic in this picture, but not knowing this is what makes it work so well. You can read it both ways – either he really believes these words or he's making a reference to art being a transcendental operation. Personally, I've always had that sort of mystical feeling that some higher intelligence is working through me. One has this instinctive feeling. It can't all be just training.

Polke was always making art historical references in his work. For example, in the piece *Carl Andre in Delft* (1968) he did an amazing riff on Carl Andre's floor sculptures. The image is made up of three different kinds of Delft tiles that have been arranged in a repeated pattern within a grid. Polke then added the text at the bottom of the work, 'Carl Andre in Delft'. Polke loved clichés and loved going against anything that was seen as high art. I do too. I think we have a similar sense of humour. For me, this is art that is getting away with it. It is very Duchampian, of course.

There is a lot of humour in Polke's work. In *The Sausage Eater*, the meandering line of linked sausages is full of witty, cheeky references,

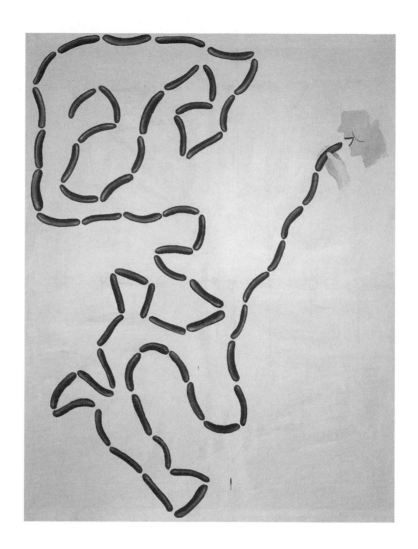

including shit. Polke could poke fun at us; we get the joke and it holds up. Polke painted *The Sausage Eater* in 1963, which was the same time that he initiated the 'Capitalist Realism' movement with his friends Gerhard Richter and Konrad Fischer. It was proposed as an anti-style of art that attacked the previous generation of artists. The god for artists in Germany had been Joseph Beuys and I'm sure they were all reacting against him. They all shared an irreverence and humour and never wanted to get too serious about their work. And they made fun of American art, which was healthy.

I have always admired Polke and certainly got a lot out of him and his art. Many other artists have too, including, for example, Martin Kippenberger. That is certainly a good way to measure art because, for me, art is a conversation with other artists.

John Baldessari lives and works in Santa Monica, California.

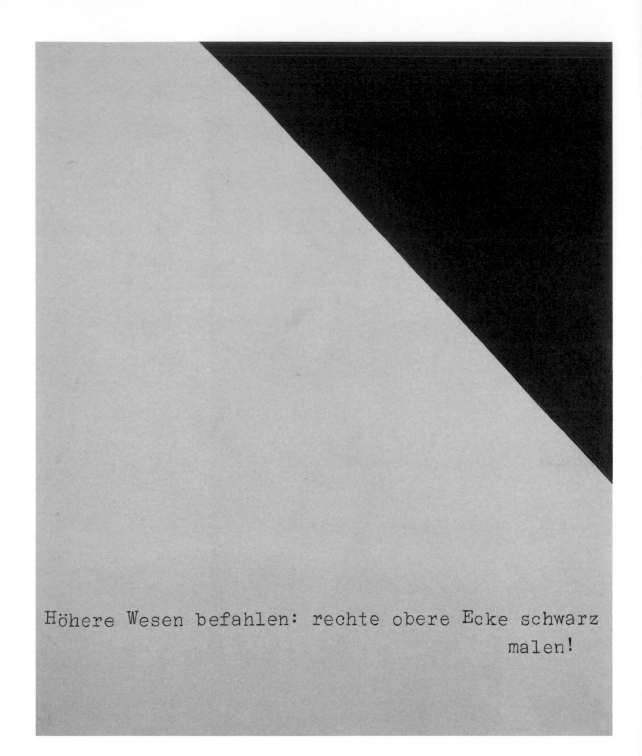

Höhere Wesen befahlen: rechte obere Ecke schwarz malen!

SIGMAR POLKE

The Higher Powers Command: Paint the
Upper Right Hand Corner Black!
1969
Lacquer on canvas
150 × 125.5 cm (59 × 49 ½ in.)
Froehlich Foundation, Stuttgart

CARL ANDRE IN DELFT

SIGMAR POLKE

Carl Andre in Delft
1968
Acrylic on patterned fabric
87.5 × 75 cm (34 ½ × 29 ½ in.)
Speck Collection, Cologne

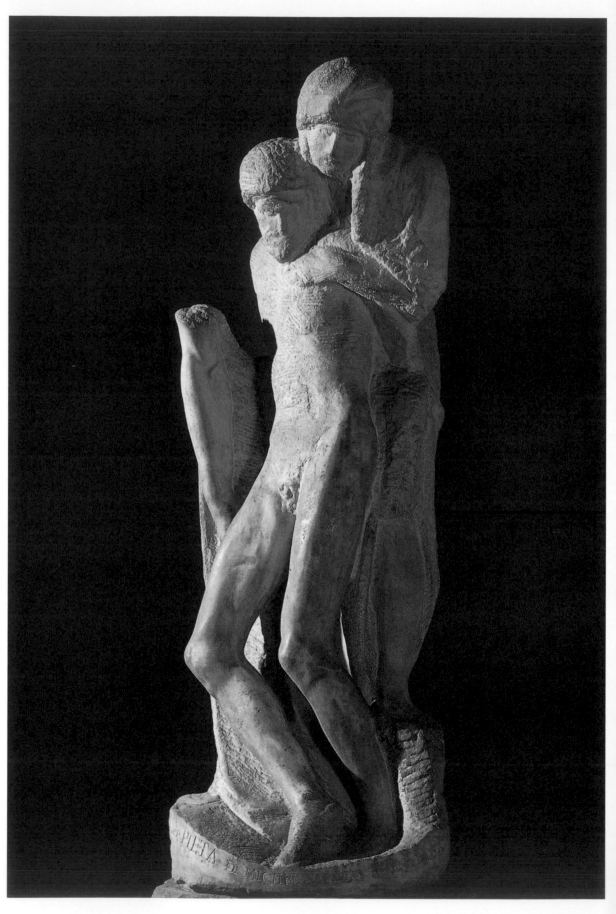

MIROSLAW BALKA

Polish, b. 1958

ON

MICHELANGELO

Florentine, 1475–1564

MICHELANGELO

Rondanini Pietà
c. 1564
Marble
195 cm (76 ¾ in.)
Castello Sforzesco, Milan

The *Rondanini Pietà* is probably the last work Michelangelo made before he died, which might explain why it looks unfinished. I had known about this sculpture for a very long time, but only from a black-and-white photograph in one of my old art books. When I first saw the photograph as a teenager, I thought that the sculpture looked very mysterious. It seemed like an imperfect work. But when I looked closer I could see that in this imperfection there was a kind of perfection. So, in some way, the work plays with the viewer.

Michelangelo spent a lot of time working on only a few details, such as the arm, the thighs and the knees of Christ. Some parts are very well finished while others remain rough. What I like about using marble is that it is a material that takes time to work with. However, this piece is like a sketch, or a drawing in space. Some elements in this sculpture are very well done while others just disappear. In this respect, the *Rondanini Pietà* is an honest work of art. I think this is one of the most important things in the creative arts.

You can see some mistakes in the sculpture but that doesn't matter to me. Artists can make mistakes. In fact, it is in the mistake that one can find the power and the truth of a situation. For example, the hand here appears disconnected from Christ's body. The work is like an intriguing puzzle and you have to glue the elements together.

The *Rondanini Pietà* is very different from the first Pietà that Michelangelo made, which is in St Peter's Basilica in Rome. That sculpture is very beautiful – in the way you would call such a sculpture 'beautiful'. However, I have never liked that Pietà because it is too well done. You don't see the importance of each of the parts that make up the whole. The body of Christ is given the same importance as the folds in the cloth that he lies on – everything is treated the same. In the unfinished *Rondanini Pietà*, with all its imperfections, you can't tell if it is really a Pietà or not. The face has been sculpted in a very simple way. It doesn't look like a Renaissance work of art – more like a guide suggesting how to make a work of art. Some of the parts even look quite abstract. And, for the first time in art history, the Madonna looks like a little grandma, and it seems as if the figure of Christ is carrying her. (It reminds me of a similar scene in Shohei Imamura's 1983 film *The Ballad of Narayama*.) I think this portrayal of fragility is very important for this work.

A few years ago I saw the *Rondanini Pietà* in the flesh, at the Castello Sforzesco in Milan. It was a disappointing experience. They had restored it, and now the Pietà looks too clean and white. I much prefer the memory of looking at the picture of the dirty, grey sculpture in my book.

Miroslaw Balka lives and works in Warsaw.

DAVID BATCHELOR

British, b. 1955

ON

ALPHONSE ALLAIS

French, 1854–1905

ALPHONSE ALLAIS (ABOVE)

First Communion of Anaemic Virgins in a Snowstorm
1883
White monochrome
18.5 × 12.4 cm (7 ¼ × 4 ⅞ in.)
Bibliothèque Nationale de France, Paris

ALPHONSE ALLAIS (BELOW)

Apoplectic Cardinals Harvesting Tomatoes on the Shore of the Red Sea (Aurora Borealis Effect)
1884
Red monochrome
18.5 × 12.4 cm (7 ¼ × 4 ⅞ in.)
Bibliothèque Nationale de France, Paris

It was thirty years ago, in a large Post-Impressionist exhibition at the Royal Academy in London. Among the seemingly endless cornfields and cherry trees and toiling peasants and card players and bowls of fruit and the occasional Tahitian nude, there were a few surprising and unexpected works, among them Giuseppe Pellizza da Volpedo's vast and imposing *The Fourth Estate* (1901). At over 5 metres wide, it was both outstanding and out-of-place; a social realist vision of striking workers, all dark tones, stern faces and outstretched arms. But for me there was a far stranger work, a far more irregular, unlikely and disruptive presence among the many luminous medium-sized canvases. No more than around 30 centimetres wide, it was, as I recall, stuck in the corner of the room somewhere near the middle of the show. It was a single sheet of blank white paper.

There are anomalies and there are anomalies. There are things that don't quite fit and there are things that appear to have come from another planet. In this case, that other planet was a future that could hardly be imagined in the surrounding works. Or then again, perhaps it could: this, one of at least two similar works made by journalist and prankster Alphonse Allais in 1883–84, was titled *First Communion of Anaemic Virgins in a Snowstorm*. It is in part a *reductio ad absurdum* of Impressionist atmospherics. So was his other work, a sheet of bright red paper titled *Apoplectic Cardinals Harvesting Tomatoes on the Shore of the Red Sea (Aurora Borealis Effect)*. But if these works could be imagined in the 1880s, it seems they could only be imagined as a joke, a joke that is contained both in the title and in the decorative graphic surround. For the record, the work I recall seeing had neither the title nor the framing device: it was just a sheet of white paper, and all the more disturbing for that.

First Communion is a monochrome, and very probably the first monochrome in art of the modern period. It precedes by over thirty-five years the three emphatic, primary-coloured monochrome paintings Alexander Rodchenko created in 1921. By the 1920s a painting that was nothing other than a flat, uninterrupted field of colour was already more than just an ironic possibility; it was perhaps an inevitability, albeit a complex one, with unpredictable and potentially revolutionary implications. For Allais, it was a leap in the dark that could perhaps only be executed by someone on the sceptical margins of modern art. That, perhaps, is what makes *First Communion* so startling and so fresh, still, now, nearly 130 years later and after almost a century of monochromes by the likes of Rodchenko, Yves Klein, Robert Rauschenberg, Lucio Fontana, Mario Merz, Hélio Oiticica, Gerhard Richter and many, many others.

It is at least as likely that Allais was deriding modern painting as celebrating its radical potentialities; his prophetic vision of a totally abstract art was probably meant more as a sardonic warning than an eager anticipation. But to me that doesn't matter very much. As with many later

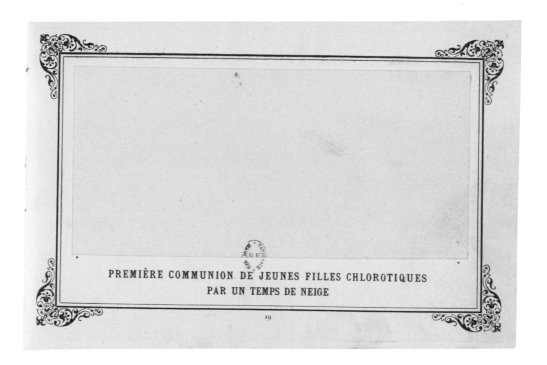

PREMIÈRE COMMUNION DE JEUNES FILLES CHLOROTIQUES
PAR UN TEMPS DE NEIGE

19

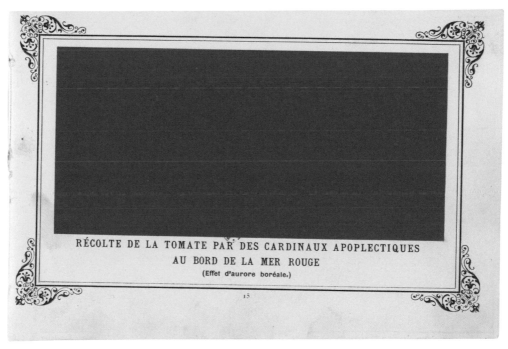

RÉCOLTE DE LA TOMATE PAR DES CARDINAUX APOPLECTIQUES
AU BORD DE LA MER ROUGE
(Effet d'aurore boréale.)

15

David Batchelor lives and works in London.

monochromes, his, for all their apparent simplicity, are richly ambiguous. 'All that is solid melts into air', Marx had said, a few years earlier, about the effects of industrialized capitalism, and Allais's work visualizes, well, almost exactly that. He alludes to a world of bucolic scenes, traditional rituals and sentimental ties, and he points to its utter obliteration. This was arguably a part of the logic of modern painting, but it was something more certain to be accomplished by the logic of modernity. For me the promise, and the threat, that is the subject of *The Fourth Estate* is contained more efficiently, more eloquently, and far more hilariously in *First Communion*. It is truly visionary.

JOHN BOCK

German, b. 1965

ON

ARMAND SCHULTHESS

Swiss, 1901–1972

ARMAND SCHULTHESS
(BELOW AND OPPOSITE)

The Encyclopedic Garden
1951–72
Now destroyed
Photographed in situ,
Switzerland, 1972

Armand Schulthess was a special man. He was not an artist in the normal sense of the word. He was strange. He had worked in an office, in the department of economic affairs in a local administration in Switzerland, until he was about fifty years old, after which he decided to drop out of society.

In 1951 he moved to a house near Auressio in the Swiss countryside, which had a large, two-hectare woodland attached. Here he created an enormous artwork in his garden. He made drawings, diagrams and writings on tin cans, on pieces of garbage and cardboard, and on found bits of wood. He hung these around the garden, from the branches of the trees, in bushes, and placed them on the stone walls.

Schulthess would write messages and texts on many of the objects. For example, he wrote 'Come to me, I have the new record from Wagner. Listen to it with me.' Or 'I have a new book by Sigmund Freud', and then would include a sentence from the book. Sometimes he would give you a lot of information about an author. Some of the diagrams included drawings

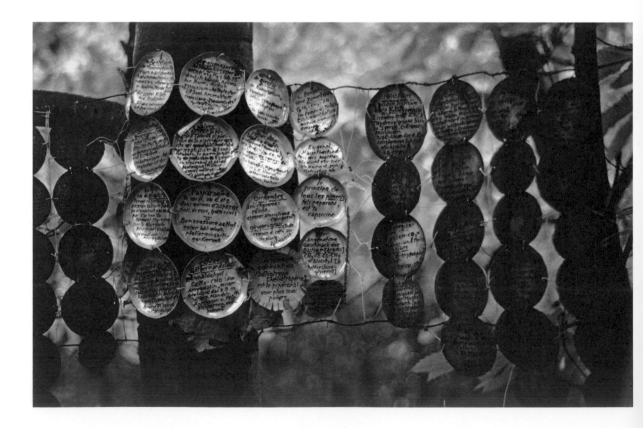

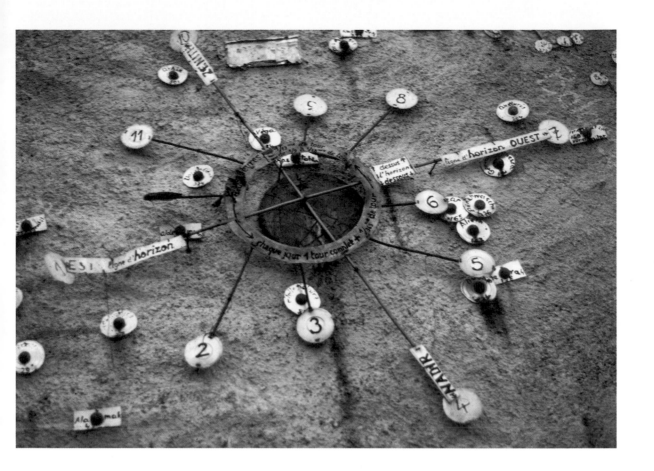

from the cosmos – big drawings of the moon, Jupiter and the Earth.
A lot of the information came from his large collection of books and
articles that he kept in his house. Schulthess had a variety of subjects and
genres in this collection – science, art, music, theatre, anatomy, astrology
and philosophy. Some of the ideas from the books he read would find
their way into the notes and diagrams in the garden. It was a kind of
philosophical garden where he attempted to order the world (his world)
like an encyclopaedia.

Schulthess didn't care about keeping the garden immaculate, and the
objects would get rusty or would fall down in the wind. Even so, each day
he would go outside to check everything and make occasional repairs.

Schulthess has definitely influenced my work. What I like about him is
that he was interested in getting in contact with people through the work
he was doing (though I don't think he had many visitors). This interest
is important to me and relates to my art. The vehicle is the object, or the
object is the vehicle. Of course, there are many differences between his
work and mine. While my contact with the outside world begins in the live
act, his was through these signs and objects in his garden.

There is a rare film about Schulthess made in 1974 by Hans-Ulrich
Schlumpf, which contains footage captured between 1963 and 1972.
I remember seeing it about fifteen years ago. In fact, this was my first
experience of seeing Schulthess's work. It is a very sad story. In the film
you see his family destroying the work after he died. They thought that
everything was garbage, so they set it on fire. It is very hard to watch.
However, not all was lost. A few of the pieces that survived now belong
to the German-Swiss artist Ingeborg Lüscher (who also wrote a book

The Encyclopedic Garden
1951–72
Now destroyed
Photographed in situ,
Switzerland, 1972

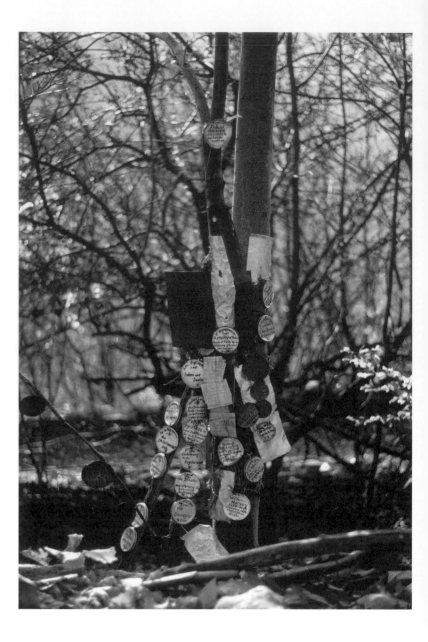

*John Bock lives and
works in Berlin.*

about Schulthess), and you can see some of these pieces in the Casa Anatta museum in Monte Verità, Switzerland.

I think that when Schulthess was working in an office he felt he was imprisoned. So when he bought the house with the woodland he believed he had been liberated. And he worked very hard at his project. Why did he work like this? I don't know. Schulthess was alone but he felt he had to do something to find his position in the world. Not in the real world of people, but in the world of knowledge, in the abstract world.

As a child growing up in Paris, from the time that I was around three years old, my mother and grandmother regularly took me to what was my favourite playground: the Jardin des Tuileries that lies in the heart of the city, between the Louvre and the Champs-Élysées. I must admit that at this age I had no idea who designed such a place, and it wasn't until later in my childhood that I understood that a garden could be designed. For a long time I thought that a garden or a park within a city was a fact of nature, kept intact and preserved, amidst thousands of houses.

André Le Nôtre succeeded his father Jean, who was master gardener to King Louis XIII, in re-designing the Tuileries. Several years later he extended the main axis of the garden westwards to create a fantastic perspective on the city's main avenue, which would later be called the Champs-Élysées.

I also visited Versailles when I was a child. Here again, I was much more impressed by the park and the gardens than I was by the palace itself. I was really struck by the site and its organization. It was a kind of a magical space. Why magical? Because I was moved by what I saw, but unable to understand all the tricks that were at work in such a grandiose space.

Over time I became increasingly interested in gardens in general, but more precisely ones designed by Le Nôtre. I visited dozens of them, from the most well-known ones, such as Chantilly, Wattignies, and, one of the most extraordinary, the gardens at the Château de Vaux-le-Vicomte, to some of Le Nôtre's more modest gardens, including the garden at the Château d'Entrecasteaux and the garden at the Château d'Ussé.

What appeals to me about all these places is that at first glance each garden looks simple and harmonious, but then when you spend more time and look closely you understand the incredible complexity in how these have been designed. How, for example, the long stretch of water at Versailles known as the Grand Canal is at such an angle as to appear as if it is climbing towards the sky when we know perfectly well that the water surface can only be horizontal.

How do such tricks work? It took me a long time to understand Le Nôtre's visual mechanics at work. He plays with the earth. He makes hills and flat surfaces. He distributes trees, creates drawings with flowers, and places sculptures and paths. He designs fountains and cascades. Le Nôtre plays with anamorphous shapes as well as the distribution of thousands of various elements. How did he place objects in very large or small spaces, with such an astonishing masterly manner?

He also plays with sound, with the wind. He plays with the changing colours of the different seasons, with movement and with rigidity, with the

Versailles, view of the garden from
the palace
Garden design completed before 1700

*Daniel Buren lives and
works in situ.*

ephemeral as well as the permanent. Le Nôtre knows how to frame as well
as to disconcert. And we can't forget that he had a vision about how such a
grand scale of works would look ten, twenty, or a hundred years later.

Many people regard André Le Nôtre as a gardener. However, I see him
as an architect, a painter, and a sculptor, as well as a gardener. I consider him
as a great all-round visual artist, in fact one of the best in the Western world.
He is a visionary who is as modern today as he was four centuries ago. If I
have to refer to a real master who led my ambitions and my dreams, I always
immediately think about the works of André Le Nôtre. He, more than any
other, has inspired me as a visual artist, and my wishes to enlarge the vision.

ANDRÉ LE NÔTRE

Château de Vaux-le-Vicomte, Île-de-France,
aerial view of the garden
Garden design completed in 1661

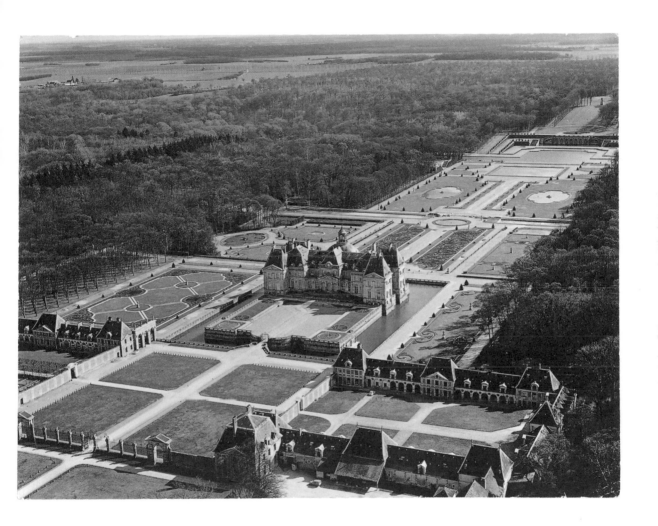

JEAN-MARC BUSTAMANTE

French, b. 1952

ON

PIETER SAENREDAM

Dutch, 1597–1665

PIETER SAENREDAM

The Great or Saint Lawrence's Church at Alkmaar
1661
Oil on panel
59 × 40 cm (23 ¼ × 15 ¾ in.)
Museum Boijmans Van
Beuningen, Rotterdam

Looking at the paintings of Pieter Saenredam, I've always had a feeling of calm, a degree of delight as well, a jubilatory unease. These paintings of architecture go far beyond being portraits of churches. This great painterly virtuosity, which seems to send reality into hysterics, emanates a promise of hope, as if the painter had wanted to accumulate the maximum amount of information to allow himself a freedom of action, and allow us to see the thing seen, if I can put it that way. For me that represents my own insatiable quest for the impossible transparency of the world.

Pieter Saenredam manipulates space. He gives the place depicted a monumentality that is bigger than reality, another perfection, too. Pieter Saenredam knows how to provoke illusions and force the viewer's gaze to assume a position, to re-enter a relationship with the space, thanks to the internal movement that the artist gives to the construction of the painting. I pursue the impossible point of view in my works, too, the search for the deepening of the gaze.

There is no framing, strictly speaking, but an infinity of framing within the painting. It's a matter of putting a world, a single world, in place. I feel a strong affinity with this conception of art in which the clairvoyant artist enlightens us within a fragile balance. Pieter Saenredam dazzles us in this promise that his paintings make to us, the promise of an eternity. Saenredam seems to be playing with the photographic, not as a camera, but as a perspective that captures the distortions of light, of lines. Pale lights, blue skies, sweet surfaces with shades of caramel increasing the sense of unease towards a certain childish nostalgia, and I'm charmed, and a brother-at-arms.

If these works seem meaningless, they might be telling us that the void has never been so certain. There's a timeless dimension to this work, which touches me at the moment where the loss of the horizon makes us envy such an illusion.

Jean-Marc Bustamante lives and works in Paris.

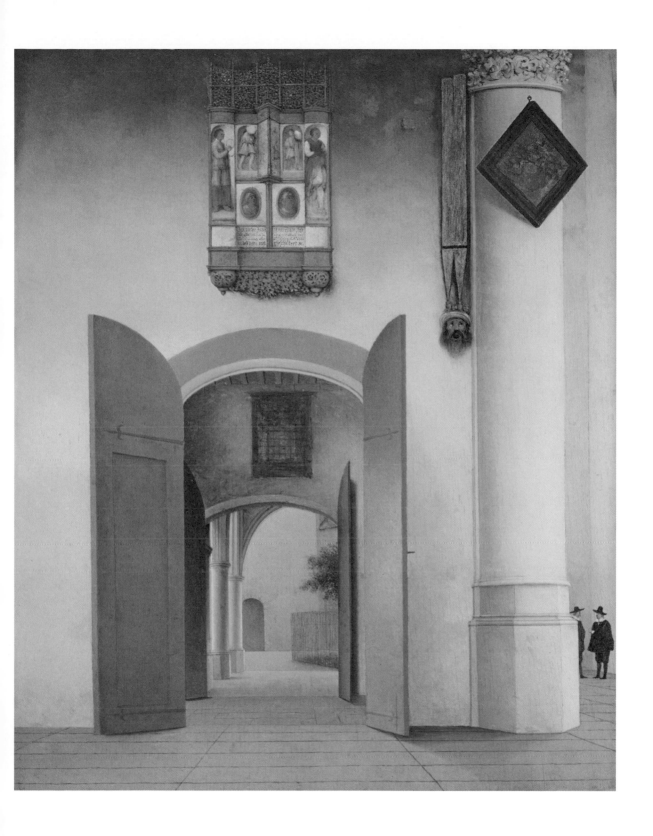

PETER CAMPUS

American, b. 1937

ON

MILTON AVERY

American, 1885–1965

MILTON AVERY

Jagged Wave
1954
Oil on canvas
76.2 × 137.2 cm (30 × 54 in.)
Grey Art Gallery, New York
University Art Collection

I came across Milton Avery's *Jagged Wave* quite by accident in 2008 at the Grey Art Gallery in New York. I was on my way to a meeting across the street and, as I was early, went into the gallery to kill some time. The show was called 'New York Cool: Painting and Sculpture from the NYU Art Collection' and included works donated in the 1950s and 1960s. I had known Avery's work since I began to study art as a teenager, but this painting was new to me. The impact of seeing it was enormous, and helped me guide my own work towards his kind of abstraction: a mixture of things recognizable that are reduced into more simplified forms.

In *Jagged Wave* the colours are exaggerated: the sea is black, the kind of black one doesn't see in the sea often, the sand is the colour of sand, and the band of sky above the ocean is sand-coloured as well. A blue or even grey sky would destroy the picture. The waves are waves, or at least the essence of waves. They are forceful and angry and active, full of motion, and full of the stillness of a painting.

Avery spoke to me quietly. For me – a non-painter – it was beautifully painted. I can see the influence of Matisse in the flatness of the spaces. The absence of perspective brings to mind the period before the discovery of the illusion of space in painting, when artworks were as flat as what they were painted on, such as the sixteenth-century version of the *Shahnameh*, that glorious book of Persian miniatures.

The picture is presented in three horizontal bands, the central band containing the active waves. The black ocean contains the waves. Avery presents the ocean as ominous, foreboding and unknowable, background to the surface waves. From a psychological viewpoint, the waves are consciousness, the dark ocean the subconscious. (Okay, so those of you without degrees in psychology will scowl at this. But why not? Freud was a big thing among intellectuals in those days, and clinical psychology was newly present.) The waves are rough, from a stormy sea: filled with sound and fury, signifying nothing. I reckon that Avery, towards the end of his life – he was sixty-nine at the time, while at the time of writing this, I am seventy-two, by which I mean, an expert – had developed a more balanced approach to the vagaries of consciousness.

There is, of course, the possibility that I am overcome with nostalgia. I can't totally reject it. Clearly the times were different. I was seventeen when this painting was crafted and I can remember that time: post-war boom, anti-communism in America, a blandness that conjured a pretence of safety

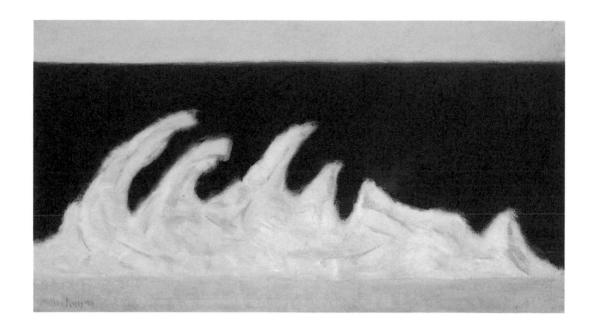

against the background of nuclear threat. My understanding of nostalgia is the past hindering the present. No, I have no desire to re-enter that period, not even in my imagination.

Instead, to me *Jagged Wave* is almost biblical, Old Testament stuff. Jonah facing this sea. It is about our souls, our psyches if you prefer, in flux, sometimes in active agitation, mirroring the ocean waves. The ocean is beyond us, and we are from it, but cannot understand it any better than we can understand ourselves.

I have not seen *Jagged Wave* recently, so this has become a different experience from seeing the modernist pictures on my parents' walls, or visiting familiar works in the Metropolitan Museum and the Museum of Modern Art in New York. It has become a vivid memory like the memory of a Simone Forte performance piece in the late sixties, a memory that I recently discovered I share with fellow artist Michael Snow. Or the memory of Hopi dances. These visual memories are somewhere in my cortex, and I hope it will be difficult to dislodge them.

Peter Campus lives and works in New York.

VIJA CELMINS
American, b. 1938

ON

PHILIP GUSTON
American, 1913–1980

PHILIP GUSTON

Untitled
1963
Synthetic polymer paint on paper
76.2 × 101.6 cm (30 × 40 in.)
The Museum of Modern Art,
New York

I often visit the Museum of Modern Art, New York, but on a recent visit I came across a room of Philip Guston's early paintings. One dated 1954 was a gorgeous abstract canvas shimmering with rosy light. Another, from 1969, *Edge of Town*, had a very descriptive scene of Ku Klux Klan members sitting in a convertible, smoking cigars, their hoods up and weapons ready.

Within these two extremes, I was drawn to a couple of paintings from the 1960s, big, grey, ungainly paintings that contained blocks of black shapes. They had the look of a child's finger painting, spontaneous but crude, not knowing, chaotic, but not quite. Stepping back to see them, the paint strokes are not random stabs of the brush: they work together to make a sophisticated surface, which describes both the shallow space of the painting and also a more illusionistic, deeper space. Standing close to the painting and looking hard, I can feel the great energy and sensuous quality of the strokes.

Guston was, it seems to me, doing battle between the paint itself, with its inherent tendency to 'be enough', and the artistic impulse to form an image of things made of paint, but relating to the world outside painting, the world in which we live.

In these paintings, sitting in this grey sea of strokes, are blob-like shapes. Boots? Rocks? Cups?! Block-like heads? His later paintings from the 1970s are full of heads, mostly Guston's own head, sleeping, smoking and working in his studio.

I also had the thought that these grey paintings were a decision to deny, or at least to leave behind, the beauty of his tactile and sensuous abstract paintings of the 1950s. In fact, in almost all of these works, the strokes seem to be blotting out rosy-red paintings underneath. Along the edges, the smudges make a particularly characteristic and beautiful Guston colour combination of pink, grey, red and black.

Because we are familiar with many of Guston's later paintings full of things – feet, heads, light bulbs, paint tubes – these turbulent, grey paintings that came before seem transitory, as if a grey blanket had been temporarily thrown over the objects fighting to get out. However, I see them as courageous in their rawness and energy, and in their rejection of over-refinement and easy interpretation. They are works that make a definite turn, for a moment of time, to strike a darker, more ambiguous chord, but stand as complete and extraordinary as any in Guston's oeuvre.

I never really knew Guston's work when I was in my early twenties and trying to make big, abstract painting; I mostly just knew de Kooning and Pollock. I began to notice Guston later when I was already on my way in

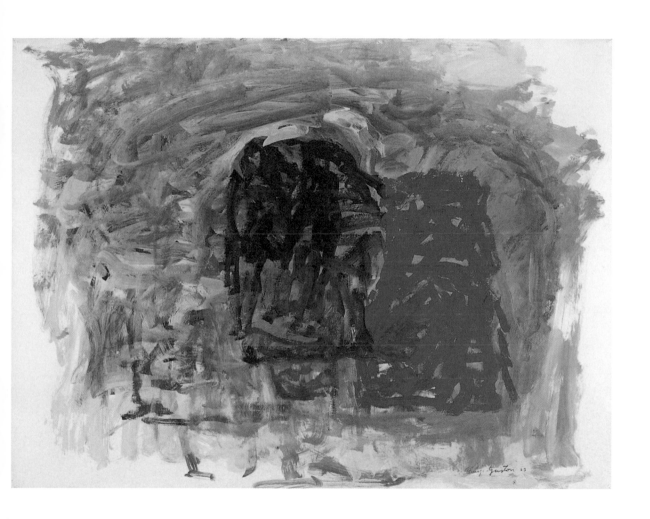

*Vija Celmins lives and
works in New York.*

another direction. Seeing the work close-up brought me to attention. I think
it was the image, and storytelling, so reinvented in paint that did it. It was
as if the paint, so sensuous and there for itself only, also carried a mute but
harrowing set of stories about our lives, the life of making art. The work
made another world so believable and so engaging. I guess you can see I
have become a great admirer of Guston, and his grey work from the 1960s
is perhaps the most challenging.

SPARTACUS CHETWYND

British, b. 1973

ON

PIRRO LIGORIO

Neapolitan, c. 1510–1583

SPARTACUS CHETWYND (BELOW)

Debt – A Morality Play. The Hell Mouth
2004
Wood and cardboard
Installation view at the Migros
Museum für Gegenwartskunst,
Zürich, 2007

PIRRO LIGORIO (OPPOSITE)

Park of the Monsters
Bomarzo, Italy
Sixteenth century
Photograph taken in 1952
by Herbert List

The Park of Monsters in Bomarzo is like a theme park that is carved in rock! It was designed by Pirro Ligorio, who had been commissioned by nobleman Pier Francesco Orsini in the second half of the sixteenth century. It is a pleasure garden, not made for any particular reason. Orsini's beloved wife died in 1564 while the garden was already under construction, and as a result it seems to have morphed into a memorial or reflection on death. So maybe the garden's outlandish style is a result of crazed grief? Or maybe it is a mixture of emotions piqued by Orsini's peeved feelings towards his neighbours' formalized gardens?

I went to Bomarzo when I was a teenager and I remember that you could walk up to the sculptures. One of the giant heads has a room inside it that is carved out of solid rock. It is a perfect room with windows that are the eyes set within the huge monster's face. The door is the mouth.

The park is inspiring because it is so big and random, and clearly built to last. When you visit the gardens now they are initially a bit disappointing, as the sculptures are roped off and there is a guard watching your every move. I imagine it was more exciting a hundred years ago – photos show everything entangled in brambles like Sleeping Beauty's castle.

Salvador Dalí and Jean Cocteau were both inspired by Bomarzo. I wonder if David Cronenberg also was? In his sci-fi horror film *Scanners* (1981), one of the 'afflicted' is an artist – Benjamin Pierce. To overcome the pressure of constantly hearing other people's thoughts, Benjamin finds refuge in his art, sculpting stressful, life-size mannequins in horrible

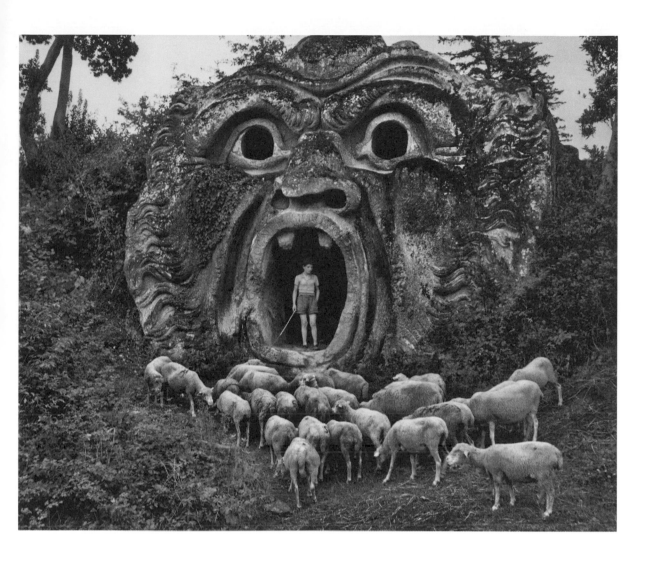

situations. The hero investigates Benjamin and goes to his studio. He is ushered into a giant sculpture of a head, where they have a chat seated on cushions: 'I have friends, I don't want them but I have them…My art, my art keeps me sane … (taps his head and repeats) … SANE.' In *Scanners* the giant head is on its side, you enter though the neck, the face is narrow, and its mouth is closed. I guess it is unrelated, but it would be great to think that Cronenberg had been influenced by Bomarzo.

In 2005 I built a huge cardboard version of one of the Bomarzo heads. I was looking at pictures of medieval religious plays and they all had images of people jumping in and out of a giant head, a 'Hell Mouth'. It seems the entrance to either Hell or a Luna Park is a giant mouth. I thought to build one. I looked up a book in the library on Bomarzo to be able to copy from the picture.

I have imagined building my own home like an Earthship, a sustainable structure made from recycled materials. I have pictured myself pounding away at compacted earth. When I think about Bomarzo my desire to build a more elaborate home is overwhelming. I wish I could build a house in the shape of a giant head. It would have to have a south-facing glass wall and a roof designed to collect rainwater. It could be 'terrible' in style and have a literal ghastliness about it.

Spartacus Chetwynd lives and works in London.

FRANCESCO CLEMENTE
Italian, b. 1952

ON

HENRY FUSELI
Swiss, 1741–1825

HENRY FUSELI

Fragment of Satan Musing on his Works (Satan Discovering his Fate in the Scale Aloft, Flying from Gabriel and the Angelic Squadron)
1790–1800
Oil on canvas
87 × 77 cm (34 ¼ × 30 ¼ in.)
Collection of Alba and Francesco Clemente

I became a painter because I felt I recognized in some rare artists the manifestation of a truly contemplative language. From the past: Petrus Christus, Zurbarán, Blake and Fuseli. In our time: Mondrian for painting, Ginsberg for poetry and Maya Deren for film. In the field of science Gregory Bateson has attempted to build a fragmentary language, more faithful to an organic, integrated vision of the mind.

I believe my task as a painter is to generate and sustain such a language, the fragmentary language not of one mind but of many minds, not of one truth but of many contradictory truths, not of one culture but of a dynamic mix of cultures.

So it was that, after living in India for many years, I unexpectedly found myself in New York. In one of my earliest dreams in my new city, I received an unexpected visitor. Satan appeared while I slept and held me in conversation for a while. No flames or wailing, no serpent's tail, nothing dramatic at all. Simply a figure with greyish skin, plainly dressed, mature, but not old. Lying on a couch, his head propped against a pillow, he explained that I should cultivate this posture, as it allowed one to think clearly, unencumbered by the weight of the body. There was something profound about his presence, an infinite opacity, paradoxically absorbent, so much heavier than sadness. It didn't inspire fear, but helplessness.

I didn't know what to make of my dream; to say the least, I was surprised by it. But the true shock came some three weeks later when I found myself in a snobbish antiques store. There before me hung what remains of Fuseli's portrait of Satan, the subject bearing a shocking resemblance to the Satan in my dream. The shop owners were too haughty to admit that the painting was a Fuseli, and I ended up buying it at a surprisingly reasonable price. It was the first acquisition of my new life in New York, the life of an émigré – much like that of Fuseli himself, who had come to London from Switzerland.

As in my dream, where Satan was all head, his body an undervalued shadow on the couch, the Fuseli *Fragment of Satan* is missing the body, as it is a fragment of a larger painting now lost. The colouring of the face is greyish; the posture of the hands and eyes pensive, melancholic. From the head rises a curved line of smoke, in the shape of a caduceus, flanked by the wings of Hermes, the deity of the wandering mind. Saturn, the planet of neurosis and depression, rules the background sky.

The beauty of pictures is that, even when they refer to a story, that story can be misconstrued, or ignored altogether, whereupon a new story may surface beyond and in spite of the intentions of the artist. In the case of the Fuseli painting, I like to think that *Satan* is the head of Modern Man. This is why I've kept the painting for all these years, as my protection and talisman. A talisman is nothing more than a mnemonic device, contrived to remind us

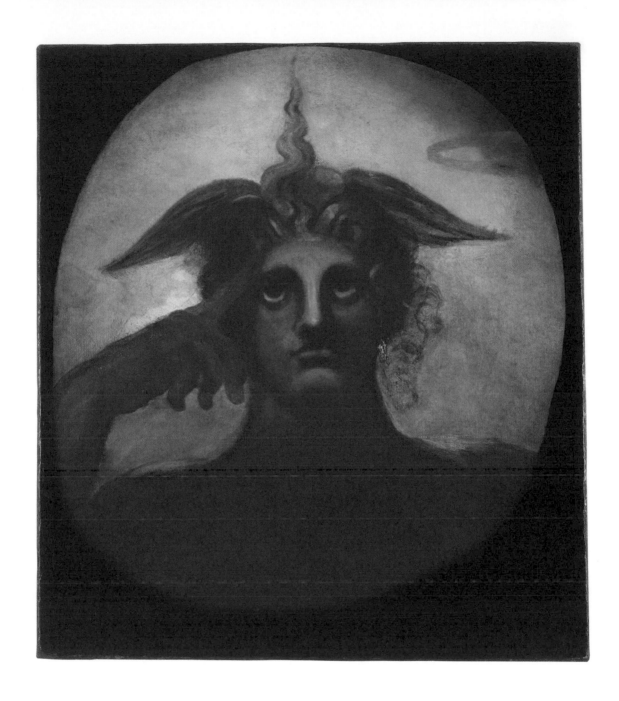

of who we are. To know oneself is to protect oneself, not least against one's mind. The mind we have been given in our time is a Satanic mind, inasmuch as we turn our backs to the light, enchanted by the vagaries of thoughts and opinions, and ignoring the silence of truth.

This is the condition we have been given, and the one Fuseli so eloquently and concisely depicts: Satan, modern man, modern artist, locked in his own head, looks up for an escape, searching for more ideas. He neglects to look down, toward the heart and toward the life of forms. While ideas divide us, forms unite us. Satan, contemporary man, contemporary artist, divides, and is divided; he is hopelessly sentimental, and condemns himself to darkness, can see only darkness in darkness. My daily encounters with Fuseli's *Satan* strengthen my resolve, as an artist, to prove that other, more luminous ways to see are still possible.

Francesco Clemente lives and works in New York, India and Italy.

CHUCK CLOSE

American, b. 1940

ON

JOHANNES VERMEER

Dutch, 1632–1675

JOHANNES VERMEER

The Milkmaid
c. 1657–58
Oil on canvas
45.5 × 41 cm (18 × 16 ⅛ in.)
Rijksmuseum, Amsterdam

Ever since I was a student, my favourite artist of all time has been Johannes Vermeer. I understand, or at least can intuit, how every painting ever made, from the Lascaux caves to the most cutting-edge work of today, was painted. Information about a painting's creation is imbedded in the paint itself. Touch, hand, process, technique and other indicators of physicality are laid out for a trained and sophisticated eye to unpack and decipher, especially that of another artist who has had the shared experience of having pushed a lot of paint around. Recorded in the surface is all manner of 'pictorial syntax', the visual equivalent of the vocabulary novelists choose, which we use to recognize a particular writer's voice. Different stylistic and descriptive choices are where style is imbedded – where the rubber meets the road. It is a kind of Hansel and Gretel trail to be followed, if the viewer is so inclined, to retrace the path the artist took and understand how this journey is different from that taken by other artists, even those addressing the same subject matter. A work of art is a record of the decisions that the artist made, which can still be decoded centuries later.

All of this is to say that Johannes Vermeer is the only artist whose paintings I cannot readily deconstruct; their physicality and process seem to resist all analytical scrutiny. Other than the fact that they were all made with the use of a lens and a camera-obscura-like mechanical contrivance of some kind, the paintings remain impenetrable.

I have no idea how Vermeer made them. The paint appears to have been blown onto the canvas or panel by a divine breath of air – the perfect breeze. The paint does not seem to function as a film of pigment – neither opaque nor translucent – but instead as light itself.

While most people only notice the subject matter and marvel at the verisimilitude, time spent with a painting like *The Milkmaid* is time spent communing with an image so sublimely painted that it transcends its physical reality of mere paint on a panel, and becomes an apparition worthy of creation by the gods. Such sophisticated and remarkable paint handling only seems to heighten the nearly irresistible attraction to a plain and ordinary-looking Dutch woman, with sleeves rolled up revealing a farmer's tan, involved in the most domestic of circumstances – pouring milk into a bowl. She is surrounded by bread and other food stuffs so naturalistic that a fly could be confused and try to land on them. The pail and the basket that hang on the wall nearby are so correct (from a perspectival point of view) and photo-like that they defy hand-paintedness. On the floor rests a foot-warmer, which, despite the abundant light flooding through the window, speaks to the unmistakable chill in the air. Chips of plaster are missing from

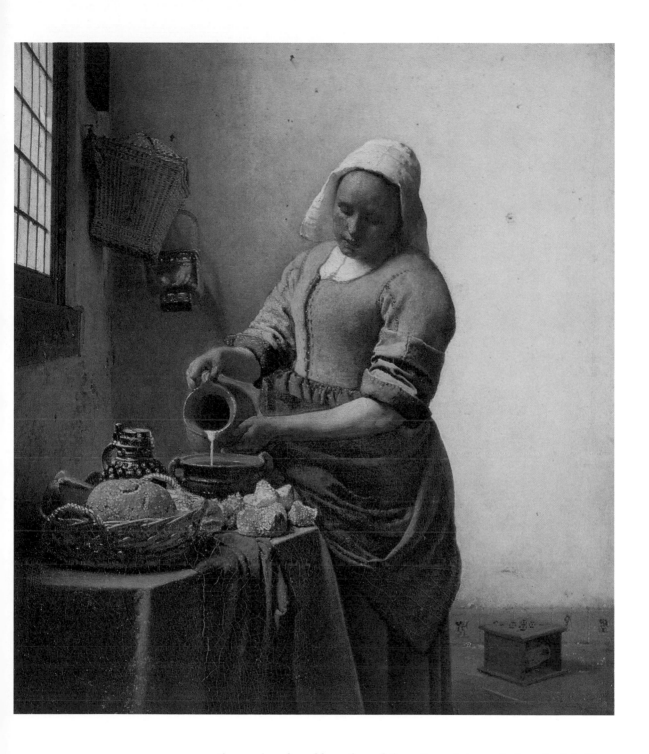

the rough and cruddy surface of the wall, much in need of a paint job. The intense attention the milkmaid pays to the job at hand speaks to the nobility of the honest work of domestic labour.

So much information and compressed energy is packed into such a small painting. Inch for inch, *The Milkmaid* is one of the most remarkable painterly achievements in the history of art.

Chuck Close lives and works in New York.

GEORGE CONDO

American, b. 1957

ON

REMBRANDT VAN RIJN

Dutch, 1606–1669

REMBRANDT VAN RIJN

Christ Preaching or *'The Hundred Guilder Print'*
c. 1647–49
Etching, drypoint and engraving
28 × 39 cm (11 × 15 ⅜ in.)
Rijksmuseum, Amsterdam

Rembrandt is an artist who is so ingrained in my consciousness that it is almost impossible to remember when I first saw his work. Could it have been my father showing me some of his paintings in a book? Or was it my grandfather? Or did I discover them myself? Whatever the case, the light turned on in my head, so to speak, when I saw an exhibition of Rembrandt's etchings at the Museum of Fine Arts in Boston when I was a teenager. What I liked about them was not just the quality of the line, or the intensity of the chiaroscuro, but also the sense of drama that he created in these etchings. In *Christ Preaching*, Rembrandt captured a myriad of expressions and emotions on the faces of the people listening to Christ, as if he had really been there himself as a witness. It made me understand that an artist could create a concrete pictorial reality even if it came purely from the imagination.

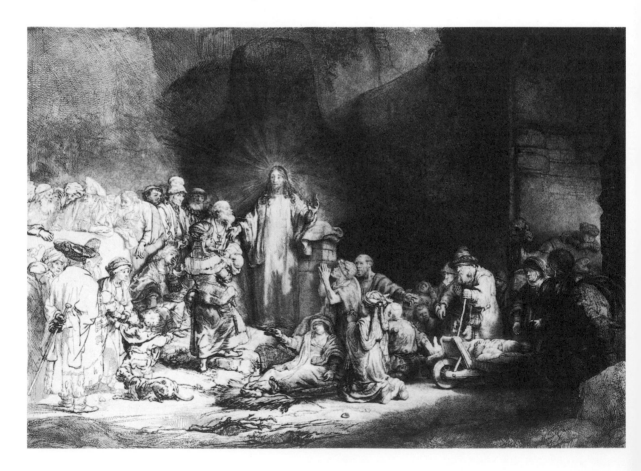

When I see Rembrandt's portraits I get an emotional response from them, which is something you can only get from a great artist. He renders intense human emotion through his use of paint, the mixture of light, atmosphere and facial expressions. The quality of his work lies in the believability of the image, its spirit and soul, not just the technical execution. It is, of course, hard to ignore Rembrandt's life narrative, which was filled with so much sadness – the death of two infant daughters and his first wife, as well as his son Titus, and then, later, bankruptcy. Many people feel that Rembrandt was expressing his own sorrow in his art, but I think he was also depicting the sadness of other lives, as well as humanity in general.

Rembrandt's paintings and etchings endlessly played with this idea of combining personal and general experience. He seemed like a man who was trying to find 'himself' in every portrait he created. His own scarred and chiselled features can even be seen in the portraits he painted on commission. The despondent, dejected look of his late self-portraits seems to say: 'Well, what can you do – that's life.' I think this is a beautiful thing. There is a purity and sincerity in Rembrandt's work. He is more like the forerunner of an Impressionist asking, 'How does it feel?' not 'What does it look like?' There is nothing academic or superficial about Rembrandt's artwork.

Rembrandt has definitely influenced my work in several ways. For instance, the way he positions a figure in space within a canvas might influence the figures that I imagine for my paintings. The painting *Skinny Jim* (2009), for example, was partly influenced by the composition of Rembrandt's *Portrait of Nicolaes Ruts* (1631). You can see that in both paintings a hand comes around one side of the body and is holding something. I also adopted Rembrandt's positioning of light and dark in the atmosphere surrounding the figure. This was not an appropriation, it was a presencing, a referential superimposition. It was not intended as an insider artist's joke either. It was my way of establishing the believability of an imaginary character through the use of visual languages in art.

I once made a work that you could call a direct homage to Rembrandt – *Memories of Rembrandt* (1994). It is a composition made up of various scrambled components remembered from Rembrandt's portraits. Such homages are interesting, but only up to a point. It is more interesting to see how artists visually take apart and re-assemble existing works of art, and the inspiration they derive from them, to arrive at a totally new creation, which contains all that came before it.

George Condo lives and works in New York.

GEORGE CONDO (RIGHT)

Skinny Jim
2009
Oil on linen
117.50 × 134.50 cm (46 ¼ × 53 in.)

GEORGE CONDO (BELOW)

Memories of Rembrandt
1994
Oil on canvas
178 × 178 cm (70 × 70 in.)

REMBRANDT VAN RIJN (OPPOSITE)

Portrait of Nicolaes Ruts
1631
Oil on mahogany panel
116.8 × 87.3 cm (46 × 34 ⅜ in.)
The Frick Collection, New York

MICHAEL CRAIG-MARTIN
British, b. 1941

ON

MARCEL DUCHAMP
French, 1887–1968

MARCEL DUCHAMP

Tu m'
1918
Oil on canvas, with bottle brush,
three safety pins and one bolt
69.8 × 303 cm (27 ½ × 119 ¼ in.)
Yale University Art Gallery,
New Haven

I first came across *Tu m'* by Marcel Duchamp at the Yale University Art Gallery as a student at the art school in 1961. I was immediately drawn to it because it was unlike any other painting I had ever seen – its unusual proportions, the provocation and absurdity of the protruding brush, the pointing hand. That it had been donated by the mysterious-sounding Société Anonyme only enhanced its aura of specialness.

It was years later that I came to fully recognize and appreciate its combination of seriousness and wit, of orthodoxy and transgression, its interlinking of visual and conceptual conceits, and its teasing playfulness with the conventions of painting and representation.

Tu m' was Duchamp's last painting on canvas. He had rejected painting by the time he agreed to this special commission from his friend and patron, the artist Katherine Dreier. The work was made to go above a bookcase in her library, hence its unusual shape and size – it is more than ten feet wide. Duchamp had long been disillusioned with what he called retinal art, art that appealed only to the eye, which he considered to be the inherent limitation of painting. He was seeking new forms for art that would give primacy to the mind over the eye, and had already been working on his monumental

Bride Stripped Bare by Her Bachelors, Even (The Large Glass) (1915–23) for several years.

Tu m' is like a very sophisticated handbook of painting, interweaving a catalogue of image-making conceits and possibilities, playing back and forth between reality and illusion, questioning the veracity and reliability of both.

Duchamp breaks painting down into its formal elements – colour, line, plane, space – and addresses each separately. Receding into space from the centre of the painting to the upper left corner and beyond is an infinite series of colour swatches, each of which casts its painted shadow on the swatch below. A real metal bolt goes through the centre of the topmost swatch, as if to lock it to the surface of the painting.

Below this is an image of a pointing hand. It is not simply a picture of a hand but an image intended to act as a directional sign. Duchamp hired a commercial sign painter to paint it: he signed himself 'A. Klang'. While making use of the capacity of images to have different meanings and functions, Duchamp undermines the assumed necessity of the artist's hand in the making of an authentic artwork.

The hand points to a white rectangle seen in perspective, like a blank sheet of paper. Flowing from the edges of this white rectangle are eight curving lines, derived from another of Duchamp's works, *3 Standard Stoppages*, made in 1913–14, using chance to create standard and repeatable lines. The *3 Standard Stoppages* appear again on the left-hand side of the painting, here forming the edges of three opaque overlapping planes.

Floating bands of colour and sequences of circles recede into the distance, creating the illusion of an image in space, an image transparent and hovering, dynamic and mechanical, rather like an early flying machine.

Between the colour swatches and the white rectangle, there appears to be a long jagged tear in the canvas, as though it had been slashed. This *trompe l'oeil* tear is painted, not real, but it has been crudely 'repaired' with

MICHAEL CRAIG-MARTIN
(ABOVE AND OPPOSITE)

An Oak Tree
1973
Assorted objects and printed text
Objects: 14.6 × 46.5 × 13.8 cm /
Text: 30.4 × 30.4 cm (5 ¾ × 18 ¼
in. / 12 × 12 in.)
National Gallery of Australia,
Canberra

Michael Craig-Martin lives and
works in London.

real safety pins. A similarly real, two-foot long bottle brush (perhaps an allusion to Duchamp's 'readymade' bottle dryer) protrudes at a right angle through the tear. He makes it clear that illusion is just a trick, a sleight of hand.

Finally, Duchamp uses the one form of image making where the artist is not the author – shadows. Three painted shadows extend across the surface of the painting, two are of his readymades – the bicycle wheel and the coat rack – and the third a corkscrew, a typically Duchampian phallic symbol. They are, of course, accompanied by a fourth shadow, the actual shadow cast by the bottle brush.

The ultimate irony of *Tu m'* is that in making a painting that was intended to underscore the emptiness of the medium, Duchamp produced a work that brilliantly reveals painting's capacity to be intellectually and visually complex and challenging. It is a homage, not a requiem.

Tu m' may not be Duchamp's most significant achievement but I think its importance in the history of painting is generally overlooked. For me personally, I am happy to say, it has lost none of its magic.

Q: To begin with, could you describe this work?

A: Yes, of course. What I've done is change a glass of water into a full-grown oak tree without altering the accidents of the glass of water.

Q: The accidents?

A: Yes. The colour, feel, weight, size....

Q: Do you mean that the glass of water is a symbol of an oak tree?

A: No. It's not a symbol. I've changed the physical substance of the glass of water into that of an oak tree.

Q: it looks like a glass of water....

A: Of course it does. I didn't change its appearance. But it's not a glass of water. It's an oak tree.

Q: Can you prove what you claim to have done?

A: Well, yes and no. I claim to have maintained the physical form of the glass of water and, as you can see, I have. However, as one normally looks for evidence of physical change in terms of altered form, no such proof exists.

Q: Haven't you simply called this glass of water an oak tree?

A: Absolutely not. It's not a glass of water any more. I have changed its actual substance. It would no longer be accurate to call it a glass of water. One could call it anything one wished but that would not alter the fact that it is an oak tree.

Q: Isn't this just a case of the emperor's new clothes?

A: No. With the emperor's new clothes people claimed to see something which wasn't there because they felt they should. I would be very surprised if anyone told me they saw an oak tree.

Q: Was it difficult to effect the change?

A: No effort at all. But it took me years of work before I realized I could do it.

Q: When precisely did the glass of water become an oak tree?

A: When I put water in the glass.

Q: Does this happen every time you fill a glass with water?

A: No, of course not. Only when I intend to change it into an oak tree.

Q: Then intention causes the change?

A: I would say it precipitates the change.

Q: You don't know how you do it?

A: It contradicts what I feel I know about cause and effect.

Q: It seems to me that you're claiming to have worked a miracle. Isn't that the case?

A: I'm flattered that you think so.

Q: But aren't you the only person who can do something like this?

A: How could I know?

Q: Could you teach others to do it?

A: No It's not something one can teach.

Q: Do you consider changing the glass of water into an oak tree constitutes an artwork?

A: Yes.

Q: What precisely is the artwork? The glass of water?

A: There is no glass of water any more.

Q: The process of change?

A: There is no process involved in the change.

Q: The oak tree?

A: Yes. The oak tree.

Q: But the oak tree only exists in the mind.

A: No. The actual oak tree is physically present but in the form of the glass of water. As the glass of water was a particular glass of water, the oak tree is also particular. To conceive the category 'oak tree' or to picture a particular oak tree is not to understand band experience what appears to be a glass of water as an oak tree. Just as it is imperceivable, it is also inconceivable.

Q: Did the particular oak tree exist somewhere else before it took the form of a glass of water?

A: No. This particular oak tree did not exist previously. I should also point out that it does not and will not ever have any other form but that of a glass of water.

Q: How long will it continue to be an oak tree?

A: Until I change it.

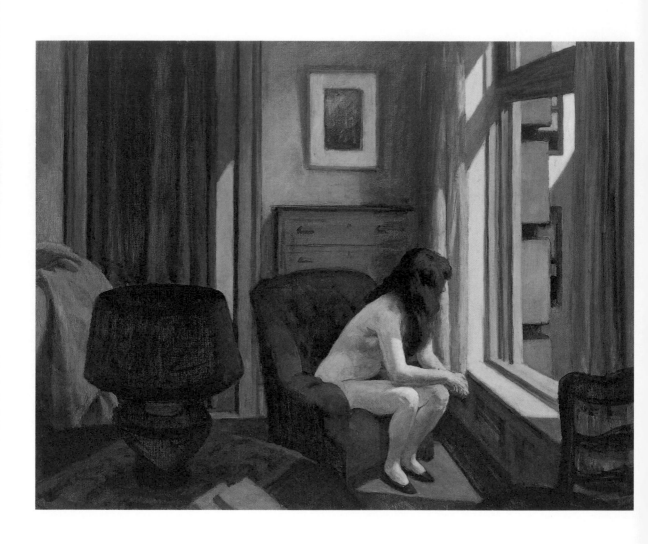

GREGORY CREWDSON

American, b. 1962

ON

EDWARD HOPPER

American, 1882–1967

Edward Hopper has been a huge influence on me. His work is grounded in an American sensibility that deals with ideas of beauty, theatricality, sadness, rootlessness and desire. It is now virtually impossible to read America visually without referring back to the archive of photography and cinema that has come from Hopper's paintings. His art has shaped certain essential themes and interests in so many contemporary painters, writers and, above all, photographers and filmmakers.

He used to liken his own paintings to the single frames of films. There is always a suggestion of framing in his pictures, whether it's windows, doorways or shafts of light, but the single frames he refers to are also very much about the fragment. Hopper's narratives occur in moments that are forever suspended between a 'before' and an 'after' – elliptical, impregnated moments that never really resolve themselves. There is an enormous reservoir of psychological anxiety in his work, a sense of stories repressed beneath the calm surface.

Everything in a Hopper painting, his interiors in particular, is full of meaning that propels the narrative. It's the telling detail, whether it be a suitcase, a book or a bed, that is really important. Every artist creates his or her own vocabulary, a microcosm where motifs appear and re-appear, revealing certain obsessions. It's amazing how many of Hopper's pictures feature something as simple as a bed, windows, or doorways. I think this serves to further emphasize the viewer looking with a kind of voyeuristic gaze into the world. It is an idea that Hitchcock used in *Rear Window* (1954) where you have people looking out from one private world into another.

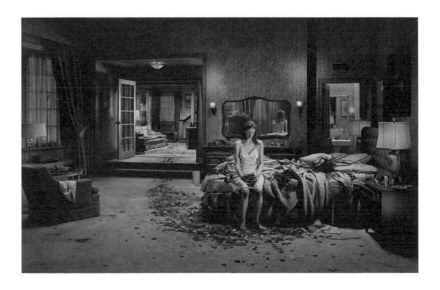

Hopper's figures are often seen peering through windows or into the landscape. Ultimately, I believe the window creates the possibility of another existence outside their own. He's not only showing us alienation, but also a degree of hopefulness.

And there is an extraordinary sense of light in Hopper's work. On the surface it appears to be realistic, but there is something particular about his light that, to me, makes his paintings feel more psychological. There are these very ordinary situations, and the light is being used as a narrative code to reveal the story. It also provides some possibility for transformation of the ordinary, which gives the images a certain theatricality. Steven Spielberg picked up on this and used it very well in *Close Encounters of the Third Kind* (1977). In the film there is a collision of the themes of the paranormal and a strange confusion of nature and domesticity. It is also there in Paul Thomas Anderson's film *Magnolia* (1999), particularly in the scene that culminates in a rain shower of frogs.

The idea of theatricality is prominent in American visual culture. I think it has something to do with the nation's fixation on artifice. There is a mix between artifice and everyday life. In terms of art, this notion of the uncanny is grounded in a defined angle on realism. Hopper's is not a conventional realism, but a psychological one. (You can see it also in John Currin's paintings and Robert Gober's sculpture.)

Hopper's landscape painting has also been enormously influential for several generations of figure photographers (I have always joked that he is one of the most important photographers), from Diane Arbus and Robert Frank, to Cindy Sherman's early black-and-white film stills and Philip-Lorca diCorcia. In particular, Hopper has had a major impact on the way American landscape and exterior spaces have been photographed.

Hopper was very much drawn to American vernacular spaces, where there is a sense of the familiar and the ordinary. His work feels as if it can be everywhere and nowhere; it is less about a particular place, and more about a collective imagination. Many people equate Hopper with suburbia, but most of what he painted was in New England. There's something about the way he depicted the Cape Cod houses, for example, that has resonated with people nationwide. One also gets this sense of mobility and isolation. Moving out of a small-town situation, the westward migration, the road trip – these are all very much part of the American psyche. Joel Sternfeld,

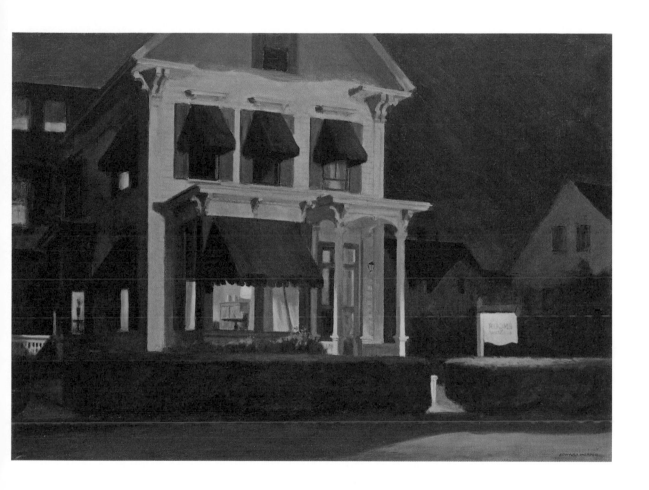

Stephen Shore and the topographic photographers, such as Robert Adams, have all picked up on his interest in the American vernacular.

Photographers and filmmakers have engaged with the duality that is at the heart of Edward Hopper's art – that of beauty and sadness. I think that duality is the key aspect of his work, and why so many have been affected by it.

Gregory Crewdson lives and works in New York.

DEXTER DALWOOD

British, b. 1960

ON

ROBERT RAUSCHENBERG

American, 1925–2008

A few years ago I broke a self-imposed rule: I never like to go back to see a band I have previously seen in their prime. It breaks the spell. Thirty years after seeing Iggy Pop at the Rainbow Theatre, London, in 1978, I reluctantly went with a friend to see the re-formed Stooges at the Meltdown festival in London. The band started up, and Iggy appeared, ran across the stage, and dove into the audience. No warming up of the crowd – just straight in, and he then continued to pour out pure adrenaline for the whole set. It started me thinking, what could possibly be painting's equivalent to this? In a correspondence with the writer Dave Hickey, I asked him whom he could think of and he said: 'Bob Rauschenberg in the mid fifties, stone crazy and stage-diving like mad'.

Rebus is one of those works that makes you realize just how much the art world has changed. The pure force of its making comes rattling through the decades and demands to be taken seriously; it is an unapologetic attempt to create a work that says 'this is it, for here and now'.

Painting can bring all these strands of representation together and force itself to be considered, and in its achievement the parameters of painting are widened, sounding a rallying cry away from fading ideologies and comfortable context. You can't help feeling that in that early period of the 1950s, Rauschenberg was genuinely 'sticking it to the man'. The use of the eraser as a drawing tool, which culminated in *Erased de Kooning Drawing* (1953); the freestanding combine painting (an artwork that includes various objects within the painted surface) *Minutiae* (1954), originally made as a stage construction for a performance of Merce Cunningham's ballet of the same name. Rauschenberg was using what was lying around his studio – pioneering a cut-up technique. It was similar to what William Burroughs did when he was holed up in the El Minzah Hotel in Tangier, bombed out of his head and surrounded by lists and pieces of his chopped-up manuscript – those elements which would be rescued by Allen Ginsberg and eventually published as *Naked Lunch*, a few years after *Rebus* was made.

Similarly, *Rebus* combines found images with art historical images and in doing so drives a wedge between real time and art history. A menagerie of influences came together in the act/performance of making this work. You can't help feeling that it pokes fun at the truth of the artist's mark-making and the high aesthetic ground that Abstract Expressionism had come to occupy.

Rauschenberg set out a new, brutal and yet beautiful agenda for image-making. Andy Warhol was able to process this and make a hybrid consumer-based version. *Rebus* exists in an age without Photoshop or computer-manipulated images. Like the analogue rock star Iggy Pop, Rauschenberg's *Rebus* cuts through the consumable to a primordial stew of creativity that still packs a punch.

Dexter Dalwood lives and works in London.

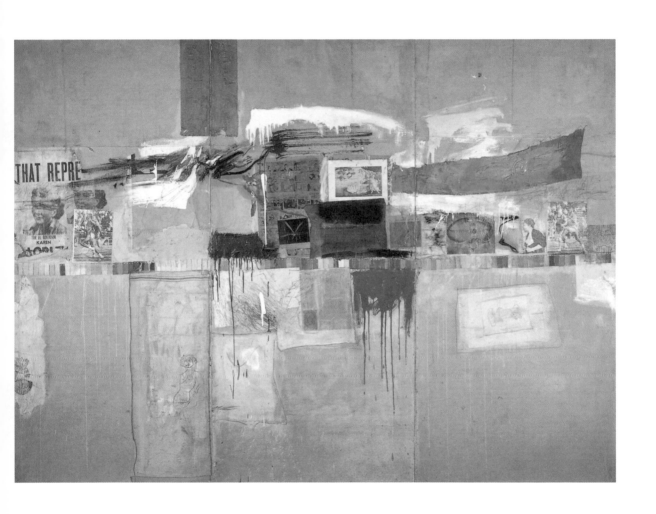

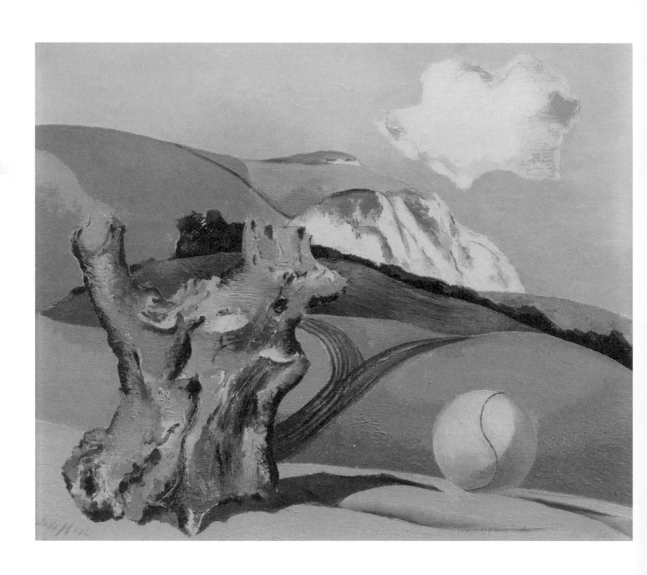

TACITA DEAN
British, b. 1965

ON

PAUL NASH
British, 1889–1946

PAUL NASH

Event on the Downs
1934
Oil on canvas
51 × 61 cm (20 × 24 in.)
The Government Art Collection,
UK

Trying to choose a favourite work of art is a complicated business, often more revealing about oneself than it is about the artist one chooses. A while back, for example, I woke earlier than usual in the summer heat and sat on the balcony looking hard at a book of Paul Nash's paintings, and tried to pin down exactly what it was about them that I found so compelling. After an hour or so, I was overcome by a wistful longing, which I often associate with his work – a desire to return to the places in his pictures as if I had known them myself and recognized them. Confusion, perhaps, or at least a confluence, between where it is that I think I am remembering and what it is that he is depicting.

Others paint pictures of places but few, if any, compel me to return to them in this way. Maybe Giorgio de Chirico, but the journey leads elsewhere. It is because place is more amorphous than we suppose, less manageable and less comprehensible. Place is about biography. Nash makes place not by verisimilitude, but by summoning up totemic symbols and motifs and spirit. It is because his is an unconscious depiction, borne out of a creative process, which has its informal heart in the walking, roaming and exploring of English surrealism and the English landscape: looking and finding ancient animism in the rocks, trees and hills of an old land.

This is where I go to in his paintings: a half-remembered or half-imagined but familiar place that I can share with him – a warm cornfield on the edge of a disused country estate, a chalk scar disfiguring a hill, the humus and fungi and dead leaves on the floor of a damp copse. Recognition means connection means attraction.

I have written about *Event on the Downs* (1934) before, a painting that I will always love, which I included in a group exhibition I selected called 'An Aside'. I know it intimately. A tree stump sits by a tennis ball in the foreground, a forked track divides the middle ground, and the chalk Downs fill the background. A cloud-as-flint or a flint-as-cloud favours no ground, and hovers nowhere in an impasto sky. The relationships between the inhabitants or personages in Nash's paintings, whether they be organic or inorganic, are always unsettling, out of scale and odd. His painting style is also awkward, as he often leaves canvas bare, and appears not to be an artist who loves the stuff of paint. Instead he fills in anxiously, and the slight ungainliness of his pictures is also part of their attraction. There is vulnerability in his lack of authoritative technique – virtuosity denied by the power of his intent.

Event on the Downs is a favourite work but there are others too, and I cannot choose. I am happy to return to any one of Nash's paintings.

Tacita Dean lives and works in Berlin.

JEREMY DELLER
British, b. 1966

ON

WILLIAM HOGARTH
British, 1697–1764

WILLIAM HOGARTH

The Shrimp Girl
c. 1740–45
Oil on canvas
63.5 × 52.5 cm (25 x 20 ¾ in.)
The National Gallery, London

I first saw William Hogarth's paintings when I used to go to the National Gallery in London when I was about ten or eleven years old. I didn't think much of this painting then, probably because I thought that it wasn't finished.

Hogarth was constantly experimenting with subject matter. He was fascinated by the humanity around him; this is what I like about him. Despite being dead for nearly 250 years, Hogarth is a contemporary artist and, as long as people live in cities, will continue to be one. He documented an immediately recognizable urban life in Britain with paintings populated by corrupt politicians, single mothers, swindlers and feckless aristos. No one, and nothing, is spared his gaze. When you look at his work you realize how little has changed in Britain.

Hogarth was obsessed with the class system and observed its workings at close hand. He hated the snobbery of the Royal Academy of Arts, and his involvement with Thomas Coram's orphanage, the Foundling Hospital, indicates that he would have known plenty about those at the bottom of the social ladder. Many of his most famous works, such as *A Harlot's Progress* (1732) and *The Rake's Progress* (1733), are concerned with individuals either ascending or, more commonly, descending, if not crashing, through class barriers.

Shrimp Girl, for me at least, is also concerned with the perceived mobility of the social classes at the time, but Hogarth conveys this in a subtle way. When you first look at this portrait you see a smiling woman wearing a hat. She could be an aristocrat – the hat looks large and elaborate. However, when you look more closely you can see that this hat is actually a tray for shrimps, which she is selling on the street.

Shrimp Girl is a sketch, so it is painted very lightly. It is almost like a Gainsborough painting. But whereas with Gainsborough you get flattery, with Hogarth you get sympathy. Hogarth has more in common with Frans Hals, who also had a sensitive eye when depicting working people. But, as a painter, Hogarth's range is greater than Hals's. Hogarth's technical skill is often overlooked in favour of his subject matter, but he is at least the equal of the French Rococo artists Boucher, his contemporary, and Fragonard, who was working a generation later.

The fact that this picture remained in the artist's studio until his death could suggest a number of things. I would like to think it was a favourite work of his and he did not want to sell. Or it could mean Hogarth did not know what to do with such a work – one that was more than just a genre picture and might have not been readily understood, or well received if exhibited.

Jeremy Deller lives and works in London.

THOMAS DEMAND

German, b. 1964

ON

PAOLO UCCELLO

Florentine, 1397–1475

This painting is one of three depicting the chronological sequence of events at the battle of San Romano between the Florentines and the Sienese. The works were commissioned by the Bartolini Salimbeni family around 1440, but they soon fell into the hands of the Medici family.

The paintings remained together until the eighteenth century, and are now split between the National Gallery in London, the Louvre in Paris, and the Uffizi in Florence. I studied in Paris and in London in the early 1990s, and going to see the San Romano paintings in those respective cities became a reassuring habit for me. I still make sure I have half an hour for each one any time I am in either city. In other words, I have spent many hours in front of the National Gallery painting, observing how the brushstrokes reveal the hand of the painter.

This painting was surprisingly large for its day, and presents the viewer with a vast collage of surfaces, including fabulously patterned damask fabrics and dully shining armour, whose lustre is composed of silver pigment. In between are complex geometrical constructs, with near-parallel lances and legs forming a forest of lines. Then there are the soft faces of the horses and the people, the latter, unmoved by the bloodbath, fixing the viewer with stoical stares. In the middle ground, the orange grove that separates the fighting from the background landscape is shockingly decorative. The oranges sit formally on the trees, showing through the leaves like small stars. The armour becomes a kind of ornamentation that unites the frieze-like group of figures in the foreground. All of these elements are overlaid like collaged cut-outs, while in the background you can see a harvest being brought in.

Many of the colours have faded or browned over time but this must once have been a psychedelic, vibrant painting. In the sixteenth century, Giorgio Vasari criticized the extreme colour scheme as offensive to the eye. However, I think that Uccello organizes this colourfulness, as well as the complex composition, with great virtuosity. And there is a faint foreshadowing of the abstraction of the twentieth century.

Uccello was a pioneer in the field of perspective. The foreground of this painting is clearly separated from the background, its stage-like space defined by the positioning of the lances. The sharpness, the precision of the finest lines converging at the perfect point – stunning for its day. However, the sightlines don't go anywhere and there's little of the blissful intoxication with newly acquired skills that can be sensed in the central perspectives of Uccello's contemporaries. Instead, there are minutely worked, completely abstract surfaces. The painting is in a muddle, but a wonderfully organized muddle.

No wonder the Cubists studied these pictures closely. Similar stylistic devices can be found in late (Synthetic) Cubism, where a real newspaper

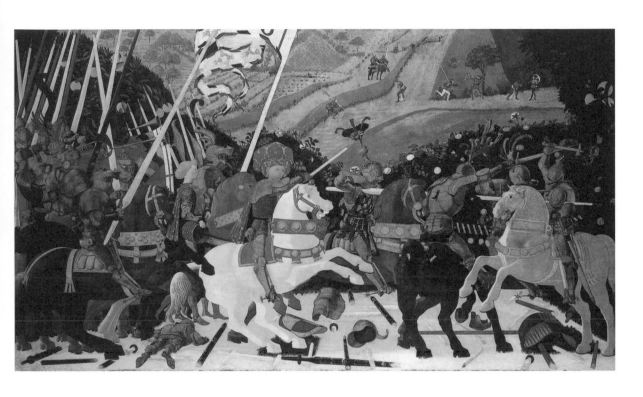

was simply stuck onto the picture when an image of *Le Monde* was called for. Take a look at Juan Gris, or Picasso's Cubist sculptures – there's a direct connection. And it's all here at the tail end of the Gothic period!

I, in turn, have seen this Cubist plasticity as fertile inspiration. In my piece *Room* (1994), I made brazen use of the pictorial organization of Uccello's *Battle of San Romano*. The photograph to which my work makes direct reference is an image of the destroyed Wolf's Lair – one of Hitler's Eastern Front headquarters – being inspected by the lightly injured Hitler in the company of Mussolini. This image played a prominent part in my education: it is not only important as general historical and sociological evidence of actual, real resistance, but is also of personal biographical significance, as it would be included in each year's school lesson about the Third Reich. So when I decided to reconstruct an image that had, in part, formed me, I also addressed my own biography. Yet the only conceivable approach was to exchange the indexicality of the original photograph, which struck me as somehow vague, for Uccello's crystalline perspective, collaged corporeality, and theatrical presentation.

Today we are used to the photographic in figurative representation. Admittedly that is not what we have in Uccello's painting. Although his depiction – hyperrealist at the time – still comes across as largely well realized, I can't help thinking that the flatness, the sliced-off images around the edges of the picture, and the lack of spatial depth, look as if they've been captured by a telephoto lens. Popular in sports photography and with the paparazzi, the telephoto lens is used to view an event from a considerable distance without interfering in it, or becoming its victim.

One of the things I love about art is when it allows us to view our relationship with our world as if from the outside, thereby enabling us to watch ourselves experiencing that world. The main purpose of *this* commissioned painting was to depict a glorious act for the city of Florence. Back then, war between the private armies of wealthy families was a permanent state of affairs, and was about pure conflict of interest rather than right and wrong. We no longer have these rejected medieval practices; what we do have is this painting.

Thomas Demand lives and works in Berlin.

DR LAKRA

Mexican, b. 1972

ON

HIERONYMUS BOSCH

Netherlandish, c. 1450–1516

HIERONYMUS BOSCH

The Garden of Earthly Delights
c. 1500–1505
Oil on panel
220 × 389 cm (86 ⅝ × 153 ⅛ in.)
Museo Nacional del Prado, Madrid

The first painting by Hieronymus Bosch that I saw was *The Garden of Earthly Delights*. My grandfather had a big poster of it in his house, even larger than the original as it turned out (I was very surprised when I saw the original at the Prado Museum in Madrid). As far as I can remember, the poster was always there.

My grandfather was a psychoanalyst and had the poster at the entrance to his office, so maybe he used it to provoke his patients. I remember looking at it for hours with a mixture of fear and fascination. I also remember playing a game to find specific characters or bizarre details in the half-deformed animals. I used to look very closely at all the strange plants and glass bubbles. My favourite section was always Hell. It seemed to be constantly changing and I would often find a character that I had not noticed before. I knew the story of what this picture represented, but for me the characters and the fantasy element of the picture were more important. The story is always told with a sense of humour (a macabre grin), and with a bit of sadism. The work is full of many figures that seem to be hiding or emerging out of something or somewhere. These fantastical beings are in situations that are hard to explain. This is what I enjoy most, and I think my obsession with the grotesque, the irreverent and the

HIERONYMUS BOSCH

Christ Carrying the Cross
After 1500
Oil on panel
74 × 81 cm (29 ⅛ × 31 ⅞ in.)
Museum of Fine Arts, Ghent

scatological comes from seeing *The Garden of Earthly Delights*. Bosch was the key that opened doors for me.

Later, I discovered that my parents decided to call me Jerónimo after Bosch, which, as you can imagine, increased my curiosity and pleasure in his paintings. That first encounter with Bosch led me – one way or another – to look at other artists such as Pieter Bruegel, Lucas Cranach and Matthias Grünewald, and also to James Ensor's paintings.

Another of my favourite paintings by Bosch is *Christ Carrying the Cross*. He painted several crucifixion scenes but I like this one in particular because the main symbol – the cross – only appears in part. There is no horizon and Bosch has not used any traditional perspective device. Instead, the image is a tight close up – a parade of diabolical faces, some with their eyes open, some with eyes closed. The central figure of Christ carrying the cross has his eyes closed, but you also see an image of Christ with eyes open imprinted on Veronica's cloak in the bottom left of the picture. Some of the characters have earrings in strange places. At the bottom of the picture you can see a man with a pair of pearl earrings dangling from his chin. All this together makes for an extraordinary picture. Although it is not as detailed as his other paintings, it seems a strong, unique composition and, for me, shows an enormous sense of humour. Even though I've only ever seen this picture in art books, it has become one of my favourites.

*Dr Lakra (Jerónimo López Ramírez)
lives and works in Oaxaca, Mexico.*

MARLENE DUMAS

South African, b. 1953

ON

JEAN-AUGUSTE-DOMINIQUE INGRES

French, 1780–1867

JEAN-AUGUSTE-DOMINIQUE INGRES

*Joséphine-Éléonore-Marie-Pauline de
Galard de Brassac de Béarn,
Princesse de Broglie*
1851–53
Oil on canvas
121.3 × 90.8 cm (47 ¾ × 35 ¾ in.)
The Metropolitan Museum of Art,
New York

One of the most gripping exhibitions I have ever seen was the Jean-Auguste-Dominique Ingres retrospective at the Louvre in Paris in 2006.

The most beautiful of the many rooms was the one dedicated to his portraits of ladies dressed in the fashion of the day. Their dresses seemed as emotionally expressive as their facial expressions. I singled out the portrait of Joséphine-Éléonore-Marie-Pauline de Galard de Brassac de Béarn, Princesse de Broglie, completed in 1853, precisely one hundred years before

I was born. (This lady died aged thirty-five. After that, her inconsolable husband kept the painting hidden behind a curtain.)

As is often the case with good portraits, not everyone agrees about what the sitter's expression means. According to her husband, Joséphine was both shy and very religious. He described her expression as one that reflected the perfection and purity of her moral character. But one critic at the time characterized it as one of cold reserve and aristocratic contempt.

I think it is true that Ingres's women usually appear very pensive, as if their thoughts are elsewhere, as if they are absent-minded. Clearly, they radiate more of Apollo's calmness than Dionysus' spontaneity. Joséphine's expression is almost mask-like. So different from the equally masterful, but more intimate *Girl with a Pearl Earring* (*c.* 1665) by Vermeer, who looks at her spectators longingly and full of desire. Joséphine is far more aloof. Both paintings have blue and golden yellow as their most striking colours, but where Vermeer's painting is gentle, warm and in soft focus, Ingres's focus is sharp.

Joséphine's immaculate satin dress has so much blue. With that in mind, I go on an imaginary journey, to the East and to Africa. And I even find myself in heaven. Blue as the colour of distant longing of which the realization lies far away. Westerners have always wanted to go over the seas and, later on, in the hereafter, to heaven. Blue also stands for going 'over the seas', going over the horizon. Ultramarine blue was once the most highly priced pigment, more valuable than gold. The medieval word *oltramarino* means 'over the seas'. It was not just used for blue, but also represented imported goods. This is how the Virgin Mary, the most painted woman in Christian art, acquired her blue cloak from the East. This most valuable blue came from the mountains of north-eastern Afghanistan, from the semi-precious stone lapis lazuli.

In Joséphine's expression I also see qualities that Goethe attributed to blue in his *Theory of Colour*. Blue seems to both soothe and stimulate. As he said, 'Just as we wish to pursue a pleasant object that moves away from us, we enjoy gazing upon blue – not because it forces itself upon us, but because it draws us after it.' Blue reminds me of the shiver when attracted for the first time to an (as yet) unspoken love. In English blue stands for both depressing and transcendent things, for melancholy, sacredness and pornography. John Lee Hooker said that with the creation of man and woman, 'the blues began'.

Marlene Dumas lives and works in Amsterdam.

ELMGREEN & DRAGSET

Danish, b. 1961 / Norwegian, b. 1969

ON

VILHELM HAMMERSHØI

Danish, 1864–1916

VILHELM HAMMERSHØI

*White Doors or Open Doors
(Strandgade 30)*
1905
Oil on canvas
52 × 60 cm (20 ½ × 23 ⅝ in.)
The David Collection, Copenhagen

The dry, remote and understated depiction of a repressed way of life is something very Scandinavian. There are no loud dramas here. This Protestant, organized manner of suffering in silence and not making a fuss about one's unhappiness is so typical of the Northern regions. The motifs depicted by the Danish painter Vilhelm Hammershøi tell the stories of homes in which the inhabitants seem to play the least significant role. The deserted rooms in many of his paintings show only minor signs of human activity; an open door becomes a subtle yet powerful comment on the

ELMGREEN & DRAGSET (BELOW)

The Collectors
2009
Installation
Exhibited at the Nordic Pavilion
& Danish Pavilion, 53rd Venice
Biennale, 2009

ELMGREEN & DRAGSET (OPPOSITE)

Powerless Structures Fig. 122
2000
Wood, door handles, hinges, safety
locks and chain
Each door 217.5 × 103.5 cm (85 ⅝
× 40 ¾ in.)

Elmgreen & Dragset
(Michael Elmgreen and Ingar Dragset)
live and work in Berlin.

loneliness lived out in these domestic settings. You, the viewer, are left with the door half open, half closed, imagining the characters who exist only through their absence.

We have always imagined Hammershøi's paintings to be early precursors of set designs for the films by Ingmar Bergman. With an almost perverted pleasure, both Hammershøi and Bergman make us painfully aware of how our homes so often become the prisons of all those desires of ours that never unfold. These rooms constitute a perfect frame within which we've been told to behave with civilized manners and sleep with our hands above the duvet. They contain all our fears and phobias and our memories of Christmases past spent with close relations who never really liked one another. These aesthetics of the unspoken triggered us to imagine the home of a wretched, dysfunctional family in our work *The Collectors*, exhibited at the Danish Pavilion at the 2009 Venice Biennale.

Hammershøi's emphasis on the darker shades of white – his distant, dispassionate observations, the bleakness of his universe and his focus on simple, everyday details rather than grand spectacles – have been of general inspiration to our working method, most apparent in our ongoing socio-critical series 'Powerless Structures'. A Hammershøi-esque void or lack is a recurring theme throughout our work, as in the interconnected series of constructed social services spaces we created in 'The Welfare Show' at the Serpentine Gallery in London in 2006, and in our 2010 exhibition at ZKM, Karlsruhe, where the hollowness of celebrity culture was the subject, conveyed through architectural constellations that only hint at the presence of human activity.

Clean neoclassical interiors such as those depicted by Hammershøi also inspired a whole generation of mid-century, rational Nordic designers like Arne Jacobsen and Hans Wegner, whose designs we have referenced on several occasions in our work. Just add a Bang & Olufsen stereo to a Hammershøi scenario and the image becomes wholly contemporary. Sadly, melancholic Puritanism is hard to kill.

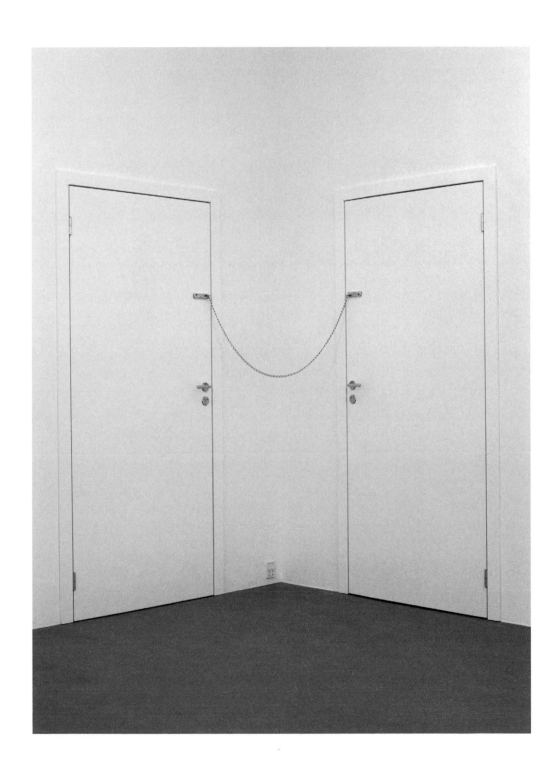

URS FISCHER
Swiss, b. 1973

ON

MEDARDO ROSSO
Italian, 1858–1928

MEDARDO ROSSO

The Final Kiss
1883–85
Plaster
Now destroyed

I'm a sucker for imaginary things. The image of a model of Tatlin's Tower being paraded through town during Soviet demonstrations, despite the monument never being built, nourishes an element of fiction that has little to do with the actual proposed structure. Likewise, my relationship to Medardo Rosso's work is of a fictional nature. Many of his pieces don't exist anymore: they only live on as photographs of sculptures. Sculptures in my mind. A particular favourite of mine is a photographic image of Rosso's *Final Kiss*, made in the 1880s. The photo shows a woman lying prostrate, her head resting on, or looking into, a sewer grate or some other subterranean rabbit hole made of industrial metal mesh. She is talking to someone, or listening, or being fed, or anything else you can imagine one would do on a sewer grate. The sculpture in the photograph appears to be a draft, a sketch or a maquette.

Does the work look good from another angle than the one in this photograph? I'm not sure. Photography tends to turn a sculpture into the image of a sculpture. How does the back of the *Pietà* look? You don't check out Mary's bottom. Michelangelo's *David* is another story.

I find that there is ample pathos in Rosso's sculpture, but no apparent biblical references, no conversations with classical mythology or historical personages. There is recognition and representation of a bareness, a clearness that seems to come about in the urban environment of the late nineteenth century. Rosso's take on this human condition – at least the version that exists in my imagination – feels more relevant now than Rodin's allegories do. Looking at *Final Kiss*, I see an artistic vision highly sympathetic to the prosaic.

Photography created a way to know the arrested moment. It created the static present, freezing reality, and through that a new form of memory – not unlike a sculpture, but in a raw way. The extrusion of the outer world through a lens into a flat image. It enabled the mind to see surface. A new form of image, that took on a new life in people's psyches and fantasies. The unleashed beauty of the prosaic. Rosso's sculpture feels like a natural product of this photographic vision, the moment as a state of mind – superficial depth or deep superficiality.

Impressionism acknowledges this sort of photographic vision, even in reacting against it. Rosso's version of Impressionism brings a visceral aspect to this, in an exceptionally graceful way. It is teeming with human (in)tangibility. In this 'final kiss', you feel the plight of the anonymous sculpted woman, even though her situation rests between obscurity and a simple male fantasy.

Rosso's sculpture has no pedestal per se – its just a figure on a made ground, looking down at the invisible, into the abyss. The sculpture's centre of gravity is what lies beneath the figure: the underground as the opposite of a pedestal, the sunken pedestal – a new heroic. It is somewhat of an existential standoff, with a sewer grate as the membrane between two worlds. Or maybe she has just lost her marbles.

I recently found out that *Final Kiss* was a commissioned funerary sculpture, Rosso's first commissioned work. Chosen by Pietro Curletti, a wealthy Milanese industrialist, as a tomb decoration for his father, the sculpture was originally called *Gratitude*. I don't know if it was ever cast or finished. Someone other than Rosso gave the work its great current title at a later point.

A lot of sculpture gains its singular power by replacing something fleeting with something concrete and non-ephemeral. The notion of time is largely absent in this game. Sculpture as the real living dead. You can place a sculpture art historically, but when encountering a three-dimensional form in space, you're always inclined to consider it as something current, of the present. You and a sculpture share space. Sculpture can be very social, if you don't mind the company.

Vintage photographs are veils, steadily detaching themselves from the present that they captured, now past. Photos relieve any form of matter of its physical properties; they democratize all things. They can recreate sculptures and ready them for fictional encounters. Imagine a photo of a work by the great Athenian sculptor Phidias, in all its original colour, photographed when it was new. The artwork pickled in data, Photoshopped, like plastic surgery.

Thanks to a photo we know what *Final Kiss* looked like; thanks to the sculpture's disappearance we will never really know. The sweetness of the imagined.

Urs Fischer lives and works in New York.

JOAN FONTCUBERTA

Spanish, b. 1955

ON

LOUIS DAGUERRE

French, 1787–1851

LOUIS DAGUERRE

*Two Views of the Boulevard du Temple,
Paris, Taken the Same Day*
c. 1838
Daguerrotypes
Bayerisches Nationalmuseum,
Munich

The first time I saw these images was in the Spanish edition of Beaumont Newhall's book *The History of Photography from 1839 to the Present*, published in Spain in 1982. Newhall's book is the most important study of the history of photography and was first published in 1937 as a catalogue for an exhibition at the Museum of Modern Art, New York, celebrating 100 years of the art of light. It featured reproductions of two early daguerreotypes taken in 1838 by Daguerre himself. The two photographs are separated by a few hours interval, and are both taken from the window of Daguerre's studio on the Boulevard du Temple in Paris. What attracted my attention to this pair of images was that, even though they seem to represent the same landscape, they are, in fact, slightly different.

Once belonging to the collection of the Bayerisches Nationalmuseum in Munich, these daguerreotypes were reproduced by Newhall as

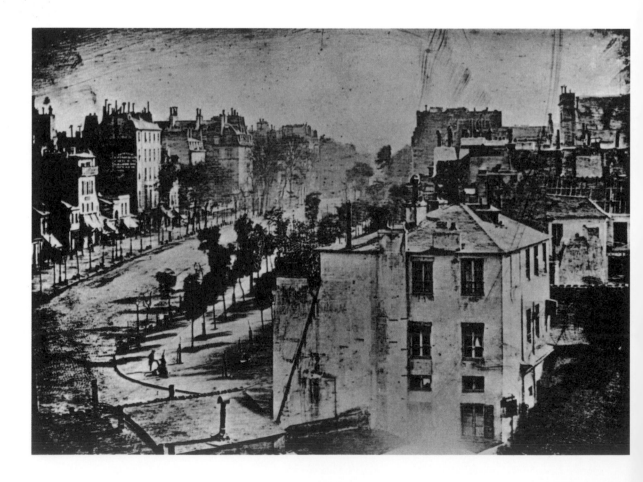

preparatory documentation for his exhibition at MoMA. Unfortunately, the original daguerreotypes were heavily damaged during the Second World War. The circumstances of this loss, the poetics of visual remnants, the replacement of the original copy, the remains of a work, of which we have only one functional reference (the image of an image, a photograph of a photograph), gives me a lot to think about regarding the nature of representation, above and beyond postmodernist preoccupations that have shaped much of my generation.

As a visual artist interested in illusion and the simulacrum, I find that the comparison of these two images reveals something fascinating. The variation between these two views is curious. The camera was probably set on a tripod for these shots, so that the frame would be identical – though light and shadow differ. But what really differentiates the two shots is the

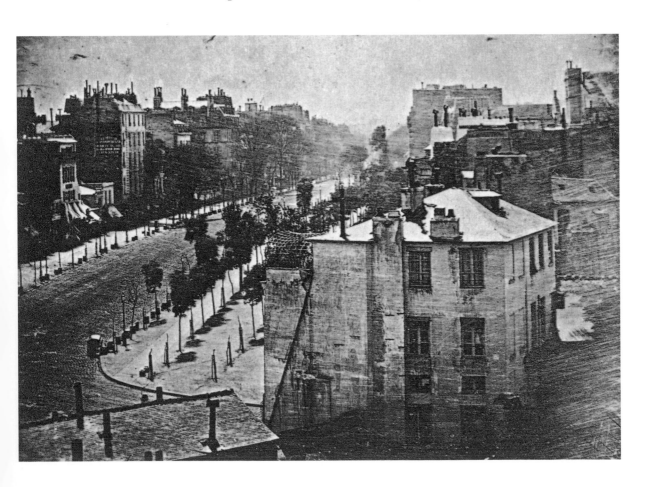

presence, in the lower left corner, of the figure of a man having his shoes polished by a shoeshine boy.

Let's make an assumption about the order in which the photos were taken. I imagine that Daguerre took the first shot and was unhappy with the result. The bustling city appeared deserted. Techniques then were rudimentary, and the low light-sensitivity of the photographic plates meant that it was not possible to capture movement or life in action as anything moving would disappear from the image. However, Daguerre was not discouraged by this problem. He came from the world of theatre and spectacle. I reckon that he devised a little trick in order to capture movement: he would get two sets of people to stand in as the shoeshine boy and the client, each keeping still, not even being allowed to breathe until they got the signal from Daguerre. The characters do not represent the bustle of people and carriages on the Parisian boulevard in full swing, but they at least show some life and establish human scale in the otherwise empty scene.

This image is a historic photographic milestone. Here we have the first appearance of a human being in a photographic print. And if I'm right about Daguerre's trick, then it is also the first faked photo. It is hard to believe that the figures in the picture stayed still for half an hour. What surprises me is the ease with which a pioneer of the new photographic medium uses fiction to get us closer to our perception of reality. We are more familiar with such actions in contemporary photography, but here we see it happening at the very beginning of the history of photography, more than 170 years ago. With this *coup d'effet*, Daguerre performs an illusionist gesture to prove that only through deception can we reach a certain truth, that only a conscious simulation will provide an epistemologically satisfactory representation. This idea has influenced and guided me in my own work, and the loss of Daguerre's two wonderful photographs has ultimately been my gain.

Joan Fontcuberta lives and works in Barcelona.

KATHARINA FRITSCH
German, b. 1956

ON

J. M. W. TURNER
British, 1775–1851

On a visit to London some years ago, I went to Tate Britain and, as always, deeply impressed but impatient, I paced through those beautiful rooms and past numerous paintings by Turner. Okay, I thought, Turner, precursor of the Impressionists, not really wanting to get too involved. But suddenly I found myself being sucked into a strangely framed, orangey-coloured one – which is how I remember it – that completely captured my attention. It was *War. The Exile and the Rock Limpet*, painted in 1842.

The frame poses the first puzzle. Why is it octagonal? Some have suggested that it was originally round. For me, the frame simply adds to the overall psychedelic, eccentric character of this painting. We see Napoleon standing in an apocalyptic landscape on the banks of an undefined, almost dried-up river against a blood-red sunset on the horizon. The play of colours in the evening sky rises up from the red with small sprinklings of cinnabar, through a poisonous lemon yellow to a diffuse whitishness at the top. In the upper left corner we can already catch a glimpse of a patch of cool, blue night sky with circling black birds.

In the close middle ground is Napoleon, reflected so grotesquely in the river that his already elongated figure appears even taller. Our usual image of the emperor is surely short, if anything, and rather solid. His arms are crossed over his chest and he is meditating, gazing at a small, whitish blob in the foreground – a rock limpet that seems to be entirely at home in the puddle at his feet. A type of mollusc, the limpet symbolizes slowness (perhaps it alludes here to the tortuously slow passage of time spent in exile), and perseverance. This creature is able to attach itself so tightly to a rocky surface that outright force is needed to remove it. To the right of the limpet there is a channel of sorts, roofed over with burned or rotting wood, and apparently leading into mouldy nothingness. Further still to the right, where the ground rises up, we can just make out in the brownish, contaminated haze the schematic silhouettes of a number of soldiers in a devastated landscape. It was this background, plus the all-pervasive turmoil of the atmosphere, that immediately reminded me of James Ensor's paintings of the beach at Ostend in Belgium. Since I am drawn to the surreal, it was not by chance that I was so taken by this picture, which seems to be so atypical of Turner.

To me, the figure of Napoleon almost has the air of a caricature or a grotesque, in stark contrast to the heroic portrayals of him that were common currency in the nineteenth century. The emperor looks like a wooden doll or a tin soldier, as does the schematic guard sketched in behind him. The latter even appears somewhat hapless. It is immediately obvious that Napoleon has come to his end, empty and burned out like the landscape around him. But it almost seems as though he is experiencing some dawning awareness in the silent exchange with the self-sufficient,

J. M. W TURNER

War. The Exile and the Rock Limpet
c. 1842
Oil on canvas
79.4 × 79.4 cm (31 ¼ × 31 ¼ in.)
Tate Collection, London

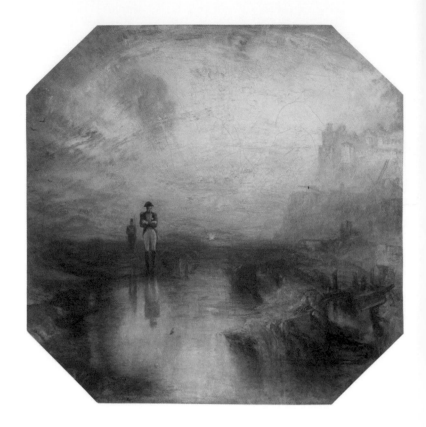

autonomous little creature in the foreground. Could it be that Napoleon's thoughts are following a similar course to those of his predecessor Robespierre, so penetratingly described by the biographer Friedrich Sieburg:

> The sun glowed and nothing threw any shadow. It was as though the air were filled with a God's lament. It was the hour of Pan, when the past become intelligible and the future visible. In that solitary midday moment Robespierre knew that posterity would reject him and misjudge his efforts, and his sense of injustice left a bitter taste in his mouth and must have nearly broken his heart…All knowledge was materialized under his hand and translated into organization – into State. The result was – death.[1]

Although posterity was better disposed towards him than the bloodless, ideological Robespierre, Napoleon was also a power-broker determined to force things to conform to his own universe. Yet in the end nature and time gained the upper hand, here mockingly embodied in a tiny, but free, mollusc, which is perhaps also a symbol for artists, who, although so often caught up in others' delusions of power, always know – if they are any good – that it is better for pictures to remain pictures.

Katharina Fritsch lives and
works in Düsseldorf.

1. Sieberg, Friedrich, *Robespierre: The Incorruptible*, trans. John Dilke (New York: McBride, 1938), p. 200.

RYAN GANDER
British, b. 1976

ON

THEO VAN DOESBURG
Dutch, 1883–1931

Counter Composition XV. A composition counter to what? That's what I remember thinking as an art student leafing through the pages of a book on Theo van Doesburg. At the time, I was in awe of these paintings and wished I had made them. I had no ideas of my own, I didn't understand art's capacity to change the way we think about the world. I just wanted to be an artist. I just wanted to *be* van Doesburg.

About ten years later, when I began to read the texts in art catalogues (as opposed to just looking at the pictures), I worked out what exactly these compositions were counter *to*. Van Doesburg's composition was counter to Mondrian's. The story goes that Mondrian and van Doesburg became good friends. They established the art movement De Stijl together, but when van Doesburg moved to Paris with his wife Nelly in 1923, and the two artists saw more of each other, they began to bicker over their differing ideologies. The following year Mondrian and van Doesburg had an almighty row, said to have been over the 'dynamic aspect of the diagonal line'. Subsequently, they fell out and never spoke again. It is not like one slept with the other's wife, but such rigidity and rigour surrounded their individual beliefs on the simplicity of turning a canvas forty-five degrees, that a corner of art history was changed forever.

Mondrian's geometric compositions aesthetically peppered my childhood and teenage years. His images were endlessly reproduced and encountered. A signature style that became an emblem for modern art. A Mondrian is in fact now, in many imaginations, an illustration of art, a motif of itself. The first time I remember seeing this was in the early 1980s while watching televised footage of the Tour de France with my brother Neil, an avid road racer. The cycling team La Vie Claire sported clothing with Mondrian-inspired stitching, and rode bicycles with designs derived from Mondrian patterns. The image of my brother's Mondrian saddle cover will always remain burned into my memory. And since then I have noticed the style elsewhere. Mondrian's patterns have fallen into the pages of the Miffy books, Dutch children's stories about a cartoon rabbit, adorned the sides of central heating installation vans, and wrapped themselves around aerosol canisters of hairspray.

Of course, I am talking about Mondrian, not his counter composition competition. However, for me, it is van Doesburg who wins. You see, *Counter Composition XV* is a step ahead. Understanding Mondrian's initial concerns and the purpose of his investigations, *Counter Composition XV* is a tongue-in-cheek nod. It is a wink of self-reflexivity. It quotes Mondrian, while shrugging off his preoccupation with practice, development and work

THEO VAN DOESBURG

Counter Composition XV
1925
Oil on canvas
50 × 50 cm (19 ¾ × 19 ¾ in.)
Museum Sztuki, Lodz

*Ryan Gander lives and
works in London.*

ethic. *Counter Composition XV*'s black lines are beefed up, rendered in bold, and, it seems to me, its forty-five degree twist holds no aesthetic reasoning. It is to deliver exactly that, a twist, an altered perspective, but maybe more importantly, by that fact that we know it is askew, we also know that it is *not* a Mondrian, yet manages to mutter everything Mondrian says, under its breath.

Read from my perspective, this work has more in common with a piece of conceptual art made today than a Neo-Plasticism painting from more than eighty years ago. It is cocky, light on its feet, considered. It understands its history, its legacy and its position in the world. It has balls and it contains, in fact, a multitude of qualities that I, as a practising conceptual artist today, consider ingredients for a kick-ass work of art.

When I think about the diagonal feud between Mondrian and van Doesburg, it strikes me that such a closed-down mentality and such stubbornness would be impossible to maintain today. I'm reminded of something Michael Fullerton, an artist friend from Glasgow, once told me. He explained that Glasgow is an easier place to make artwork than London, because you spend your evenings in Glasgow drinking with another artist, someone you want to make better work than. Maybe having some opposition is a good place to start, a watershed of some kind, or a counter competition. After all, is it not difference of opinion that keeps us current?

ANTONY GORMLEY

British, b. 1950

ON

JACOB EPSTEIN

British, 1880–1959

Why is this work important? Why is Epstein important? And why is there *still* the distaste with which he is viewed by many? As far as I'm concerned, Epstein was the most radical sculptor working at the beginning of the twentieth century. He was responsible for the arrival of modernism and direct carving in the UK, and was an incredibly important figure for the early careers of Henry Moore, Eric Gill, Henri Gaudier-Brzeska, and many young, searching intelligences within sculpture at that time.

Epstein grew up in New York and spent the early years of the twentieth century in Paris. He knew Brancusi and Modigliani, and caught their excitement about non European visual traditions. Works from the French colonies of West Africa (for instance, totemic sculptures from the Fang and Baule peoples) were beginning to arrive in private Parisian collections and at the Musée de l'Homme, bringing with them alternative ways of thinking about the body in art. All of this was a far cry from the debased classicism, narrative scenes, historical figures and rather limp, simpering nudes supported by the Academies and the Salon, whose controlling power is now hard to conceive of.

Epstein had a natural inclination for big subjects: fertility, death, the power of nature, human vulnerability and yearning. He shared with both Brancusi and Modigliani a passionate interest in this art from another world which gave new, simple, formal solutions to, for example, how a brow ridge might connect to a nose.

Epstein was the first person to bring to England, in 1905, the excitement of African and Oceanic carving, with its mixture of celebration and dread. *The Rock Drill*, however, manages to do something very particular in the evolution of Western art, above and beyond formal concerns. Here (at the same time as Duchamp's *Bicycle Wheel*, 1913), we have an engagement with a readymade of a very different kind: a rock drill, produced by a Chicago company for boring high quartzite granite, in which precious minerals might be found. This tool commands a massive 250 pounds per square inch of pressure. The minute you see that extended phallic end, and the pneumatic chambers that connect the probe with the top of the tripod, you can see the way that Epstein is thinking: the latest word in aggressive industrial technology as a potent symbol of masculinity.

To me, the body is straight out of Mary Shelley's *Frankenstein*: a piece of animal biology considered as a machine; the golem or man-made man. This evokes the new consciousness. The human being, now settled in constructed cities with grid-like streets, drains and piped water, with writing, architecture and a host of new tools, was implicated in a matrix from which a new being would emerge.

Here we have a man-made man riding a technology, intent on splitting the earth; a man no longer conscious of a horizon. Visored and blinkered

(the visor suggests the head of a praying mantis or the hood of a welding mask), his gaze is focused entirely upon that which he wants to colonize, possess and exploit.

This is a cloned body, and one which dispenses with the need for the female. Here, in its diaphragm, lies future life as an abstract thread of three connecting cells: a form of becoming, of unknown completion. We only have to wind forward a little to witness the effects of Agent Orange on the generation that grew up in Vietnam in the late 1970s and early 1980s; the deformity that comes to the unborn as a result of industrialized war.

Why Epstein is important is that, unlike Matisse, Picasso and even to some extent the surreal Giacometti, he was not content to look at alternative traditions of art from Oceania, New Guinea and Africa as simply a way of solving formal problems. He was interested in the inherent subject matter, the potent magic, the power of an idol that contains all the hopes and fears about human continuity: sexuality, procreation and continuance, and the power of disease, disaster and death that works against it. I think that this conflation of industry and sexuality makes *The Rock Drill* both conceptually contemporary and totemic; a magic object about technology. It is a celebration of human potential but also a warning about catastrophe.

I first saw the work at the 'British Sculpture in the Twentieth Century' exhibition held at London's Whitechapel Art Gallery in 1981–82. Living now, at a time when we are all aware of living on borrowed time, the prophetic aspect of *The Rock Drill* is so relevant and prescient it makes Marcel Duchamp's work look like the work of an effete, intellectual dilettante; an urban *flâneur* fiddling about in the toolbox of art but making no propositions that have any effect on the world outside of it. With Epstein, we have not only a response to the potential of sculpture in an incredibly brave, formal marriage, we also have a work that represents a stark political assessment of the attitudes that underpin the industrial framework that now supports human life.

Antony Gormley lives and works in London.

DAN GRAHAM
American, b. 1942

ON

JOHN CHAMBERLAIN
American, 1927–2011

JOHN CHAMBERLAIN (ABOVE)

Barge Marfa
1983
Urethane foam covered in canvas
The Chinati Foundation, Marfa,
Texas

JOHN CHAMBERLAIN (BELOW)

Untitled (Couch)
1980
Urethane, foam and cord
94 × 101.6 × 221 cm (37 × 40 ×
87 in.)
Private collection

*Dan Graham lives and
works in New York.*

I remember seeing John Chamberlain's foam rubber couches in an exhibition called *Westkunst* in Cologne, curated by Kasper Koenig in 1981. There was a piece in the entrance to the exhibition that consisted of a foam rubber couch where people could relax – hippie style. The couch had two armrests, one on either side. Mounted on the armrests were video monitors, which displayed advertisements from American television where mistakes had been made.

Chamberlain's work to me is about built-in obsolescence – his foam rubber couches without covers would oxidize and decay quickly with time. And *Westkunst* was about the influence of American products after the Second World War. The products in the commercials, like Chamberlain's couch, were disposable.

Some years earlier, in 1971, I had been to the John Chamberlain retrospective in Frank Lloyd Wright's Guggenheim Museum, where the museum's 'hard' architecture contrasted with the 'soft' inter-subjectivity of Chamberlain's raw, foam-rubber furniture.

For Chamberlain's exhibition, a very large foam couch was placed in the Guggenheim's ground-floor lobby. Foam rubber has a human-like feel. Usually used for the underpinning of mattresses or chairs, couches or beds, it is rarely experienced as a visible surface. Yet when Chamberlain moulded the exposed foam rubber into couches and chairs they referred to modern, high-fashion furniture.

With Chamberlain's couch, the user/spectator does not gaze at an object or a representation of art, but experiences his or her body, which itself changes the sculptural form as the foam adapts to each body and also to other people's movements. By using the couch, the spectator helps to contribute to its temporal disintegration through use and the oxidation process, aiding the change in material. This relates to Chamberlain's earlier junk automobile sculptures and their references to America's capitalistic dependence on built-in obsolescence.

In the Guggenheim, people resting on Chamberlain's couch in the lobby were subjected to the gaze of spectators from above. But when a spectator was actually sitting on the couch, its softness was experienced in terms of his or her own body's warmth in relation to the warmth or coolness of the material and to the subtle movements and temperature of the other bodies seated on the couch. Like in drug experiences, the spectator had a sense of floating 'in' space and a subjective 'melting' and 'floating' of the body.

Sitting on Chamberlain's couch in the Guggenheim lobby, the objectively linear time of the retrospective installed along the museum's iconic 'hard' spiral, the chronicled history of Chamberlain's art, disappeared. The object observed was transformed into a subjective (and even inter-subjective) biophysical sensation.

JEPPE HEIN

Danish, b. 1974

ON

ASGER JORN

Danish, 1914–1973

ASGER JORN

Stalingrad, le non-lieu où le fou-rire du courage
1957–60, 1967, 1972
Oil on canvas
296 × 492 cm (116 ½ × 193 ¾ in.)
Museum Jorn, Silkeborg, Denmark

Jeppe Hein lives and works in Berlin.

I can't remember the first time I saw *Stalingrad*, but it has been in my mind, and part of my life, for many years. I was a frequent visitor, with my parents, to the Museum Jorn in Silkeborg, Denmark, where this painting by Asger Jorn hangs. It is undoubtedly the work of art with which I have spent the most time.

When you look at *Stalingrad* in a book you can see a large abstract painting with predominantly black and white colours. If, however, you are in the museum and you sit on the bench – which is several metres from the painting – and you take a bit of time to look at it, something amazing happens. I have done this many times.

My eyes look into the black-and-white landscape. My breathing becomes slow and heavier. Something begins to bubble inside me. Something nice. Something unpleasant. I stare at *Stalingrad*. This strange painting opens itself to me. My eyes move around, all over the surface of the painting. The colours jump out at me: yellow, blue, red, green. All possible shades of colour pass over me. A wealth of emotions starts pouring out of me. I see dots, I hear buzzing. My breathing quickens.

My eyes move towards the canvas and suddenly I feel a cold sweat and a quiver of discomfort. My breathing is faster now. My eyes are seeking something beautiful, but deep in *Stalingrad* they only find horror, grief and frustration. My eyes are struggling to find peace – a break from all the confusion in my body and my head. My hands are sweaty. I try to move a bit to get out of the stranglehold that the painting keeps me in. My eyes are roving back and forth in search of something else. Finally my eye sees something – a little opening perhaps…is it light? My hands are warm. The tingling feeling in my neck disappears and a heat fills my heart and stomach. A roaring feeling of delight surges forward. My eyes discover places in this painting I've never seen before, and as my body returns to a feeling of peace, thousands of new thoughts and feelings are still recognizable, as if I were inside *Stalingrad*.

I get up from the bench and take a few weary steps back. I smile and say out loud 'thank you', as I always do when I am with this painting.

SUSAN HILLER

American, b. 1940

ON

ALBERT PINKHAM RYDER

American, 1847–1917

ALBERT PINKHAM RYDER

The Race Track (Death on a Pale Horse)
1896–1913
Oil on canvas
70.5 × 89.2 cm (27 ¾ × 35 ⅛ in.)
The Cleveland Museum of Art,
Cleveland, Ohio

It was always either raining or snowing on the Saturdays when my mother dropped us off in front of the Cleveland Museum of Art. My brother and I would go to the information desk to collect canvas folding stools, drawing boards, paper, pencils, crayons and chalks; then we would consult the notice board to find out where our age group was meeting that week. Once, when I was eight or nine, my group was directed to the American art galleries to hear a talk about realism, the Hudson River School and George Bellows. During the talk, I kept looking sideways at a small painting by Albert Pinkham Ryder. An entry in the Literature, Arts and Medicine Database of the New York University School of Medicine locates this work succinctly: '*The Race Track* or *Death on a Pale Horse*, Oil on canvas, 1896–1908; alternate title *The Reverse*. Keywords: Death and Dying, Narrative as Method, Society, Spirituality, Suffering, Suicide.'

Dark, indistinct, mysterious, the image was somehow embedded in or underneath layers of paint. I could not take my eyes off it. I liked the blurriness, the ambiguity, the indeterminacy. In *Paragraphs from the Studio of a Recluse* (1905), Ryder wrote: 'The artist should fear to become the slave of detail.' The painting gave me a shivery feeling. It was a feeling of dread and I liked it. 'It is not the shock of recognition that his paintings evoke, but the feeling little children have of being lost and found again in a strange, God-filled world.' (Alexander Eliot, *Three Hundred Years of American Art*, 1962)

Ryder/rider. Pale horse, pale rider. 'When the Lamb opened the fourth seal, I heard the voice of the fourth living creature say, "Come!" I looked and there before me was a pale horse. Its rider was named Death, and Hell was following close behind him.' (The Book of Revelation 6:1-8)

I had not realized that real paintings by real artists could give a shape to fear, like ghost stories or the horror comics I read surreptitiously. I liked the weird snake in the foreground – it looked like something I might be able to draw, and that encouraged me. 'Technically, Ryder was not a perfectionist painter.' (R. L. Pennyhead, *The Genius of Albert Ryder*)

The painting was almost monochrome. Its limited colours set the scene in eerie light just before a terrible storm. 'The light is that of neither day nor night. When asked about this, Ryder's reply was vague: "I hadn't thought about it."'(Elizabeth Broun, *Albert Pinkham Ryder*, 1989)

Horse, rider and snake were centrally placed in the painting. Like a frieze, three satisfyingly simple strata defined foreground, middle ground and background without much attention to perspective. Ominous cloud formations, a broken railing, a dead tree and distant hill framed the main characters. The looming clouds, alternating bands of light and dark, were apparently in motion like the galloping horse and the skeletal rider's lifted arm. It seemed at any moment they might compose themselves into more

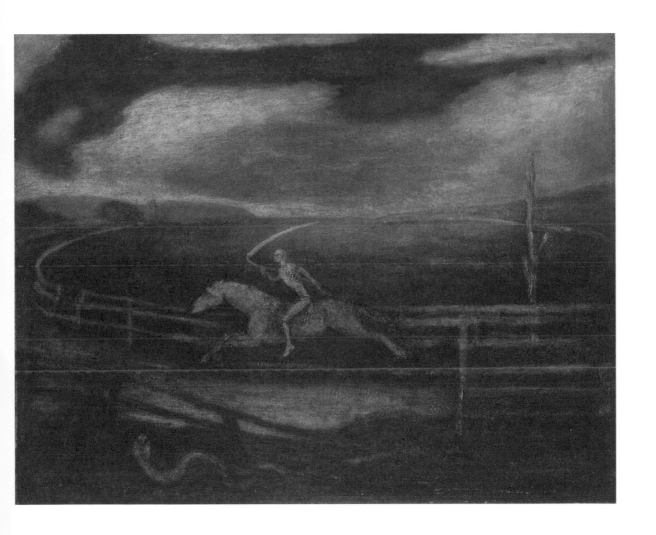

explicit, more frightening shapes, 'the vague but not serious dread of the cloud arabesque …' (Roger Fry, *The Art of Albert Ryder,* 1908)

There are some images that once seen are part of one's imagination forever. *The Race Track (Death on a Pale Horse)* isn't subtle, it isn't a clever painting, it is only an uncensored archetype from some collective folk memory fully felt and re-imagined with enough intelligence and skill. It allowed me to focus some childhood apprehensions and it still allows me to imagine death in perpetual pursuit, scythe raised to strike at any moment. Like a dreamer, sometimes I'm in the picture, sometimes I'm viewing it from somewhere else.

Susan Hiller lives and works in London and Berlin.

THOMAS HIRSCHHORN

Swiss, b. 1957

ON

ANDY WARHOL

American, 1928–1987

ANDY WARHOL

129 Die in Jet
1962
Acrylic on canvas
254.5 × 182.5 cm (100 × 72 in.)
Museum Ludwig, Cologne

In May 1978, school colleagues of mine from the Kunstgewerbeschule Zürich took me to the opening of an exhibition. It was the Andy Warhol exhibition at Zürich Kunsthaus and it changed my life. It was not the first exhibition I went to, of course, but it was the first time that I faced an artwork and was immediately concerned. For the first time I felt implicated; for the first time I was touched by art. I remember, in particular, the work *129 Die in Jet*. I was dazzled, I was happy. *129 Die in Jet* implicated me!

I will always remember this specific moment as a moment of grace and solitude. I felt included in the work, included in art. I realized that art, because it's art, has the power of transformation. The power to transform each human being. I realized that art gives me the space to think on my own. From then on, art became part of the real – 'the real' but not the reality – and therefore I saw the possibility and importance of confronting the real.

It was not a coincidence that *129 Die in Jet* struck me so strongly, because Andy Warhol said 'yes'. Andy Warhol is the artist of agreement. He agreed with the social and economic reality. He agreed with consumer society. Agreeing means to confront oneself with reality as it is. Agreeing allows for a possible acceptance or refusal of something. To agree does not mean to approve, yet being in agreement makes rejection or acceptance possible.

As the author Heiner Müller said, 'Only he who agrees can change things.' Andy Warhol showed me that reality cannot be changed unless you agree with it. To agree requires being audacious. Audacious in thinking that art, because it's art, is resistance. Art resists facts. Art resists political, aesthetical and cultural habits. Through its resistance art is movement, positive-ness, intensity, belief. Andy Warhol cooperated with reality in order to change it. There is a kind of loss of reality in his work, and it is precisely this loss that creates a new real.

The image Andy Warhol painted in *129 Die in Jet* was taken from the cover of the *New York Mirror*, June 4, 1962, the day after the crash of an Air France plane taking off from Orly airport in Paris. At that time it was the world's worst air disaster. The painting was Andy Warhol's first depiction of death. This work gives the sense of something futile and absolute. Art, because it's art, is autonomous. Autonomy is what gives the artwork its beauty and its absoluteness.

I also understood that art, because it's art, is universal. Universality means Justice, Equality, the Other, the Truth, the One World. With *129 Die in Jet*, I understood something new – that making something big does not necessarily mean it is important. I understood that enlarging something means commitment. But there is an emptiness created through enlargement. Andy Warhol's painting showed me that commitment and enlargement remove the meaning. He suggested another kind of meaning, a different meaning. Andy Warhol was my teacher. Didn't he say 'Don't cry – work!'?

Thanks to *129 Die in Jet* I understood that art can create the conditions for implication, beyond anything else. I understood that I can only create or fulfill something if I address reality positively, even the hard core of reality. It is a matter of never allowing the pleasure, the happiness, the enjoyment and beauty of work, the positive in creation, to be asphyxiated by criticism. This doesn't mean to react, this means to always be active. I understood that art is always action, art is never merely a reaction or a critique. It doesn't mean being uncritical or refusing to make a critique, it means being positive despite the sharpest critique, despite uncompromising rejection, and despite unconditional resistance. It means not denying oneself passion, hopes and dreams. Creating something means taking risks, and this can only be done by never analysing the work while making it. To take risks, to find joy in working – these are the preconditions for making art. Only in being positive can I create something that comes from myself. I want to be positive, even within the negative. I learned this from Andy Warhol.

Thomas Hirschhorn lives and works in Paris.

CANDIDA HÖFER

German, b. 1944

ON

LUDWIG MIES VAN DER ROHE

German, 1886–1969

LUDWIG MIES VAN DER ROHE
(ABOVE)

Neue Nationalgalerie, Berlin
1965–68

KUEHN MALVEZZI-ARCHITECTS
(BELOW)

Work table designed for Candida Höfer
2000
Collection of Candida Höfer, Cologne

Candida Höfer lives and
works in Cologne.

I have seen many of Ludwig Mies van der Rohe's buildings. I have seen many from the outside in various cities, including Chicago, New York, Baltimore, Berlin, Toronto, Barcelona and Krefeld. I have seen some of them from the inside. In my work I usually concentrate on the inside, and I often forget about the outside.

No matter their purpose, his buildings have a quality which is inside-out and outside-in, and beyond that they are in the cityscapes – like the air emanating from a favourite book which has its pages quickly thumbed through, a lightness coming from the idea, from the quality of the materials used which all in turn are the fundamentals of making spaces from light, stone, brick, steel, wood and glass. Among his buildings, Haus Lange and Haus Esters in Krefeld, designed in 1928, are the ones that I have visited most often. Each of the exhibitions I have seen there seemed to have been absorbed into the architecture, in a way that looked as if the exhibitions had recreated the buildings to their purpose, a miracle created by scale, dimensions, light, and by the views and insights revealed by doors and windows.

And then there is the Neue Nationalgalerie in Berlin, which tempts artists who are exhibiting there to leave the space almost untouched. Ulrich Rückriem, I think, was one of the first to do this with his minimal stone sculpture made of the same granite as the museum floor.

My personal homage to Mies van der Rohe is my white working table at which I sit in my house in Cologne, looking over the green of the shore to the grey of the Rhine river. The table was not designed by Mies van der Rohe, but I commissioned it and had it built in his spirit. I hope he does not mind.

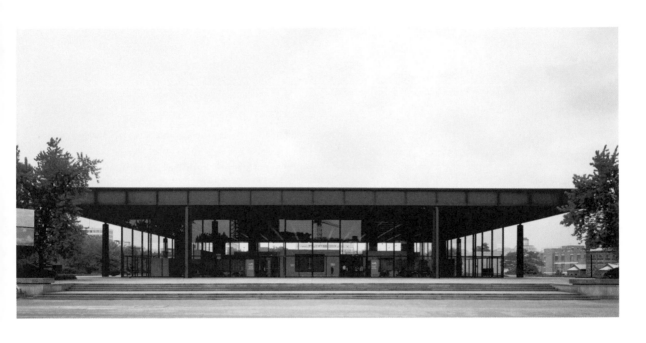

CRISTINA IGLESIAS

Spanish, b. 1956

ON

JUAN SÁNCHEZ COTÁN

Spanish, 1560–1627

JUAN SÁNCHEZ COTÁN (ABOVE)

Still Life with Game, Vegetables and Fruit
1602
Oil on canvas
68 × 89 cm (26 ¾ × 35 in.)
Museo Nacional del Prado, Madrid

JUAN SÁNCHEZ COTÁN (BELOW)

Still Life with Quince, Cabbage, Melon and Cucumber
1602
Oil on canvas
69 × 84.5 cm (27 × 33 ¼ in.)
San Diego Museum of Art, California

Cristina Iglesias lives and works in Madrid.

Looking at a painting like *Still Life with Thistle* and *Indian Partridge* or *Still Life with Game, Vegetables and Fruit*, one wonders whether Juan Sánchez Cotán was a hunter. Did he hang his partridges after bagging them and after walking through his garden to gather turnips, a leek or some celery? Perhaps this was the window of a food shop, as some writers have suggested. Moreover, some of the paintings he made while a monk, or earlier, in Toledo, contain an entire symbolism of necessary abstinence. But the orchestration of their elements cannot possibly be the result of merely aesthetic concerns, as his canvases simultaneously combine extreme realism and an implicit symbolism that denotes a complex mind.

In *Still Life with Game, Vegetables and Fruit* the partridges hang from cords, dead and exhibited in a cold, calculating manner to balance the composition both aesthetically and conceptually. The celery, with its particular consistency, rests on the windowsill, as though in repose. It seems almost like the hunter after the chase. In some cases, including *Still Life with Quince, Cabbage, Melon and Cucumber*, the composition seems mathematic, the result of a very calculated decision by the artist. These still lifes seem to capture a fixed moment in a film sequence – a 'still', as it were. Few works embody the still-life genre as perfectly as those of Sánchez Cotán.

I imagine him in his Trappist monk's cell, or as a painter before leaving Toledo on his way to Granada. He has picked a quince from a tree during a walk in which he gathered the cabbage, melon and cucumber, and has tied them with a string to be carefully hung from the window frame at the right distance. Then, before he begins painting, he sits and contemplates the scene as an artwork unto itself. Afterwards, the careful attention to detail and the extremely lucid and realistic brushstrokes are an exercise of perfection and solitude.

Sanchéz Cotán's attitude when laying out the objects reminds me more of what one grasps in constructivist still lifes by Picasso, Gris and Braque than in those of his Flemish forerunners, masters of the genre. Each chosen element is like a fragment of thought that he pieces together with others to create the whole that constitutes his offering.

I always imagine Sánchez Cotán in a cell or 'white cube'. Contemplating his scenes carries one away, to a place that is not here, not in or of this world – a place outside time, where perception is also suspended.

When I think of Giacometti's *Palace at 4 A.M.* (1932) or *The Suspended Ball* (1930–31), or one of Brancusi's photos of his own sculptures in his studio, I have always felt that Sánchez Cotán's still lifes were already artworks before he even painted them.

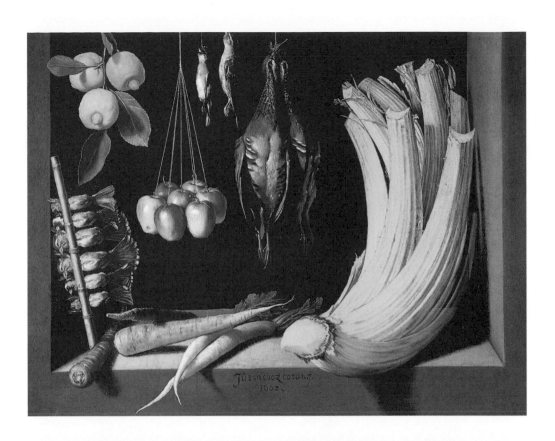

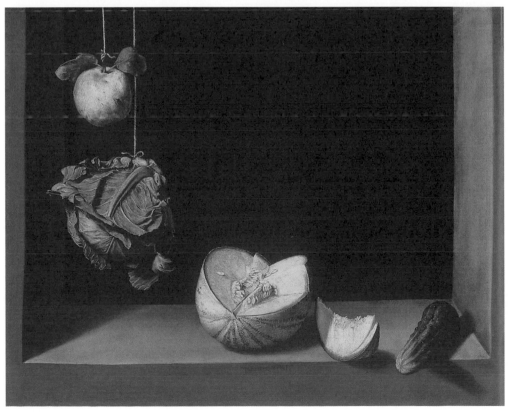

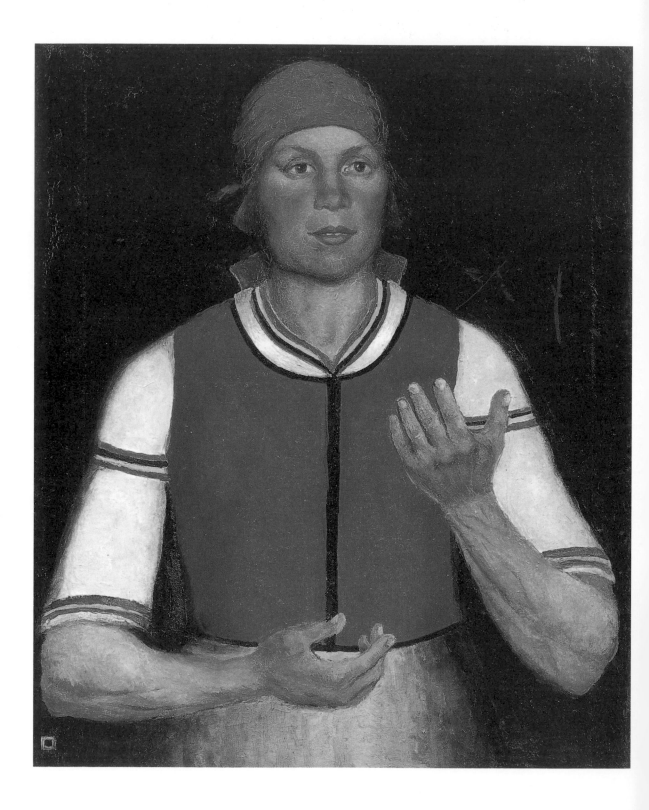

ILYA KABAKOV

Russian, b. 1933

ON

KAZIMIR MALEVICH

Russian, 1878–1935

KAZIMIR MALEVICH

Worker
1933
Oil on canvas
71.2 × 59.8 cm (28 × 23 ½ in.)
The State Russian Museum,
St Petersburg

*Ilya Kabakov lives and
works on Long Island, New York.*

I would like to share one observation, which occurred to me while looking at the picture *Worker*, dated 1933. It seems to me that any viewer who looks at that picture would find the sitter's gesture unclear and mysterious. What is it connected with? According to the title of the work and based on the face of the woman, the gesture should have something to do with production. However, you can't associate this double-hand gesture with a weaver, a builder or a repairer. Nonetheless, this gesture is very clearly demonstrative – and this is not just a neutral portrait of a woman with work-worn hands. But there is one hypothesis, a conjecture that explains this gesture: that the position of the hands is a very natural illustration of a mother, who should be holding a baby. It is worth using your imagination to superimpose the traditional image of the Madonna and child onto the Malevich picture.

Then, if my guess is right, Malevich's portrait becomes one of a deeply tragic character – an image of a mother whose child has been taken away. In this interpretation the portrait ceases to be ostensibly a concession of the great experimenter Malevich to the Soviet powers and a new life circumstance – Malevich was in fact *not* just playing along and producing the kind of art they were after. The portrait becomes an absolute icon, a symbol, of what was happening in those years, an image no less awful than Malevich's painting *Black Square* (1915).

ANNETTE MESSAGER

French, b. 1943

ON

WILLIAM BLAKE

British, 1757–1827

Annette Messager lives and works in Malakoff, France.

When I discovered the works of William Blake, which was around the end of the 1970s, a new world of sense suddenly opened up to me. I felt so close to Blake's world and yet, at the same time, I was almost jealous of his work.

Blake is, for me, both a child and an old man. *Songs of Innocence and of Experience* – the child who marvels at everything and the man tortured throughout his life by mystical insights, death, decay and pessimism. The true artist! He said: 'The imagination is not a state. It is the human existence itself.'

Blake's drawings are both joyful and melancholic, light and sad. His works – text and images – become interwoven poetically into his poems. The game that he plays between words and images also makes me think of Edward Lear's very funny Nonsense rhymes and pictures, which I love. This complete world has always stimulated me.

I feel that Blake does not seem to relate to a particular period or a specific time – in the same way that children's drawings or artworks made by 'outsider' artists seem not to. But at the same time Blake was a visionary. His work is beyond time. It is beyond past, present and future.

In my series of works from 1988 called *My Trophies,* I took blown-up black-and-white photographs of the human body and separated them into the constituent parts – eyes, ears, hands, neck. I made the parts look like a landscape or a geographical map. On top of these I added watercolours and coloured pencil drawings, many of which were inspired by William Blake. They featured trees, children flitting around, animals and fantasy characters. (Blake created a character that he called The Ghost of a Flea, did he not?) I like thinking of this maxim of Blake's that I found and have made my own: 'Without Contraries is no progression'.

The SICK ROSE

O Rose thou art sick.
The invisible worm.
That flies in the night
In the howling storm:

Has found out thy bed
Of crimson joy:
And his dark secret love
Does thy life destroy.

BEATRIZ MILHAZES

Brazilian, b. 1960

ON

HANS MEMLING

Netherlandish, c. 1430–1494

HANS MEMLING

Portrait of a Man with a Carnation
c. 1475–80
Tempera on oak panel
38 × 27.3 cm (15 × 10 ¾ in.)
The Pierpont Morgan Library,
New York

There are some artists that you feel have a connection with your work and your interests in art. For me, Matisse and the Brazilian female artist Tarsila do Amaral (1886–1973) are the strongest references. Their paintings are a constant source of stimulation and research for my studio routine. However, there are some images that you have hanging on the studio walls for company. Some of these are works of art, while others are reproductions of paintings that can give you energy and, hopefully, can motivate you to work. Hans Memling's painting *Portrait of a Man with a Carnation* is one of these examples. Ever since I first saw this painting in an exhibition of his portraits at the Frick Collection, New York, in 2005, I knew that I needed to have this picture with me. So I have two postcards of it. One hangs on the wall of my studio and the other sits behind my computer at home.

I love portraits, and *Man with a Carnation* is a strong and silent picture that gives me a sense of peace. The juxtaposition of the deep black of the sitter's clothes with the dark black of the background suggests a feeling of both loneliness and luminosity. (Having said that, I never use black in my work. When you use black, you lose a little bit of the power and the quality of the textures. The best colours to use as a background are dark green, dark blue, dark violet or purple.)

I like how the light falls on the features of the man's face and hands. Memling creates this very intimate gesture by taking a symbol of love – in this case the carnation – and painting it in a sensitive way. The man presents the carnation as if it were a melancholic discovery. This small, open and fresh, but fragile flower tells a story about a true love.

Memling painted people as fragile and tender beings. To me, this man doesn't immediately look like a man – and the way he holds the flower is not very manly. When you look at Memling's other portraits, such as his paintings of Christ, for example, the bodies and facial features look quite feminine. This goes against the grain of how other artists at the time depicted Christ.

I don't think I would be able to paint a work with this kind of simplicity. I am an abstract painter and I believe in abstraction because it's a more open door for imagination. I like to work with something that you cannot really find in the real world.

Having said that, I like works that appear static, works that allow you to look – like this one.

Beatriz Milhazes lives and works in Rio de Janeiro.

VIK MUNIZ

Brazilian, b. 1961

ON

PETER PAUL RUBENS

Flemish, 1577–1640

PETER PAUL RUBENS

Portrait of Clara Serena Rubens
c. 1616
Oil on canvas, mounted on panel
37 × 27 cm (14 ½ × 10 ⅝ in.)
Liechtenstein Museum, Vienna

Vik Muniz lives and
works in New York.

I moved to New York in the late 1980s when I was in my early twenties. At that time the Metropolitan Museum of Art was my favourite place in town. For one thing, you could go in for almost nothing and could stay as long as you wanted without being harassed for not buying anything. I would sit on a bench for hours, checking out how close people would stand in front of different paintings, how they moved in the space.

In 1986 I went to see the artworks in the Princely Collections of Liechtenstein, primarily because I knew there would be a lot of Italian inlaid stonework, which I have always liked. The show had many large works in it, in particular, an inordinate number by Rubens. They were possibly commissioned for public spaces and depicted a vast array of topics of the time: themes ranging from mythology to politics, eroticism, beauty, obesity and virtue. All were arranged in ample horizontal planes, so viewers could change positions in front of works to access specific details – just like switching channels on a TV set. The allegories had more to do with taxonomy than with representation. Seen in light of today's media those paintings seem both awkwardly modern and dead. They were too connected to the world to envision it as anything more than an inventory of things and values to be consumed. It seemed like an ancient form of advertising to me. I decided I would never become a visual artist.

But then, as I followed the exhibition, observing the audience more than the paintings, I encountered another viewing dynamic. In the Rubens section, in a smaller room adjacent to the main galleries, I noticed that people were not scanning the pictures as they meandered, but instead, without instruction, they were forming a line to see one particular work. I got into the line with no idea where it led, until I faced a painting that surprised me.

Arrested in a timeless gaze, Rubens's daughter Clara Serena, around five years old and slightly cross-eyed, burst out of the minute Baroque frame as if inviting me to play. The artist had managed to depict a subject he must have known by heart, without missing any of the asymmetries we usually overlook when drawing familiar faces. He did it without losing a single drop of the affection he had for his beautiful child. That makes this picture personal and, at the same time, universal. People stopped in front of the painting as if directed by a mark on the floor, at the exact point where they were able to negotiate between the work's surface and the portrait of the girl – that perfect spot at which an arrangement of pigments and oil embodies the soul and likeness of an angel. That tense moment of transformation when the ball has left the hands of the basketball player and hasn't yet reached the rim, the second before a first kiss – the appearance of a new form, the pure sublime.

After standing in that line again and again until the museum closed, I went home and started to draw. I knew I wanted to become an artist.

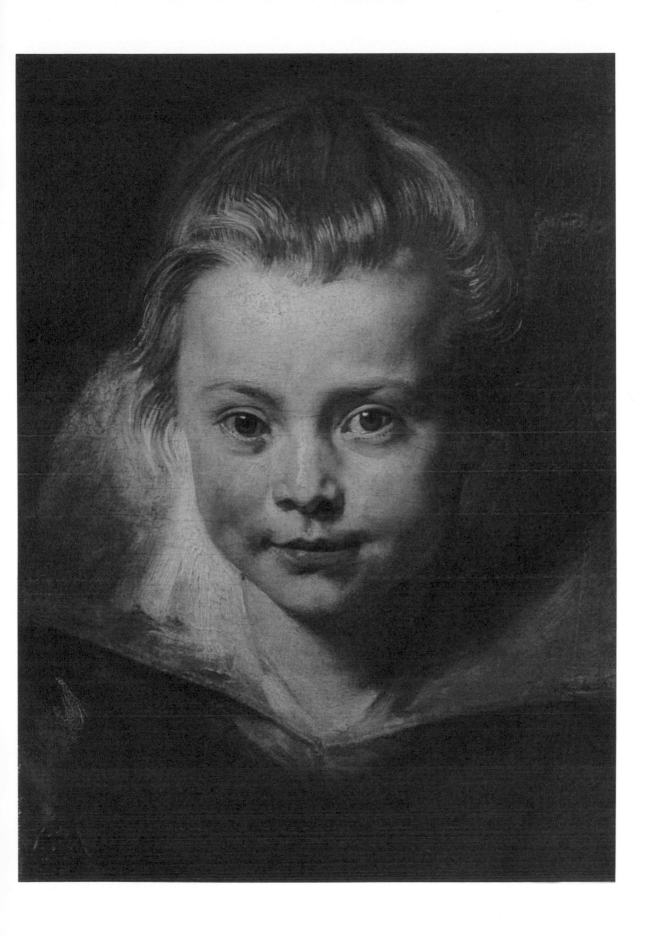

ERNESTO NETO

Brazilian, b. 1964

ON

LYGIA CLARK

Brazilian, 1920–1988

LYGIA CLARK (ABOVE)

Linear Egg
1958
Industrial paint on wood
Diameter 33 cm (13 in.)
The Museum of Fine Art,
Houston

ERNESTO NETO (BELOW)

Weight
1989
Polyamide stocking and lead spheres
25 × 25 × 4 cm (9 ¾ × 9 ¾ × ½ in.)
Weight of 5 kg

In 1954, based on research that she did on Piet Mondrian, early in the development of Brazilian Constructivist art, Lygia Clark discovered the idea that she would develop throughout her oeuvre: the 'organic line'. This idea of an organic line came to Clark when she introduced a large wooden frame around a small canvas and painted both canvas and frame. She called these pieces *Compositions* (1952) and this process 'breaking the frame'. The relationship between the canvas and the frame could be described as the relationship between the figure and the background, or the individual and the institution, or nature and culture. For Clark, the organic line became a new avenue and point of departure, both land and sea, shedding light on her work thereafter, and allowing her to cross the boundaries of modern art towards the contemporary.

After the *Compositions*, Clark began to develop 'painted objects' that she called *Modular Surfaces* (1958), which were made with industrial car paint on flat wooden boards. The pictorial space was divided into different geometric sections in two colours. In between the two fields of colour was a low relief, a cut, to symbolize the separation of the painted areas. She later made rectangular paintings composed of black squares outlined with thin white stripes – border lines delimitating the space between art and reality, establishing a dialogue and a connection with the white wall, making clear the crossing moment, the limit, the edge.

After exploring squares and rectangles, Clark produced a single black circle with a white border, a dark interior or content outlined by a white skin – *Linear Egg*. The white circle that borders the black egg is incomplete, with an interrupted section on its right side: a gap, an open space, a mouth breaking the continuity of the white line. The thin white skin contrasts with the depth of the black soul-substance in the centre. There is a free, open space through which the deep black field advances, filling the absence of the line, yet remains within the boundaries of the circle, articulating continent, content and mouth. Inexorably, everything should have a limit, an end. The surface of the circle contains the entire work, the physical organic line itself, a border between inside and outside, here and there. The open area suggests the dream, the desire to cross the border, that place of limit, where life reaches a critical turning point. *Linear Egg* represents the passage between Clark's last picture on the wall and her first sculptural relational objects. The egg is deeply figurative and organic, incorporating the movement between abstract thought and concrete object. It is beautiful.

Lygia Clark's *Linear Egg* has a special significance for me. Many years after I made *Weight*, an early work composed of a stocking filled with lead beads, I realized that my explorations of content, continent and mouth could be traced back to Clark. My *Weight* – linked to Lygia's *Linear Egg* – is the seed of everything I have created since then.

Ernesto Neto lives and works in Rio de Janeiro.

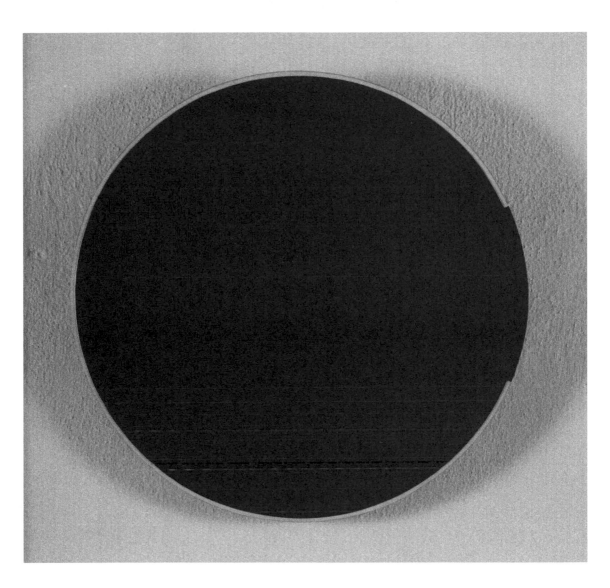

KURT SCHWITTERS

Merzbarn
1947–48
Mixed media wall relief
Hatton Gallery, Newcastle
University, Newcastle upon Tyne

Kurt Schwitters was a beautiful artist of deep integrity who had an awkward aesthetic. Schwitters started from scratch. He scratched his surface. He raked his fingernails along the streets of Hanover, Germany. He saw value in what was only waste to others, and with these found materials wove intense collaged compositions.

Schwitters's grandest statement was the Merzbau, his Merz building. This building was within his home in Hanover. The interior of his apartment was transformed into, as he once called it, a Cathedral of Erotic Misery. The Merzbau revealed his collages to be preliminary sketches for a new kind of all-encompassing art, a total environment that could embrace and reflect a world that no longer had one truth, if it had any at all.

Deemed a degenerate by the National Socialists, Schwitters was forced to flee from Germany in 1937. He left behind his environment, the dirt he rolled in, and his life's great work. War, the flattener of life and things, flattened Schwitters's alchemical reinvigorations. The Merzbau, his magical construction, was blown back to bits by Allied bombing. Taking with him whatever artworks he could, Schwitters moved to Oslo where he constructed a second Merzbau, *The House on a Slope*. But war followed and Schwitters fled again, to England. In the UK he was imprisoned as an alien, and after four years moved to the Lake District. On his sixtieth birthday, in 1947, he received a donation of $1,000 from the Museum of Modern Art in New York and begun work on the final Merzbau, the Merzbarn. This barn, which belonged to local farmer Harry Pierce, was newly built in the traditional dry-wall technique. It was two miles from Schwitters's home in Ambleside. Schwitters collected objects on the road en route and amalgamated these into the building. The artist worked like a blind man, feeling his way with 'seeing' hands to conjure up anew the total sensations of all that surrounded him. I see Schwitters's construction process, his hands on and in the wall, being a way of becoming the building, of finding place.

Following Schwitters's death, Pierce did his best to maintain the Merzbarn, but time and the Lake District damp did its best to undo the delicate construction. In the late 1950s the Merzbarn's vulnerability came to the attention of the artist Richard Hamilton. Like Schwitters, he understood the nature of loss (Hamilton had been left a single parent of two young children after his wife died in a car accident). In the following

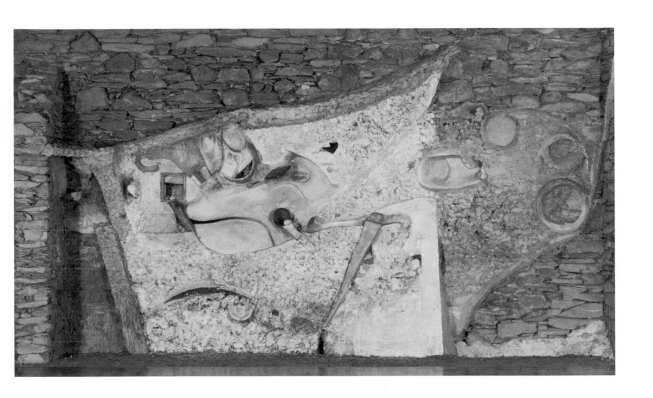

years, Hamilton would transfer his energy into two projects of reclamation – making a version of Marcel Duchamp's broken and neglected *Large Glass* (1915–23), and saving the mouldering Merzbarn. The part of the barn that was most complete was cut from the rest of the building and transferred to Newcastle. In 1966 the Merzbarn was put on permanent display at the new Hatton Gallery at Newcastle University. It still stands at the core of one of Newcastle's prime educational establishments. Schwitters wrote, 'Stone upon stone is building'. This is exactly how a cathedral begins.

What do artists do? We live, we think, we make, we leave things behind, and, if we are lucky, these things are considered valuable by people other than ourselves. Schwitters said, 'The spirit cannot be stopped. It can be changed, but not stopped.'

Paul Noble lives and works in London.

ADRIAN PACI

Albanian, b. 1969

ON

MASACCIO

Italian, 1401–1428

MASOLINO
(OPPOSITE LEFT)

The Temptation of Adam
1424–25
Fresco
208 × 88 cm (81 ⅞ × 34 ⅝ in.)
Brancacci Chapel, Church of Santa
Maria del Carmine, Florence

MASACCIO
(OPPOSITE RIGHT)

The Expulsion from the Garden of Eden
1425–27
Fresco
208 × 88 cm (81 ⅞ × 34 ⅝ in.)
Brancacci Chapel, Church of Santa
Maria del Carmine, Florence

I often think about my school days when, at the end of the year, we would all exhibit our artwork. Each student had access to a space of about 2 metres (6 feet) from floor to ceiling where they could hang their paintings and drawings. The works were all the same size, all made with the same techniques, all following the same theme, yet they were all different.

I was reminded of this while looking at the fresco cycle by Masaccio and Masolino that decorates the Brancacci Chapel in the Florentine church of Santa Maria del Carmine. The paintings share the same space, use similar themes, similar colours, and are similar in size, and yet two completely different artistic personalities emerge. There is an essential, intimate difference that separates the paintings of Masaccio from those of Masolino. This difference cannot be evaluated and classified outwardly, as if one is talking about two different styles or schools, but it is there and it is clearly evident.

If I look at Masolino's *Temptation of Adam* (1424–25), which is on one wall of the chapel, and then at Masaccio's *Expulsion from the Garden of Eden* (1425–27) on the other side, it looks as though each artist had deliberately chosen his theme in order to better express his particular characteristics. In Masolino's fresco, the bodies of Adam and Eve possess a contained grace that disguises any sexual impulse. Masaccio's painting is the complete opposite. This is not confined to Masaccio's evidently more aggressive depiction of Adam's manhood, but rather it concerns the entire atmosphere of the painting, which portrays an utterly different mankind, one in which the flesh, fallen into disgrace, is presented without any covering or embellishment. Masaccio's figures have been stripped of the graceful sterility that kept them suspended in an abstract space in Masolino's composition; they are gravitating in all their weight and volume, shaped by a strong use of chiaroscuro.

In terms of fifteenth-century style, Masaccio is capable of unexpected changes, which add freshness and novelty to his vision. There is a sense of truth to the figures of his paintings. This is not the mere truthfulness of representation, nor a truth copied from nature, but rather a truth that has been reached through a unique dialogue with nature and then spoken with all the freedom of pictorial language. We don't perceive the reality of the figures of Masaccio through a faithful, descriptive depiction of every detail; rather it becomes evident through forms and shapes whose coarseness betrays no interest in superficial beauty. There is a monumental

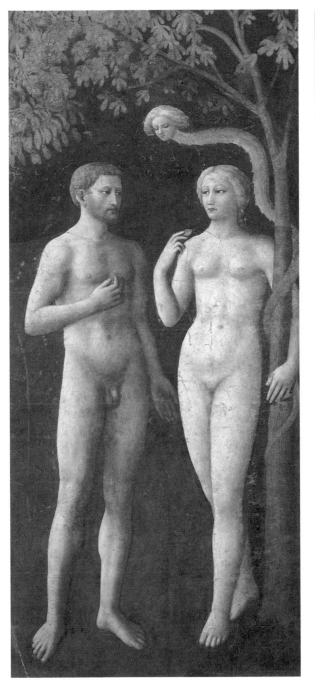

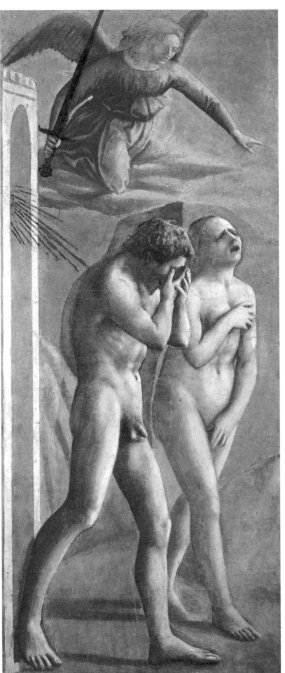

The Crucifixion
c. 1426
Tempera and gold on panel
83 × 63.5 cm (32 ¾ × 25 in.)
Museo di Capodimonte, Naples

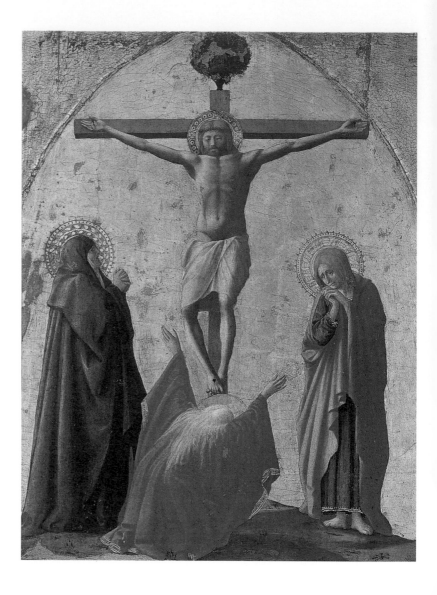

Adrian Paci lives and
works in Milan.

brutality in Masaccio's painting, an effective nonchalance that accompanies its figures and that makes them more realistic. I am thinking, for instance, of his painting *Crucifixion* (1426), which depicts the crucified Christ, head disappearing into the shadow of his body, breaking the anatomical features and thus creating an atmosphere of solemn and silent pain.

We must note, however, that although they have been stripped of their grace, Masaccio's figures have not lost their mystical dimension. The flesh is not completely desecrated, the loss of grace does not hide the drama of its absence, and an unspoken but persistent tension reminds us of a spirituality that springs from inside the forms and fills all of his paintings.

JORGE PARDO
American, b. 1963

ON

GUSTAVE COURBET
French, 1819–1877

GUSTAVE COURBET
(OVERLEAF)

The Artist's Studio, A Real Allegory
Summing up Seven Years of My Artistic
and Moral Life
c. 1854–55
Oil on canvas
361 × 598 cm (142 ⅛ × 235 ½ in.)
Musée d'Orsay, Paris

Gustave Courbet's *The Artist's Studio, A Real Allegory* is one of my favourite works of art. It is a beautifully complicated, allegorical picture. It is like a machine – there is so much going on in it. It is a narrative painting, but there is a sloppiness in this subject matter. It looks like a zoo in there! There's a kid who has just walked into the room and is standing right in front of the easel, watching the artist at work. Behind the artist is a nude model, her clothes lying in a pile on the floor in front of her, onto which a small white dog is about to jump. There is a man on the right absorbed in a book (apparently meant to be the writer Charles Baudelaire). There are a bunch of odd characters from all walks of life on the left-hand side, some of whom look like they might have come out of a Goya painting. To add to the strangeness, Courbet has added a horizontal rectangle of light. What is this? A door perhaps?

The artist in the centre of the painting is, of course, Courbet. He said about this painting: 'It's the whole world coming to me to be painted… on the right are all the shareholders, by that I mean friends, fellow workers and art lovers. On the left is the other world of everyday life: the masses, wretchedness, poverty, wealth, the exploited and the exploiters, people who make a living from death.'

To me, the painting is like a mirror. Just as in Velázquez's painting *Las Meninas* (1656), you feel that the patron of this painting is looking at this scene from the same vantage point as the viewers. However, whereas *Las Meninas* is a painting about the art of looking, Courbet's painting says, 'Up yours, I want to put everything on the surface of the painting.' And Courbet creates a flat, shallow space. He gets this effect by including the large wall at the back. The wall is significant, because it's the largest element in the painting – it takes up half the space. When you see this work in the flesh, you notice that part of this section seems unfinished. That was quite a radical thing to do at that time. It is wasteful, it is disorganized, and it is belligerent. It does all these really beautiful things, and I have a lot of empathy for that kind of approach.

I'm also very interested in works of art that, like this one, resist the rational. Here, Courbet is depicting the idea of a complex image – one that has many layers and readings. The painting also functions as an historical index – one that does a lot of different things at the same time. It wants to talk about the political absurdities of France in the 1850s, but it also works – for me at least – as a prompt for reflecting on other artworks. For example, I have always returned to this picture because it helps me to look at works by artists from the 1960s, such as Dan Graham and Michael Archer. That may seem strange to someone else when looking at this painting, but Courbet's 'sloppiness' functions as an organizing principle with which to think about their work. The work is a mirror, like a Dan Graham work is a mirror. Courbet is the artist in his picture. That's the reason why I keep coming back to this painting.

Jorge Pardo lives and
works in Los Angeles.

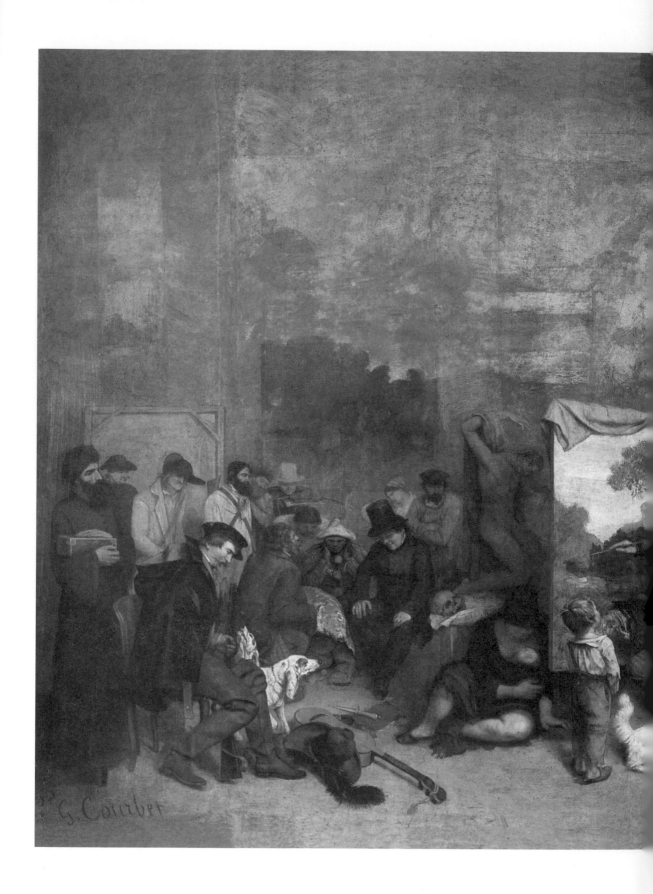

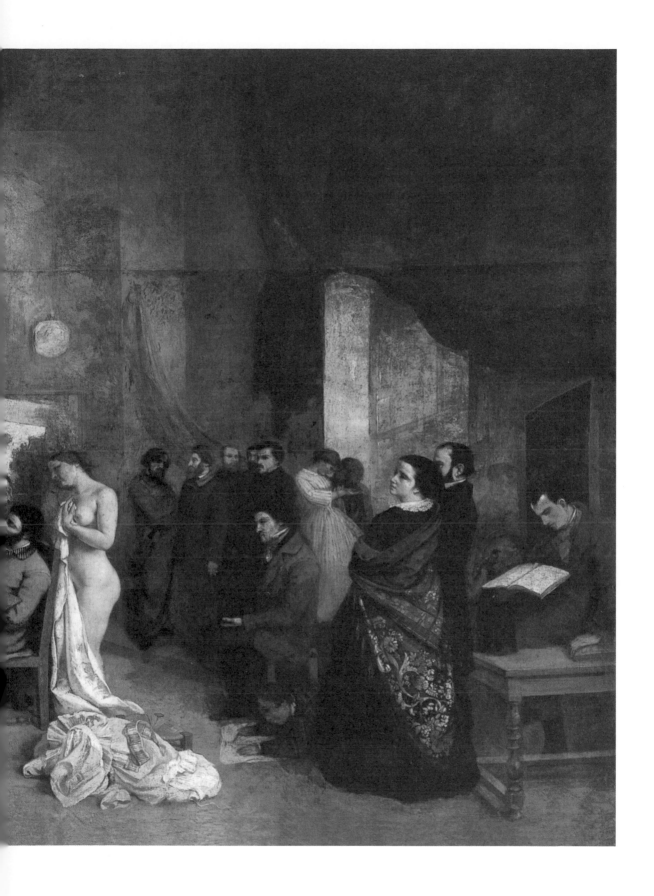

CORNELIA PARKER

British, b. 1956

ON

MAN RAY

American, 1890–1976

MAN RAY (ABOVE)

Dust Breeding
1920, printed *c.* 1967
Gelatin silver print
23.9 × 30.4 cm (9 ½ × 12 in.)
The Metropolitan Museum of Art,
New York

CORNELIA PARKER (BELOW LEFT)

Dust Breeding (On Judd)
2001
Archival colour inkjet print made
from a scan of dust, insects and
debris that collected on Donald
Judd's *100 Untitled Works* at The
Chinati Foundation
38 × 29.3 cm (15 × 11 ½ in.)

CORNELIA PARKER (BELOW RIGHT)

*Brontëan Abstract (Pinhole Made by
Charlotte Brontë)*
2006
Gelatin silver print of an
SEM image
44.5 × 49.5 cm (17 ½ x 19 ½ in.)

*Cornelia Parker lives and
works in London.*

I first came across Man Ray's *Dust Breeding* (1920) – a photograph of Marcel Duchamp's *Large Glass* (1915–23) covered with dust in his studio – many years ago, when on my foundation course. I found the image in an anthology and didn't really know what I was looking at. It looked like an aerial photograph, or a view through a microscope. *Dust Breeding* seemed a truly ambiguous image, appearing to be abstract yet at the same time acting as an accurate record of an object. It was only later, when I'd read more about Duchamp and his work, that I appreciated how he deified neglect, and that allowing dust to settle could be a valid process in the making of art.

The Large Glass took Duchamp about eight years to complete, so it was a work in progress when Man Ray took this photograph. An alternate title for Duchamp's piece is *Delay in Glass*, but could this photograph, taken in a split second, have possibly captured the depth of the delay? As the dust gathered, it was silently recording the time Duchamp took to process his ideas. He allowed this long pause to become part of the final artwork, retaining some of the accumulated dust as part of the work, fixing it permanently to the surface with varnish so that it looked like stained glass. The dust somehow embodies the depth of thought required to create such a complex piece, while at the same time obscuring the work's meaning.

Man Ray and Duchamp were friends for a large part of their lives and *Dust Breeding* somehow captures their dialogue; you can imagine the conversations and the laughter it spawned. It seems a truly collaborative piece, a snapshot of an attitude as well as a different time. From the perspective of our speeded up world, this work seems more and more anachronistic. Taking time out for seemingly idle thought seems near impossible now.

Dust Breeding has been a constant inspiration to me, greatly affecting my thinking on materials and process. It has led to my use of the macro and the micro, in a quest to find abstraction in the most representational, quiet in the noisiest place – from a pair of earplugs I've made from dust collected in the Whispering Gallery of St Paul's Cathedral (1997), to the scanning electron microscope image of a pinhole made by Charlotte Brontë (2006).

In 2001 I made a work as homage to Man Ray's photograph, called *Dust Breeding (On Judd)*. The Chinati Foundation (the contemporary art museum in Marfa, Texas founded by the minimalist sculptor Donald Judd), had asked me if I would create a print to support them. I asked them to clean Judd's 100 stainless steel sculptures housed in an aircraft hangar there and send me the dust so that I could scan it to make my image. When magnified, the dust was visually teeming, made up of particles of sand and cacti that had blown in from the desert, wasps, and legs of various other insects. Dust, in the end settles on everything, even on minimalism.

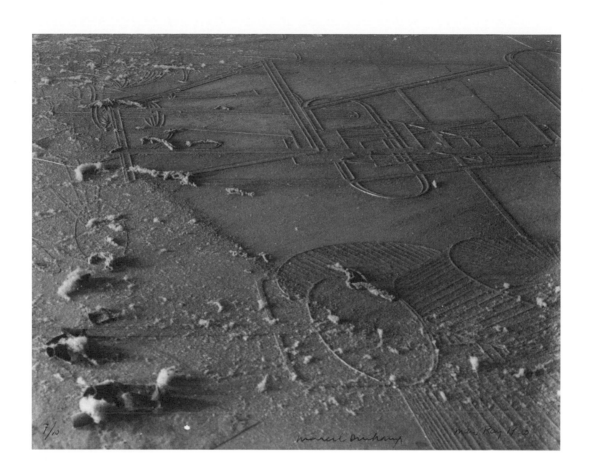

SIMON PATTERSON

British, b. 1967

ON

JOHN BALDESSARI

American, b. 1931

JOHN BALDESSARI

*A Painting That Is Its
Own Documentation*
1966–68
Acrylic on canvas
Original canvas 172.7 × 143.8 cm,
each additional canvas 87 × 143.8 cm
(68 × 56 ⅝ in., 34 ¼ × 56 ⅝ in.)
Collection of Norman and Norah
Stone, San Francisco

When I was approached to contribute to this book I felt the finger of art history jabbing me between my shoulder blades. Perhaps that is what led me to choose *A Painting That Is Its Own Documentation* by John Baldessari, which I saw for the first time in Los Angeles in 1995.

I have always admired the work of John Baldessari, and this painting in particular. The work is painted on canvas by professional signwriters and lists the date of the work's conception followed by its subsequent exhibition history, which must be updated every time the painting is shown. I like the way that, by incorporating its own history in perpetuity, *A Painting That Is Its Own Documentation* defies the fate of most works, which eventually become weighed down with their own history. Marcel Duchamp said a work of art only has a life of forty years after which it becomes history, but in this work, now in its forty-third year, John Baldessari has it both ways: *A Painting That Is Its Own Documentation* has not only become history but, paradoxically, history keeps it alive. By being continuously exhibited the work lives on, constantly renewing itself.

When I interviewed John Baldessari recently, I asked him about *A Painting That Is Its Own Documentation,* and he explained that the genesis of the work came out of studying art history and 'the continual problem of the work of art and its provenance getting lost or separated. I thought it might be interesting to make the provenance the work of art so that they were never apart.' Commenting on the Duchampian device of commissioning professionals to execute work, he added: 'A common complaint you would hear back then about first and second generation Abstract Expressionism was, "my kid can do that". It gets so tiring hearing that, so I thought: change the language, speak the language of the realm. People read magazines and newspapers so I thought, OK, I'll just use text and photographs. The reason that I very consciously put it on canvas was because if something is on canvas and has stretcher bars it is immediately "art".'

For me *A Painting That Is Its Own Documentation* is not only about provenance, or the incidentals of exhibition. Rather it is a kind of *vanitas,* a *memento mori.* Over time additional canvases have been, and will continue to be appended to the work and, while the font remains the same, the 'hand' mellows or even alters, further suggesting the passage of time. *A Painting That Is Its Own Documentation* is also a surrogate for the artist in that it demands TLC, or, in museum terms, continuous conservation. The work is also about the contingency and ultimate ephemeral nature of fame and reputation; in the end, the work has to fend for itself, accruing its own history but subject also to the vagaries of time.

*Simon Patterson lives and
works in London.*

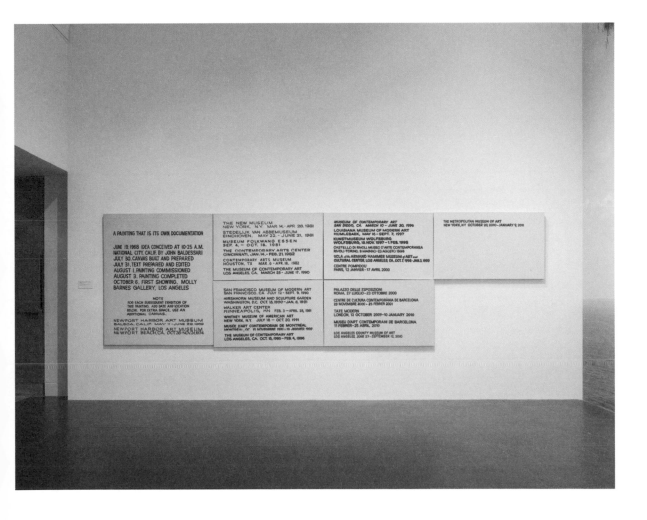

GIUSEPPE PENONE

Italian, b. 1947

ON

KAZIMIR MALEVICH

Russian, 1878–1935

KAZIMIR MALEVICH

Untitled
1914
Pencil on paper
14.7 × 10 cm (5 ¾ × 4 in.)
Collection of Giuseppe Penone

Giuseppe Penone lives and works in Turin, Italy.

A thought about a drawing by Malevich.

A cross, with all its symbolic, mystical and anthropomorphic charge, is the most visible element in the drawing's composition. It is inserted in the upper half of the sheet almost parallel to the diagonal that ideally links the upper-right and lower-left corners. The cross is inscribed in a rectangle, proportionate to the shape of the sheet, with three other elements: a 'T' shape similar to the three short arms of the cross, the shadow of this same form, and a square with the dimensions of the upper part of the cross. These latter two elements, drawn with a lighter-toned pencil, create a shadow and give the illusion that the cross and the 'T' element are suspended in space.

The whole drawing creates an impression of flight. The sensation of movement, projection and ascent of the forms is accentuated by a few light shapes in the lower part of the sheet that repeat the square and the cross. These features suggest a spiralling of the forms in space, an ascension that recalls the growth spiral of plants. Two other elements, one round, drawn in the right, upper part of the sheet, and its shadow, give a feeling of cosmic floating and fading. Each small sign seems necessary, each small stain or incident on the paper assumes a value. An extraordinary economy of material and gesture that suggests to us the construction of a utopian, visionary and mystical reality. Fourteen by ten centimetres of paper, dirty with graphite, open our eyes to a reflection on the universe.

SIMON PERITON
British, b. 1964

ON

CHRISTOPHER DRESSER
British, 1834–1904

CHRISTOPHER DRESSER
(BELOW LEFT)

Force and Energy
Originally published in *Principles of
Decorative Design*, 1873
Pencil drawing

SIMON PERITON
(BELOW RIGHT)

Doily for Christopher Dresser
1996
51 × 79 cm (20 × 31 ⅛ in.)

The first piece I ever saw by the nineteenth-century designer and writer
Christopher Dresser was a drawing called *Force and Energy*, which I came
upon by chance at some point in 1995 at the back of a book about Art
Nouveau that was on my mother's bookshelf. At the time, I had recently
started making a series of paper doilies – delicate fragile paper pieces drawn
with a scalpel from a single folded sheet of coloured paper. The first pieces
were complex curlicues of barbed thorns and dense thickets, repeated in a
decorative pattern.

 The power of Dresser's drawing was instantaneous for me, although at
first I could not work out what the image was. It looked like a bizarre web
of intricate fanning vertebrae and unfurling fronds. It also had diagonals
radiating out of the bottom left-hand corner. It appeared like a stylized,

controlled vision of nature, something organic and yet man-made. I found this intriguing. It could have been an illustration from science fiction, or a fragment of a Futurist painting. I was stunned to discover that it had been drawn in 1870.

I started reading more about Dresser and found out he was more revolutionary than I first thought. He was incredibly prolific and eclectic in his output. He made ceramic designs for Wedgwood and Minton, wonderful cast-iron works (hall stands, chairs, fireplaces) for Coalbrookdale, and his work also included textiles, wallpaper and glass. Many of his designs, particularly his silverware from the 1870s and 1880s for James Dixon & Sons, still look futuristic today. Dresser trained both as a designer and a botanist – his specialization was morphology, the study of the external form and structure of plants, animals and organisms. He was the first European designer to be formally invited to Japan, where he made an extensive study of Japanese art.

Dresser is most often compared to his contemporary, William Morris. However, Morris was suspicious of and rejected the developing machine age. By contrast, Dresser fully embraced it. Ironically, Dresser's designs were cheaper to produce and therefore available to greater sections of the population. Dresser had also published his forward-thinking ideas on design and decoration fifteen years before Morris.

The exact date of *Force and Energy* is vague. It first appeared as one of the illustrations to Dresser's book *Principles of Decorative Design*, published in 1873 in London, but the drawing had appeared previously as an illustration in one of a series of articles he contributed to the periodical *The Technical Educator* (1870–72). Describing the drawing, Dresser wrote:

'I have sought to embody chiefly the idea of power, energy, force or vigour and in order to do this I have employed such lines as we see in the bursting buds of spring … in certain bones of birds which are associated with the organs of flight … as well as those observable in the propelling fins of certain species of fish.'

A version of this design was also used on a vase designed by Dresser and produced by Wedgwood in 1867, so the design must have existed earlier than 1867. On the vase the image is paired with its mirror image, producing a dizzying symmetrical pattern.

Dresser's interest in symmetrical imagery reveals his fascination for the ornamental grotesques often formed by mirroring designs, but most commonly linked with the psychological inkblot tests of Hermann Rorschach from the 1920s. I eventually made a work based on this drawing called, simply, *Doily for Christopher Dresser*.

Simon Periton lives and works in London.

RAYMOND PETTIBON

American, b. 1957

ON

VICTOR HUGO

French, 1802–1885

I can't imagine the nineteenth century without Victor Hugo. He is such an important literary figure. I read *Les Misérables* and *The Hunchback of Notre Dame* as a child, but I know Hugo's work now more from his art. The first time I saw his drawings and watercolours was at the Drawing Center in New York in 1998, and over the years I've seen many of them and I think they are amazing. These include works like *Octopus With the Initials V. H.*, (*c.* 1866), *Mushroom* (*c.* 1850), his abstract drawings, as well as odd places and buildings that he drew – some of which included text within the image.

The *Mushroom* painting contains a horizon, and in the foreground a large mushroom emerges out of the ground. I don't know whether Hugo had intended to draw a mushroom, or if there were some facilitating strokes that caught his eye. It's a fairly realistic mushroom, although it appears a bit out of place in its environment.

The abstract compositions that Hugo made are extraordinary considering that they were done in the nineteenth century. Some of them look like works by Franz Kline. Hugo used to empty his coffee cup onto bits of old paper and spread the coffee with his fingers or a brush, and then use bits of old lace to make shapes on the paper. I've done similar kinds of things over the years as well. In the drawing he made with his fingerprints, *Taches With Fingerprints* (1864–65), you ask yourself: can you detect an artist's work from one stroke, one line?

Sometimes, I think Hugo had the 'bug' of the ink. I know what that is like – it can become an extension of you. It is in your blood. What he did was establish some kind of relationship, an affection or love, between the work and himself. It was an act of generous collaboration between one's hand, one's mind, the paper, the ink and the gesture. The result is that his drawings just look right.

Victor Hugo wrote that great artists have an element of chance in their talent and talent in their chance. That is something that I recognize. In my work, when I make the first mark on the page I don't know where it's going to go. My work also uses text and image – the text that I use is integrated into the image. You can take that idea back to the Bible and earlier embellishments of text on the page, such as illuminated manuscripts. Hugo used text as a particular device in the process of making a picture, in the same way that Alexander Cozens used his experimental black-and-white ink blot landscape drawings as teaching tools to explore methods of depicting landscape.

Hugo is not an artist who I file away and then look up at will for whatever purpose. Mine isn't just an appreciation from a distance. Hugo is someone I appreciate at close hand, and from whom I borrow – both his techniques and the freedom that comes with them.

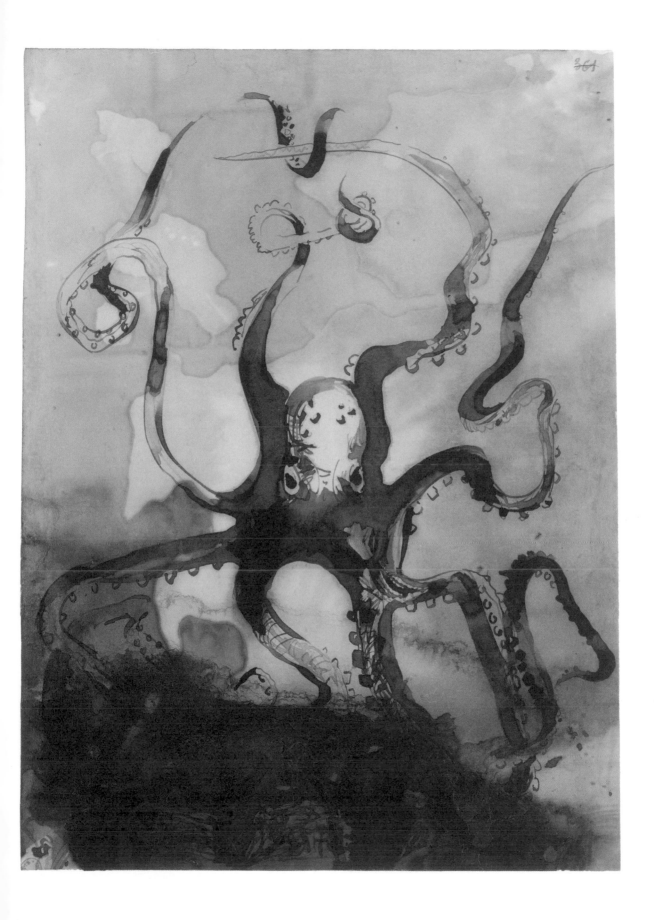

VICTOR HUGO (RIGHT)

Victor Hugo 1866: Les Travailleurs de la Mer
1866
Pen, brush and brown ink, wash, gouache and watercolour
19.2 × 25.4 cm (7 ½ × 10 in.)
Bibliothèque Nationale de France, Paris

VICTOR HUGO (BELOW)

Lace Impressions
1855–56
Brown ink, gouache, and impressions of lace on paper
12.2 × 27.4 cm (4 ¾ × 10 ¾ in.)
Private collection

RAYMOND PETTIBON (ABOVE)

No Title (The Artist And)
2009
Pen, ink and gouache on paper
66 × 102.2 cm (26 × 40 ¼ in.)

RAYMOND PETTIBON (RIGHT)

No Title (Having Once Awakened)
2009
Pen, ink and gouache on paper
55.9 × 43.8 cm (22 x 17 ¼ in.)

SOPHIE RISTELHUEBER

French, b. 1949

ON

WALKER EVANS

American, 1903–1975

In 1936, during the Great Depression, *Fortune* magazine commissioned an article about the dramatic situation of impoverished tenant farmers in the American South. The writer James Agee decided to go to Alabama along with the photographer Walker Evans, who was already working for the Farm Security Administration's photography programme. (This organization, set up by Franklin Roosevelt in 1935 to combat rural poverty, included about twenty well-known photographers sent out to record the impact of the Depression on rural Americans.) Evans and Agee dedicated themselves to chronicling the lives of three families: the so-called Ricketts, Woods and Gudgers.

Agee's text was refused by *Fortune*, but several years later, in 1941, it was published along with Evans's pictures as *Let Us Now Praise Famous Men*. This is a deeply distressing book, with an extremely complex structure, describing real people and events, yet elevating them into a poetic universe. Evans's images represent perfection in the documentary style. When I saw these images I understood for the first time that experiment and the reportage genre could also produce art. I have often in my mind Walker Evans's image of a bed in one of the homes. I first saw 'the bed' in 1971, during my first stay in New York. I used to have a postcard of that photograph on my desk.

Agee's writing reversed the classical point of view by positioning himself apart from the described object. Twenty-five lines are not enough to *describe* a simple pair of workshoes; his exhaustive accounts become like chants, or epic poems.

At the end of 1979, the artist François Hers asked me to write a text about social housing inhabitants in Belgium. He photographed the interiors of the houses and I was invited to write an accompanying sociological statement, sprinkled with quotes from the residents based on interviews. Because I'm an intense person, I decided to settle within a family. There was one in particular, in Brussels, where the father had left home. The kids, still teenagers, were living with their mother. I was young, but after two days I was part of the family and became their confidante. They began to tell me extremely personal stories, and I began to wonder 'How can I give an accurate and respectful account of their lives?' I understood that I lacked James Agee's literary talents. I had brought a small Nikon camera with me that I would give to my 'subjects' so that they could photograph the things and places that they liked in their home. One day, moved by the way the family members appeared in their surroundings, I took hold of the camera. They were simultaneously proud of their home's interior and, sadly, swallowed up by the decor they had so carefully installed.

In the end there was no text. Instead, I made a series of twenty-seven black-and-white portraits. These photographs accompanied François Hers's work to become *Interiors*, exhibited at the Centre Pompidou in Paris in 1981. Since then, I've found my own way. The camera has become the tool of my freedom and my way of displaying the details of the world. Tell everything, while showing less.

Sophie Ristelhueber lives and works in Paris.

ED RUSCHA

American, b. 1937

ON

JOHN EVERETT MILLAIS

British, 1829–1896

ED RUSCHA (BELOW)

The Los Angeles County Museum on Fire
1968
Oil on canvas
135.9 × 339.1 cm (53 ½ × 133 ½ in.)
Hirshhorn Museum and Sculpture
Garden, Smithsonian Institution,
Washington, DC

JOHN EVERETT MILLAIS (OPPOSITE)

Ophelia
1851–52
Oil on canvas
76.2 × 111.8 cm (30 × 44 in.)
Tate Collection, London

I first saw Millais's *Ophelia* when I came to the UK in 1961 and was struck by its originality. It's hard to explain what I first saw in it, but it was a moving picture to me and so realistically painted. I guess I had a fondness for all sorts of Pre-Raphaelite images back then, a feeling which subsequently passed, but the nature of this painting stayed with me.

At first I didn't delve too much into the story and the symbolism in the painting. I viewed it strictly as a picture – how it was composed and so on – but later on I learned that it had been studied and analysed by so many people, which made it even more interesting. Every little blade of grass and each plant has been botanically identified. Someone has identified almost exactly where Millais set up his easel by the river. Some believe there is a skull hidden in the painting (just to the left of the forget-me-nots on the right-hand side).

The painting itself is like an embellishment of the Ophelia story in Shakespeare's *Hamlet*. The fact that she was portrayed as a mad woman during Millais's time was, I guess, considered unsuitable subject matter. You didn't paint mad people. But when I look at the woman in the water there, I don't see a mad woman. I see a tragic woman.

I would never have realized that this painting would affect me in the way it did. *Ophelia* became a trigger in my art; an inspiration for what I'm doing. You are looking down on Ophelia from an oblique angle – and in this sense *Ophelia* is an aerial view. The diagonal of her body in the water is an aspect that was made for my work. My study of art and much that came out of it is ordered on that thinking, that you look at something almost as if it were a tabletop arrangement. I regard a lot of my paintings and even

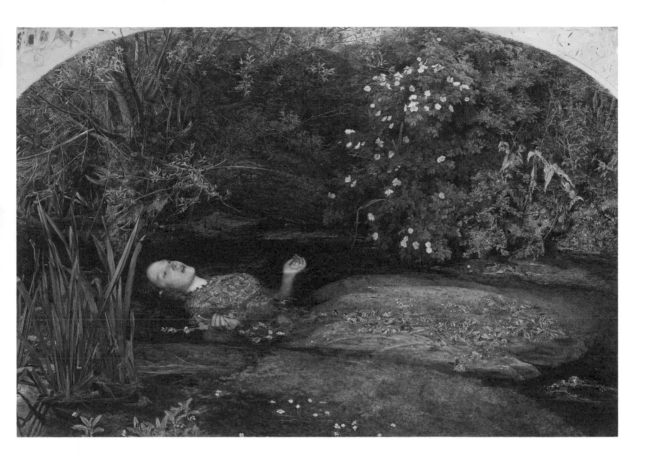

photographs (such as *Thirtyfour Parking Lots*, 1967) as offspring of this painting. For example, *Los Angeles County Museum on Fire* has a similar angle to that of *Ophelia* – we look down on the building from above. Also, the tragic circumstances of a situation in my painting are told, I think, in a very bucolic and pastoral way, just as they are in Millais's picture.

The composition of *Ophelia* has been absorbed into my thinking. When I make a picture that might resemble it I'm not doing it on purpose. It just happens. I don't get this response from any other of Millais's paintings, but with this one, for me, he hit the nail on the head.

Of course my pictures are very different from this in both intent and content. They are worlds apart in many ways: *Ophelia* is in the grand tradition of English painting, and the story goes back to Shakespeare, whereas my work goes back to 1968 and, you could say, is the culmination of commercial America. But pictorially they are connected. They are like brother and sister. I feel as if there is a little silver thread between this painting and mine. So maybe the years between the works are not so distant after all.

In some ways I feel that I am looking at myself when I am looking at *Ophelia*. So each time I come to London I feel an obligation to see it, but it is an obligation I feel good about.

Ed Ruscha lives and works in Los Angeles.

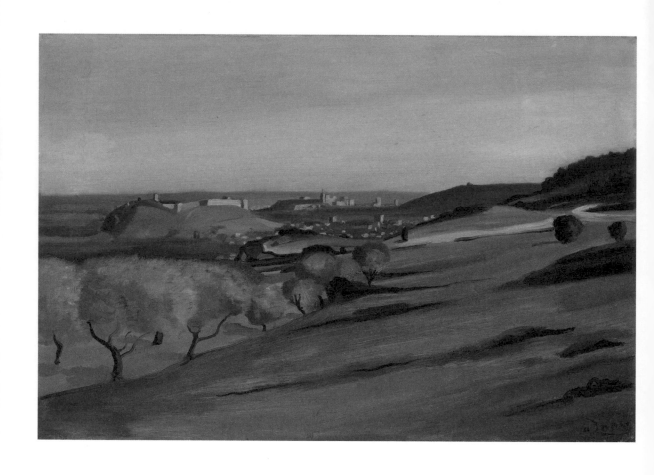

DAVID SALLE

American, b. 1952

ON

ANDRÉ DERAIN

French, 1880–1954

ANDRÉ DERAIN

Landscape in Provence
c. 1930
Oil on cradled panel
37.8 × 55 cm (14 ⅞ × 21 ⅝ in.)
The Art Institute of Chicago

I like Derain's story. He turned his back on modernism and retreated to the country. In the first decades of the twentieth century, Derain was a flat-out Fauve colourist, a radical whose work shared the stage with Matisse and Picasso. However, from the late 1920s onwards, Derain viewed his subjects through a neoclassical lens, defiantly creating a more romantic, timeless image of the artist.

We are conditioned to think of modernism, of art history generally, as a story of progress and up-to-date-ness, but some of the more interesting painting exists in the margins and corners, apart from the official story. Some artists, like Derain, Francis Picabia and Giorgio de Chirico, went backward into art history to go forward. It's a question of temperament and talent, not one of linear progress.

Derain's paintings have a wrought quality. Forms are hacked from larger solids; shapes are wrestled with and left ragged. His Fauvist palette of orange and red gave way to one of greys and browns, burgundy, dark greens, and the golds and ochres of Provence – the palette of Courbet's portraits. There are some paintings from the late 1930s and 1940s – the artist at his easel; a still life with a pear – that are so romantically cock-eyed you don't know whether to feel sad for the sallow-faced, hungry people, or laugh at Derain's overblown self-image.

He made many paintings of the landscape around his house in Provence. Derain's twisted olive trees and golden ochre hills don't have much in common with Cézanne. They are more a symbolist take on nature, expressionistic, a bit tortured looking.

Painting is hard work – a serious business. I think Derain made great paintings that feel especially relevant today. They are full of contradiction and a raging desire to be taken (loved) on their own terms. I especially love his dirty whites – the white with grey or brown dragged in, which makes the shape of a napkin or scarf – that seem as if cut from plaster, a scraped-down fragment.

David Salle lives and works in Brooklyn, New York.

JULIÃO SARMENTO
Portuguese, b. 1948

ON

EUGÈNE DELACROIX
French, 1798–1863

EUGÈNE DELACROIX

Louis d'Orleans Showing His Mistress
1825–26
Oil on canvas
35 × 25.5 cm (13 ¾ × 10 in.)
Museo Thyssen-Bornemisza,
Madrid

The room is dark. One can barely make out the contours of the space. The bed is unmade, the sheets are crumpled. A naked, pale woman lies on the bed in the centre of the image. The light that comes directly from the left creates an eerie scene. A young man, Louis d'Orleans we are told, sits on the upper part of the bed on the right-hand side of the picture. He is holding up a sheet, allowing the lower part of the woman's body to be indecently exposed. Her head is resting on a white pillow that lies on Louis's lap. Abandoned. Standing on the left-hand side of the painting, with his right thumb resting on his belt, is another gentleman, who looks down at the woman revealed before him. He does not look directly in her eyes because her head is completely covered, hidden, behind the sheet that her lover (or her master, perhaps) is holding up. Is his gaze an act of mere curiosity or one of contempt? Is the act of the man showing off his lover a vile betrayal or is it an act of magnificent offering? Is the woman a trophy? Or a wounded animal, a beautiful object of pleasure to be seen and appreciated by both men?

To me, Delacroix has painted *Louis d'Orleans Showing His Mistress* to make it look as if the canvas has been torn – slashed from the bottom to the centre of the picture – as if a violent stroke had travelled across the surface of the painting. This is a painterly depiction of verticality at its best. The woman's body is perfectly divided into two parts. In her lower part she is anonymous, indecent, exposed, offered. In her upper body she is hidden, bashful and fragile. Yet this woman, who seems the most fragile of the characters in this scene, is in fact the most powerful. She has an incredible capacity to let herself go, to be manipulated by others while still maintaining absolute control. She may seem helpless, she may seem owned and she may seem lost. However, she determines the actions of the two men on either side of her. She rules their thoughts and their actions. She becomes their master.

To be honest, I was never very much interested either in Delacroix's work or in his mellow romanticism or extravagant Orientalism. I don't care for his expressive brushstrokes, or for his indebtedness to Rubens. I don't particularly like the feeble, almost feminine way his brushstrokes adorn the canvas. However, this tiny little painting has haunted me ever since I first saw it many years ago at the Thyssen-Bornemisza Museum in Madrid. It allows me to breathe when I am breathless, allows me to rediscover the mysteries of seduction and the audacity in painting. And it makes me mad and envious because I wish I had painted it myself.

Julião Sarmento lives and works in Estoril, Portugal.

WILHELM SASNAL

Polish, b. 1972

ON

GEORGES SEURAT

French, 1859–1891

GEORGES SEURAT (ABOVE)

Bathers at Asnières
1884
Oil on canvas
201 × 300 cm (79 ⅛ × 118 ⅛ in.)
The National Gallery, London

WILHELM SASNAL (BELOW)

Bathers at Asnières
2010
Oil on canvas
160 × 120 cm (63 × 47 ¼ in.)

Wilhelm Sasnal lives and works in Kraków.

This painting has a lot to do with my past. I was born in a place called Tarnów in Poland, which had a large chemical factory that had been established between the First and Second World Wars. The factory was near a river where many people from the surrounding area would come at the weekend to swim, or sit on the bank. Two of those people were my grandparents. My grandmother told me many stories about my grandfather, and about this place. They used to go to the river just before the outbreak of the Second World War. One afternoon, when he was swimming, my grandfather was sucked under the water by a strong whirlpool current. He didn't drown though, because he knew that if he waited until his body sank down to the bottom he could push himself up and out of the current with his feet. So, in my mind, this painting has become like an homage to my grandparents, and to the place where I was born. In some ways, it is therefore what my very being is built on.

This has been my favourite painting for a long time. When I saw it for the first time, in a book when I was sixteen, it stayed with me and it grew to have this immense importance. I remember that I was preparing for my exams, and I would sit in the park and make drawings of the trees and shadows and the lights based on Seurat's work.

I like many of Seurat's paintings, but I like *Bathers at Asnières* the most. Many people describe it as being a peaceful picture – an image about holidays, sunshine and relaxation. For me, however, it is a very bleak painting. The characters are ugly and drained of anything positive. Everybody's lonely; each person is separated. I also feel a sense of foreboding when I look at this picture, of something bad about to arrive over the horizon. But perhaps that is because it reminds me of my grandparents bathing in that summer of 1939.

Many years later, however, when I went with my son to see the real painting in the National Gallery in London it was a disappointing experience. It looked like a very elaborate work that had been painted to *look* like a masterpiece. It is more magical when you see *Bathers at Asnières* in a book. For me this picture is all about the mood and the atmosphere. Seurat worked with the air.

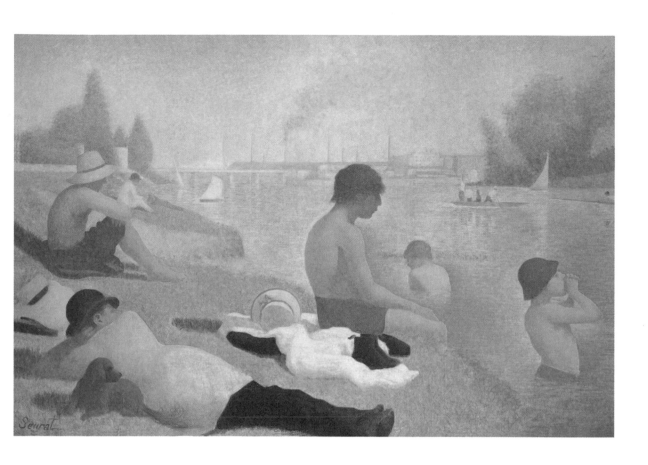

THOMAS SCHEIBITZ
German, b. 1968

ON

EL GRECO
Greek, 1541–1614

EL GRECO (OPPOSITE)

The Repentant Magdalene
c. 1577
Oil on canvas
108 × 101.3 cm (42 ½ × 39 ⅞ in.)
Worcester Art Museum,
Massachusetts

EL GRECO (PAGE 150)

The Repentant Magdalene
c. 1587–96
Oil on canvas
109 × 96 cm (43 × 37 ¾ in.)
Museu Nacional d'Art de Catalunya,
Museu Cau Ferrat, Sitges

EL GRECO (PAGE 151)

St Mary Magdalene
c. 1580
Oil on canvas
156.5 × 121 cm (61 ⅝ × 47 ⅝ in.)
Museum of Fine Arts, Budapest

I first came across El Greco in 1992 in a bookshop in Dresden, where I found a nice old book about the artist, with black-and-white reproductions. In my opinion, El Greco is one of the most radical painters in the history of art to exploit the human figure. What is it about his work that appeals to me? El Greco shows rather than tells, which is one thing I would like to achieve in my own work. He was a travelling exile who crossed the world, as one writer put it, 'on the ship of ambiguity'. In El Greco's work, abstraction and figuration are equally developed veins running through all his paintings.

In the book *El Greco & Fernando Arrabal*, the Spanish-born playwright Fernando Arrabal recalls a conversation he had with Andy Warhol in 1982, where the artist said that El Greco had succeeded in inverting the relationship between man and art. This was clearly something Warhol himself also wanted to achieve. The twentieth-century French writer and filmmaker Jean Cocteau, on the other hand, described El Greco as an erotic geometrician: someone who changed the meaning of human relationships, upset the rational order of the world, reversed traditional roles, transformed the whole into nothing and nothing into the whole. I agree with all these statements.

El Greco painted five versions of St Mary Magdalene: *The Repentant Magdalene* (*c.* 1577); *St Mary Magdalene* (*c.* 1580); *The Penitent Magdalene* (*c.* 1580–85); *The Repentant Magdalene* (*c.* 1587–96); and *St Mary Magdalene in Penitence* (1607). All five paintings depict a curiously erotic, illuminated state of transfiguration, whereby Mary conveys a sense of reluctant belief. The objects in the background occupy the same pictorial plane as the foreground, and have a chilled, frozen appearance. The cold, delineating white of the oil colour palette has – from a modern perspective – that reassuring artificiality which passes the narrative or religious aspects of the image back to the viewer, who can contemplate and comprehend the painting today without necessarily knowing Mary Magdalene's story. The paintings make you feel that you should go up to her and tell her not to abandon herself to the gruelling process of transfiguration. She seems too beautiful to be determined by an external force.

As in most of El Greco's paintings, diverse, atmospheric, painted white accents may be described as edge lights, like neon strip lights, that outline and permeate the colour palette, illuminating the fabrics, plants, clouds and skin from behind, as if they showed a stilled frame of a projected film.

I wonder if El Greco approached this subject from a religious point of view or in an effort to make a personal statement? Modern myths and esoteric lore about Mary Magdalene continue to blur her story. She was widely considered to be a prostitute, a sinner, and possibly Jesus' lover, who was fed by angels and thus needed no earthly nourishment. In 1578 El Greco fathered a son by a young aristocratic woman whom he never

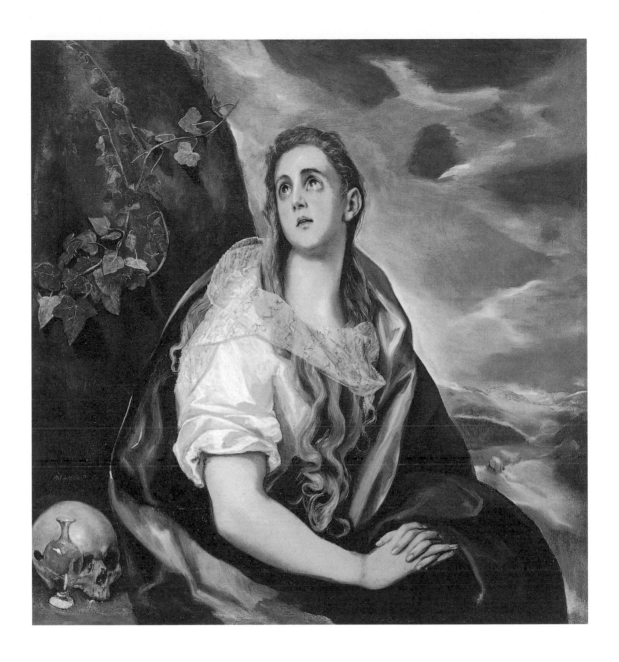

married, and he also (allegedly) had a male lover. Do these circumstances explain some of the force behind El Greco's paintings?

El Greco's settings and protagonists – unfamiliar to the patrons of his day – point the way towards a new world. Here, the painted objects and surfaces appear at once both soft and hard. Mary's robes look as hard as metal, the skin resembles light-coloured wood and her eyes are like large glass balls. At the same time everything is smoothly merged with the surroundings. The painted sky and clouds seem very close, as if an illuminated curtain has managed to hold itself up for the moment but is just about to fall.

In all five versions of the painting, Mary Magdalene appears to be barely twenty years old, which seems a remarkably young age to have experienced all the things described in the historical texts. Perhaps she is a representative figure whose task is to show rather than tell us a timeless story, which in my view is the greatest (and most enduring) artistic achievement of any work.

Thomas Scheibitz lives and works in Berlin.

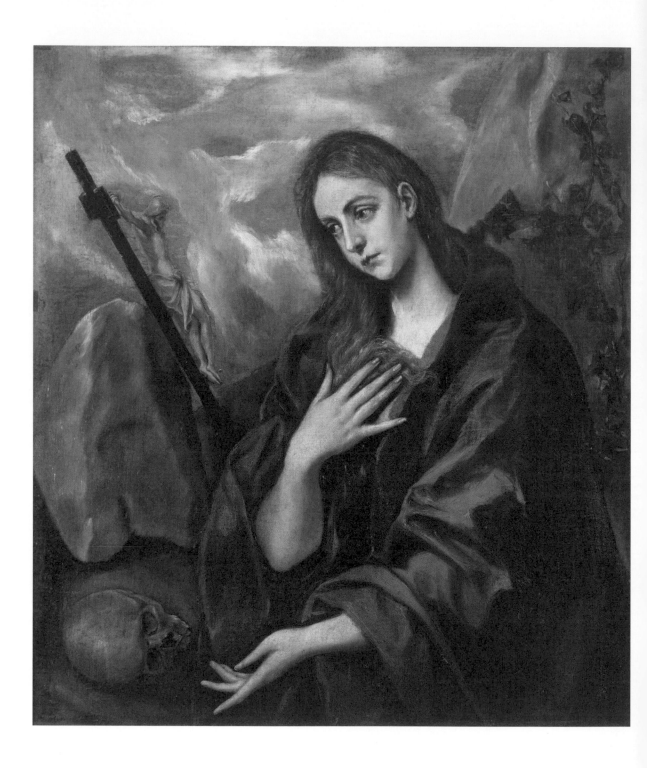

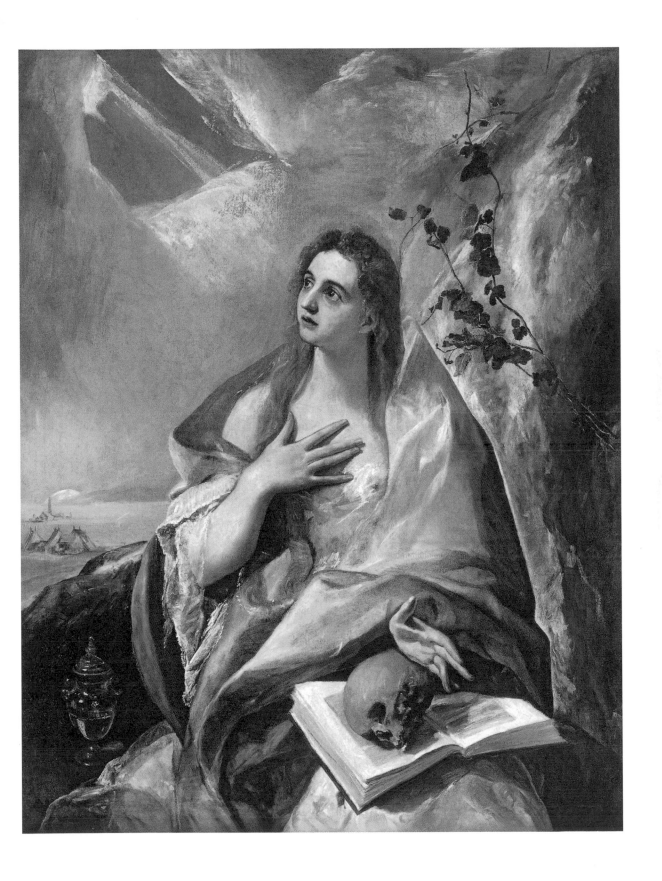

ROMAN SIGNER

Swiss, b. 1938

ON

LEE FRIEDLANDER

American, b. 1934

LEE FRIEDLANDER

Shadow – New York City
1966
Gelatin silver print
15.8 × 23.9 cm (6 ¼ × 9 ½ in.)
San Francisco Museum of
Modern Art

Roman Signer lives and
works in St Gallen, Switzerland.

I have known this photograph by Lee Friedlander for a long time. I think I first saw it in the 1980s in a book on photography; it fascinated me right away. It is rather like a photograph within a photograph, if you consider how the light forms an image on the woman's back. I imagined how the light itself could create a picture if the woman had a photosensitive film on her coat, creating a white figure that looked like an angel. On the other hand, the situation feels almost uncanny. The man behind her might not be an angel but a persecutor.

I don't know if the woman in the picture noticed that she was being photographed; probably not. I have imagined where the photograph was taken, maybe during wintertime on Fifth Avenue. I would have loved to see how Friedlander took this image. It shows a spatial and temporal happening, like a sculpture. It is a conceptual photograph.

I don't think that Friedlander has influenced my work directly but I appreciate his work as a photographer and an artist.

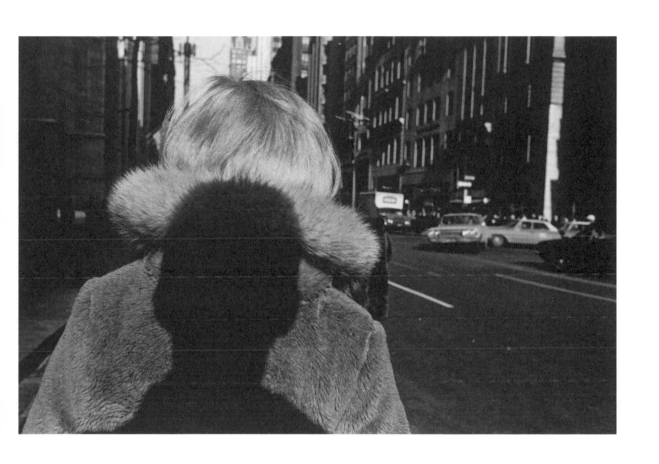

JOHN STEZAKER

British, b. 1949

ON

PHILIPP OTTO RUNGE

German, 1777–1810

PHILIPP OTTO RUNGE
(OPPOSITE LEFT)

Scherenschnitte:
Leaves and Firelily
Undated
Scissor-cut silhouette on black paper
65 × 50 cm (25 ½ × 19 ¾ in.)
Hamburger Kunsthalle, Hamburg

JOHN STEZAKER
(OPPOSITE RIGHT)

Recto-Verso
1980
Collage
45 × 35 cm (17 ½ × 13 ¾ in.)

John Stezaker lives and
works in London.

I became aware of German Romantic art through my interest in William Blake, and first came across one of Philipp Otto Runge's *Scherenschnitte* (scissor cuts) in the mid 1970s while reading Rudolf Bisanz's study of the artist.

The art of *Scherenschnitte*, cutting paper into silhouette designs, was established in Germany in the sixteenth century. Runge's plant silhouettes are inversions of the portrait tradition, not only tonally, but also in the way they are experienced. They are pure optical presences, offering a dazzling blindness. Set against the darkness of the ground, the white shapes have the effect of defamiliarizing the plant by reducing it to pure contour. There is a delay in recognition, as if this compression to flat shadow has suspended legibility, only for the plant-figure to reveal itself anew as a luminous after-image.

This tonal reversal suited Runge's mysticism, imbuing the silhouetted foliage with an incandescent presence. I can imagine Runge seeing a spiritual dimension to this release from the body: the living flower cut and sacrificed for its shadow, through which it takes on an eternal (after) life as an image. To contemporary viewers, brought up in a culture of photography, Runge's silhouettes resemble over-exposed negatives or contact prints. For Runge, however, they would have been magical ways of converting shadow into light, of preserving the contours of plants as luminous ghosts.

Runge's shadows seem to be free of the mournful associations of the silhouette portrait. His plant cut-outs are radiant with life. The reversal of light and dark is not thought to be Runge's innovation, but a convention adopted from a folk tradition of botanical *Scherenschnitte* that he learned from his mother. What I believe Runge discovered in that tradition was the magic potential of the image to restore life – his versions celebrate the metamorphic power of the cut contour to give life to shadows, alchemically transforming leaves of paper into paper leaves, while returning paper to its origin as vegetation. The aliveness of the *Scherenschnitte*, however, is not only a naturalistic restoration of the living contours of vegetation: the cut contours of the silhouette have a quality that seems to animate the plant.

I believe these collages were a first glimpse for Runge of a practice of art dedicated to a revelation of the unseen dimension of living things through the undeviating naturalistic mode of representation. In his short career, I don't think he ever found again that space of reconciliation of the detail with the overall composition, or that ambiguous sense of both stillness and reverberation, which he first discovered in the *Scherenschnitte*. I have been fascinated by this unlikely beginning of the collage tradition.

HIROSHI SUGIMOTO

Japanese, b. 1948

ON

PETRUS CHRISTUS

Netherlandish, active by 1444, died 1475/76

PETRUS CHRISTUS

Portrait of a Young Lady
c. 1470
Oil on panel
29.1 × 22.7 cm (11 ½ × 9 in.)
Gemäldegalerie, Berlin

When people call me a photographer I always feel like something of a charlatan – at least in Japanese. The word *shashin*, for photograph, combines the characters *sha*, meaning to reflect or copy, and *shin*, meaning truth, hence the photographer seems to entertain grand delusions of portraying truth.

The invention of photography by William Henry Fox Talbot was announced in 1839, and the medium first came to Japan in the late Edo period (1603–1868). But long before this, artists strove to portray truth, at times employing optical devices, such as the camera obscura, to capture layers of detail seemingly imperceptible to the human eye.

Take this *Portrait of a Young Lady* by the northern Renaissance painter Petrus Christus. The girl with the fox-like eyes, her pose slightly askew, appears to be staring at the viewer. I chanced upon this work, on loan from the Gemäldegalerie in Berlin, at the Metropolitan Museum of Art in 1994, and felt myself pinned to the spot in the thrall of her piercing gaze. Although no outstanding beauty, the young court lady was suffused with a refined aristocratic air, and I stared back. There was no winning this stare-down, of course; my sparring partner was sure of herself and never averted her eyes.

Instead, I broke away from her gaze and was immediately drawn to other details of the tiny painting, which is less than 30 centimetres square. The collar around her neck was adorned with pearls, each tinted in rainbow hues and highlighted by a dot of white – all within a 2-millimetre diameter. The oblique illumination seemed to come through a window somewhere to the upper left, which I could even make out reflected in those highlights. I almost felt that if I looked hard enough I would see the whole room reflected in each lustrous sphere. So convincing was the illusion, I swore I saw things that couldn't possibly be painted inside a 2-millimetre circle. And it wasn't just the pearls: the young woman's ornamental silver hair band, the minute fabric folds of her clothing, and especially the gleam in her eyes all seemed infinitely detailed. Her clear, porcelain-white complexion crazed in fine cracks evinced the travails of time, yet her unaffected gaze met my focus across five centuries.

I went to see this painting every Sunday morning throughout the exhibition. The gallery was quiet and sparsely attended, allowing me to stand right in front of the painting with no protective glass between us, and I would peer at the image to see everything there was to see. But still there was no end to it. Here in this tiny picture I'd found the perfect realization of the idiom 'God is in the details'.

As one whose fixation on details runs to the pathological, I appreciate this all too well. I use an outdated large-format plate camera for the very reason that the image in silver halide photography is made up of silver particles. Hence photos taken on small film show as much grain as pointillist

paintings, whereas large-format photographs can provide infinite detail.

In my seascapes, for instance, the viewer's gaze drifts over an undulating expanse of nothing-to-see until suddenly a wave comes into focus, which, on closer inspection, pulses with lesser emerging and dissipating wavelets. Then, pushing the very limits of vision, the human eye strains to discern even finer silver particles. Imperceptibly, the silver particles become particles of light, penetrate the thin paper surface, and pass through to the other side. Then they merge, quiet and calm, with the infinitesimally rich totality of the world. I find that delving into such detail requires the kind of immaculate tonalities only an old-fashioned large-format plate camera can deliver. There is no room for God in digital technologies that reduce everything to 0 and 1.

I believe Flemish painting's peculiar obsession with detail to have been one of the driving factors behind the invention of photography some three hundred years later. Curiously enough, this girl in the Petrus Christus portrait is reputed to have been a member of the English Talbot family. This is a most significant inner secret for me as this image is part of a subtle circuitous link via William Henry Fox Talbot (were they related?), the inventor of modern photography, to my own work.

Hiroshi Sugimoto lives and works in New York and Tokyo.

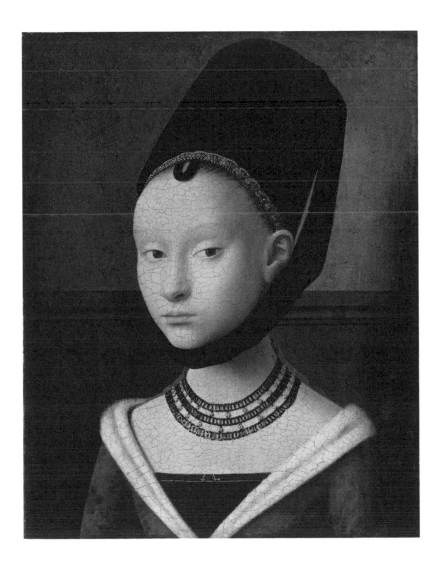

HIROSHI SUGIMOTO

Caribbean Sea, Jamaica
1980
Gelatin silver print
119.3 × 149.2 cm (47 × 58 ¾ in.)

HIROSHI SUGIMOTO

Ligurian Sea, Saviore
1993
Gelatin silver print
119.3 × 149.2 cm (47 × 58 ¾ in.)

DO HO SUH
Korean, b. 1962

ON

KIM JEONG-HUI
Korean, 1786–1856

KIM JEONG-HUI (BELOW)

Landscape in Winter
Joseon period, 1844
Handscroll, ink on rice paper
23.7 × 89 cm (9 ¼ × 35 in.)
Private collection

DO HO SUH (OPPOSITE)

*Seoul Home/L.A. Home/New York
Home/Baltimore Home/London Home/
Seattle Home/L.A. Home*
1999
Silk and aluminium pipe
378.5 × 609.6 × 609.6 cm (149 ×
240 × 240 in.)
The Museum of Contemporary Art,
Los Angeles

I have a very personal relationship with the painting *Landscape in Winter* by Kim Jeong-hui – it relates to my work and my desire to create the perfect home. It was made during a period of exile for the artist, though it is now very famous; in fact it is official National Treasure No. 180, as assigned by the Korean Cultural Heritage Administration.

Kim Jeong-hui was a scholar and civil minister during the Choson Dynasty (1392–1910) in Korea. He was also a famous calligrapher, known for inventing his own style of writing. During his life, however, he was exiled to Jeju-do, a remote island located off the southern coast of Korea.

This painting is of a small house with red pine trees on the right and Korean pine trees on the left. In Asia, pine trees are one of the four symbols of loyalty and dignity. They symbolize the uncompromising spirit of the scholar. Kim had a student named Lee Sang-jeok who visited him during his period of isolation, even travelling to China to obtain rare books for him. When Lee visited Kim, Kim had no prominence and no reputation, yet his student was loyal and faithful to him during this difficult period. Kim wanted to show his loyalty and gratitude to his student by giving him this painting.

The poem written on the left is by Confucius, which says that when the seasons change from autumn to winter, the trees lose their leaves, but the pine tree never changes. Only through the change of seasons do you see the strength and loyalty of the pine tree.

When I was a painting student in Korea, I studied Kim's paintings and calligraphy. This painting expresses his feelings about the relationship with his loyal pupil in such a minimal way. Because he was such a great calligrapher, his brushstrokes have an amazing quality, which is exhibited in all of his paintings. The Chinese and Japanese worshipped his calligraphy.

For a time, one of Lee Sang-jeok's students had possession of this painting. Eventually a Japanese scholar and professor named Fujizuka, who

lived in Korea during the Japanese occupation, obtained this painting. He had an extensive collection of work by Kim Jeong-hui, which he collected during his time in Korea and took back with him to Japan before the end of World War II. (Many Korean treasures were looted over the years, particularly during the Japanese occupation.) Later, another famous Korean calligrapher named Son Jae-hyung went to Japan to look for this particular painting and brought it back to Korea. Shortly thereafter, the Americans bombed Tokyo, and Fujizuka's entire collection was destroyed.

Son was a teacher of my father, Suh Se-ok. In the 1960s, Son built a traditional house in Seoul, using timber that had been dismantled from the ancient Gyeongbok Palace. My father bought some wood from him to build our own traditional house. I remember visiting him when I was around seven years old to collect the timber.

I am very interested in the life of this painting – its journey from Korea to Japan and back to Korea. I am drawn to the fate (*inyeon*) that connects Kim, Lee, Fujizuka, Son, my father and me. Kim used the fewest number of lines in the house to depict his solitude and loneliness. This has always resonated with me. The house is not elaborated upon: it is very minimal and stoic.

Do Ho Suh lives and works in New York, London and Seoul.

PHILIP TAAFFE

American, b. 1955

ON

RAOUL DUFY

French, 1877–1953

RAOUL DUFY

Palais de la Bahia à Marrakech
1926
Watercolour on paper
50 × 64 cm (19 ¾ × 25 ¼ in.)
Collection of Philip Taaffe,
New York

*Philip Taaffe lives and
works in New York.*

What amazes me about Raoul Dufy's paintings is how well integrated they are compositionally, and how they convey with great economy such a strong sense of light and temperature and geographical place. His efforts are thrilling. He demonstrates an on-going, never-ending *will to be there* through his relentless urge to depict. The pictures have an emotional tenor about them; there is a powerful feeling of the moment – of lived and recorded time.

I appreciate the way Dufy constructs his pictures from generalized atmospheric indications – those 'peremptory patches of colour' in Colette's words – to the more specific, idiosyncratic renderings of figurative detail. His sense of scale is superb. His use of colour is as exuberant as it is extremely thoughtful and sensitively deployed. It is, after all, an expression of his profound search for light.

Dufy paints as though he were wielding a conductor's baton – one is immediately taken by the spontaneity and splendidness of his orchestration. Through a combination of speed and sustained observation, he achieves what I would call a refracted scenography that seems effortless and definitive at the same time. There is always something life-affirming and celebratory in everything Dufy does. He is an artist of acute visual intelligence.

In Dufy's painting, I experience the sense that his artistic style was almost historically inevitable. Dufy's early inclinations towards Fauvism are one thing. But it is quite another thing for him to have evolved a bold and elegant style out of such shorthand descriptive nonchalance. It is as though he has internalized the Fauvist approach to such a degree that it has become a diaristic method.

I think Dufy's intensive collaboration with French fashion designer Paul Poiret, beginning around 1911, is very significant. As a result of his success designing block-printed textiles for Poiret, Dufy established a studio in the Impasse de Guelma, near the Place Pigalle, which he kept for the remainder of his life. I believe Dufy saw this involvement with Poiret as a clear way forward, enabling him to become the artist he truly was.

TAL R

Danish, b. 1967

ON

HENRI ROUSSEAU

French, 1844–1910

HENRI ROUSSEAU (ABOVE)

Old Junier's Cart
1908
Oil on canvas
97 × 129 cm (38 ¼ × 50 ¾ in.)
Musée de l'Orangerie, Paris

TAL R (BELOW)

Girl in Wagon
2008
Oil on canvas
185 × 185 cm (72 ¾ x 72 ¾ in.)

This is the only work of art that I can remember enjoying when I was a teenager, and I still enjoy it now. There are many different elements in this image and it operates on so many levels. On one hand it looks like a nice Sunday family journey to the countryside, but on the other hand it has any number of possible interpretations that you can project onto it. That for me is what art is all about. You look at an image and then you 'bend' it towards your own imagination. One's own life is actually not a very suitable source for creating images. You need a bit of distance, such as somebody else's image, through which you can filter your own history, imagination and interpretation.

If you look closely at this picture, you can see that it has a host of fantastic 'mistakes'. Look at how Rousseau has painted the girl on the far left. To me she is the most interesting part. He has composed the figure out of two triangles – one for the top half of her body, another for her middle. You can see that he wanted to place the bottom triangle so much that it didn't matter that her legs are painted as an afterthought and so look a bit strange. I love this idea. It means that geometry is actually winning the game against anatomy.

Then, look at how Rousseau has placed all the figures in the small wagon. It is a physical impossibility. The image is on the verge of 'melting' like an ice cream on a summer day. It doesn't really work. You can only describe these kinds of things in painting. Of course, the viewer is always very polite, and so they will accept this. It is a complete reality that cannot exist, except in dreams and in painting.

The animals play a significant part in the picture, too. The big black dog is watching the little dog and might eat it. Their faces have just as much character as the people's faces do. They may be animals, but in this picture there's not a great difference between being an animal and a human being. Standing over the dogs is the master of them all – the horse with the covered eye. This horse reminds me of the film *Equus* (1977) with Richard Burton, about a boy who in a fit of rage blinds a group of horses in a stable.

In Rousseau's painting I feel a strong sense of tension – the idea that an image is just on the border of breaking. Something savage is very close. Take away the horse's eye patch and you will find that it has a big cruel eye. Or imagine if you were to describe the look of the girl in a sound. It would be an unbearable sound.

I have made several versions of this painting but have only managed to successfully draw three elements of it: the girl, a silhouette of the horse and the wheel. The girl is like a clown – not an amusing character but more like a tragi-comic figure who is there to relieve the tense atmosphere. In my version I painted her alone in the wagon. Her body is shaped like a tent, with a small upper section and a small head the size of a sad raisin. I have

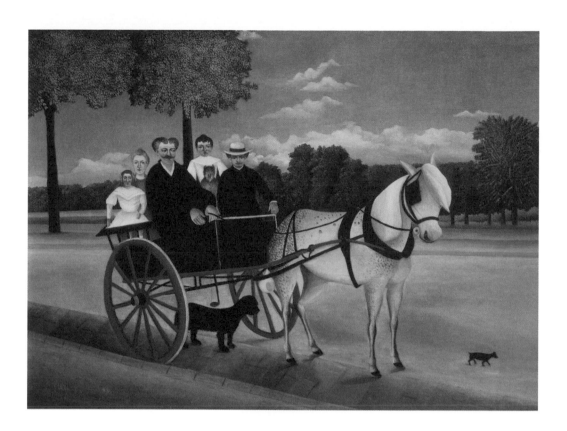

also made sculptures of her – large tent dresses with small heads. In these, one could disappear under the dress and get lost.

When I see this picture I think of the will of the father with his big hands, the father who has had a hard week, and is determined to enjoy himself on a Sunday. He puts everyone in the wagon and goes into the countryside. There is not much joy in this outing. There is a sense of unease, as if Ingmar Bergman had filmed this scene.

Tal R lives and works in Copenhagen.

RIRKRIT TIRAVANIJA

Thai, b. 1961

ON

MARCEL BROODTHAERS

Belgian, 1924–1976

My attraction to Marcel Broodthaers's *Casserole* is purely an attraction on a visceral level, inexplicable, but steeped in the knowledge that what I am looking at has a root embedded in the soul of its maker. What and why would that be important to me, the onlooker? The trap door of obscure desires waiting to cast open the curtain of doubt. Perhaps it is after the fact, distanced by time and context, distanced by histories of cultures and the possibility of misunderstanding that I should feel this thing, a thing of things, an object of objects. An obscure desire comes together in the shadow of a truth, or a dark beauty, the kind of beauty that is the opposite of what we commonly agree upon. The otherness, which I cannot place my finger on, attracts me, because it penetrates into the core of conception. There is in matter and material the answer to questions of both life and art.

This work is not what it is. It is not a pipe, nor is it the vessel of life: it is a multiple of itself. It is the sound of that other side, which we are all too

aware of, that asks the question of the everyday while answering problems of the century. Or not. But we see answers in the shadows of the moon, and we believe in the life of objects that have long surpassed their own reality. It is a casserole of mussels, in itself whole and abundant beyond capacity, beyond being contained, transgressing its container, unable to be held back from the brim, and yet, it is an empty, discarded shell of life. The question is more interesting than the answer, the quest more fulfilling than the goal.

Seeing *Casserole* today is not the same as seeing it at the time it was made, but the soul of the artist lingers. Perhaps the presence of a life lived and the process of being brings the object back to the present, back from history, and back from the shadow of the moon. As with all subjects of life, the levels and layers of one's existence are thrown into the pot, and the ebb and flow are played out, both by will and by chance. How one becomes formed and moulded is a journey to and from the sea. So, one has to ask oneself if one should continue to exist on the path to the void, or refuse and stop, as exemplified by the graffiti and a slogan written on the walls in Paris in 1968 – 'ne travaillez jamais' – around the same time as this artwork was made.

Casserole is visceral – the black on black and the forms of the crustacean are simultaneously primitive and advanced, like a time tunnel that moves backwards and forwards with the ease of a vessel designed to defy its preoccupation. Is it a sculpture or the obscure object of desire? Is it just a pot of empty mussel shells, or is it poetry found, made and choreographed, to mimic meaning in language? One thing is for certain, it is not a pipe. The question prevails in a battle between experience and meaning, sign and text. But for me it is the *bête noire* of resistance that resists easy signification, and resists the desire to become an object.

Rirkrit Tiravanija lives and works in New York.

FRED TOMASELLI
American, b. 1956

ON

AN UNKNOWN TIBETAN ARTIST
Tibetan, seventeenth century

UNKNOWN TIBETAN ARTIST

The Outer Yama Dharmaraja
Mid-seventeenth century *thangka*,
gouache on cotton
68.6 × 45.7 cm (27 × 18 in.)
The Zimmerman Family Collection

The first time I saw a Tibetan rendition of Yama, a Buddhist god of the dead, was in the early 1980s at the Los Angeles County Museum of Art. It was like a bolt of lightning that triggered my interest in the art of Tibet. In the years since, I've seen great examples in various museums around the world, including the British Museum in London and the Metropolitan Museum of Art in New York. The best and most diverse collection of Tibetan Yamas is at the Rubin Museum of Art, New York, a place I visit often.

The version that I have written about is in a private collection and can only be seen in reproduction in Robert Thurman's book *Wisdom and Compassion: The Sacred Art of Tibet*. I purchased two copies of this book about ten years ago (one for home and one for the studio), and look at them often.

There is nothing fiercer in the history of Tibetan paintings than those depicting Yama. He is the Lord of Death and King of the Law whose jobs seem to be protecting the enlightened while simultaneously guarding the gates of Hell. I've seen many depictions of Yama, but my favourite is this *thangka*, a Tibetan silk painting with embroidery, of The Outer Yama Dharmaraja, painted in central Tibet in the mid seventeenth century. This small picture roars with so much imagery that it's hard to absorb it all, unless it is slowly unpacked.

In this work, Yama is depicted as a black, three-eyed, buffalo-headed entity stomping around in a roiling mass of fire and smoke. He's crowned with skulls, decorated with human bones, and festooned with garlands of freshly severed heads. His face is contorted into a sinister, toothy laugh, and he wields a lasso in one hand and a skull club in the other. His black, red-headed penis stands erect as his three-eyed consort Yamaraja, holding a trident and straddling his leg, offers him a skull bowl sloshing with an elixir of blood. The craziest part of the picture is the green bull below the two figures, which is crushing and raping a poor person (who symbolizes ignorance) to death. This whole twisted scene is being watched over by an army of yellow-haired demon minions wearing the bloody skins of wild animals. Some of the demons at the bottom of the picture are dancing and dragging little white humans to their doom. Others seem content to act in menacing ways or ride around on donkeys carrying bags of loot. But at the very top centre of the picture – in an oasis of peace and tranquillity – is an image of the second Buddha, Tsongkhapa, who remains above and apart from the mayhem below.

It has been said that this and other black *thangkas* are particularly powerful. I've looked at some of them for hours and can never get to the bottom of these images before they overwhelm me. Sometimes they seem like glimpses into a trippy parallel reality that new-age hippies like to

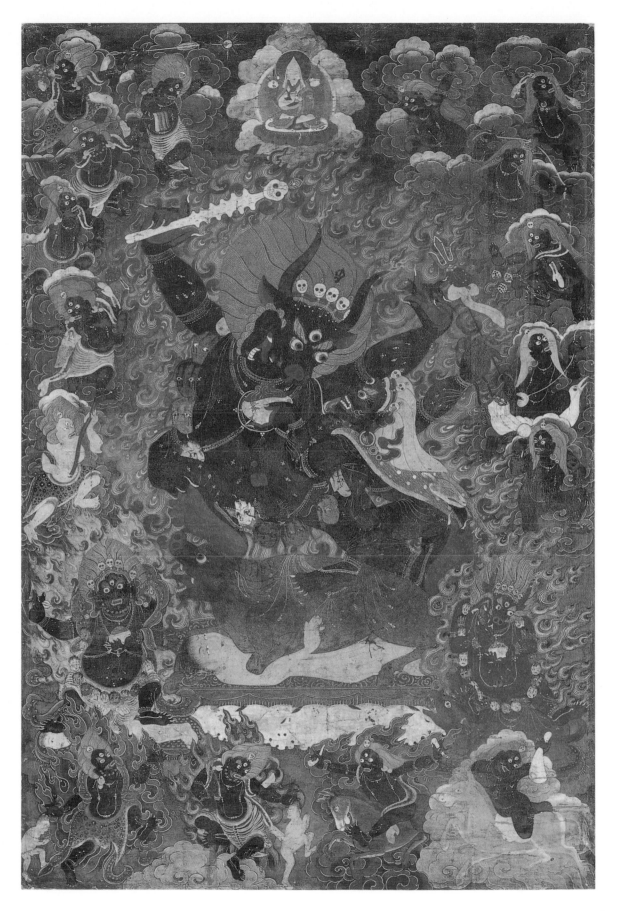

*Fred Tomaselli lives and
works in Brooklyn, New York.*

talk about. Sometimes the *thangkas* seem almost comedic, like the hyper-stylized, violent, adolescent fantasies of metal dudes, stoners and bikers. Whatever cultural context you see them in, these images evoke a conflicted world, while simultaneously being otherworldly. Though exaggerated to hallucinogenic intensity, the commingling of sex, death, savagery, tranquillity and beauty seems to sum up the human condition. The painting appears to be saying that, although we live in a world of endless war and unspeakable cruelty, it is still possible to find the luminous and the peaceful.

I've gone back to this and other Tibetan *thangkas* for inspiration in my own work. Garlands of severed body parts, for instance, have appeared in some of my more abstract works, such as *Gravity's Rainbow* (1999) and *Echo, Wow and Flutter* (2000). I've also mixed these dark Tibetan influences with those of the mannerist painter Arcimboldo, and the gothic sensibilities found in the Anthology of American Folk Music, to make figurative pictures that ruminate on death and mortality. The funny thing is that imagery associated with Yama is supposed to help the viewer get beyond ignorance and the fear of pain and death. I'm not sure it has worked for me that way, but I'm a godless atheist, so what do I know?

But perhaps their influence on me is more general. Across many Asian cultures one sees the same imagery and scenarios depicted time and time again. This repetition speaks to the idea that human culture is an inherently collective enterprise, entirely different from the modernist Western ideal of the artist as rugged individualist. As a collagist who recontextualizes the imagery of thousands of other creators, I can't help but feel a kinship with this pre-modern way of looking at culture. Maybe I'm merely the conductor of a sample choir that sings through space and time. But as long as I have images like Yama to contend with, things should stay interesting.

BILL VIOLA
American, b. 1951

ON

GIOVANNI BELLINI
Venetian, active 1459, died 1516

GIOVANNI BELLINI

The Dead Christ Supported by Angels
1465–70
Tempera and oil on wood
94.6 × 71.8 cm (37 ¼ × 28 ¼ in.)
The National Gallery, London

The path to the understanding and appreciation of the art of the Old Masters was gradual and protracted for me. Immersed in the new world of electronic media as an art student in the early 1970s, the past seemed what it sounded like – old, dusty, and moribund. Had I understood that I was participating in the early stages of a New Renaissance, a digital 'Vita Nova' as radical and profound as the original, I might have sooner recognized the contemporary connections to the alternating streams of cultural innovation and conservative tradition that continually flow through history. However, the hidden blessing in my slow progress was that it allowed me the time to study the artistic and spiritual traditions of Asia and the Middle East, an infusion that has affected my work profoundly.

I discovered the Bellini painting *The Dead Christ Supported by Angels* in the Sainsbury Wing of the National Gallery, London, on a weekday morning back in the late 1990s. My father had recently been diagnosed with colon cancer, and my family was under stress. My emotions were raw. The galleries were practically empty as I walked silently through them. I could almost hear the pictures speaking. Then I came across Bellini's picture. A slumped male figure, his torso wounded, apparently dead, with blood dripping from his hand and ribs, his fingers curled in rigor mortis. Leaning on a marble surface, set against the black void of non-being, the body is supported by two young angels, sorrow and despair visible on their faces.

I lost my composure and began weeping, looking around to make sure no one was watching. Afterwards I felt liberated. I think it was because of the angels who were about to lift Christ up to heaven. They seemed too small and delicate for such a task, and my first inclination was to call for help. However, suddenly I knew that they could do it on their own. I felt a wave of relief, and intuitively knew somehow that my father, even though he was dying, would be taken care of.

Several years later, when I was mounting my solo exhibition 'The Passions' at the same museum, I selected this Bellini image as part of a grouping of seven paintings and objects from East and West that had influenced my work. Again, I looked deeply into Bellini's small masterpiece and, despite its graphic subject matter, the reasons why it had singled me out became clear.

I find an affirmation of life in this image.

Support – Comfort – Caring – Faith.
Inner Strength – Life Sustaining – Vital Breath.
Surrender – Letting Go – Liberation.

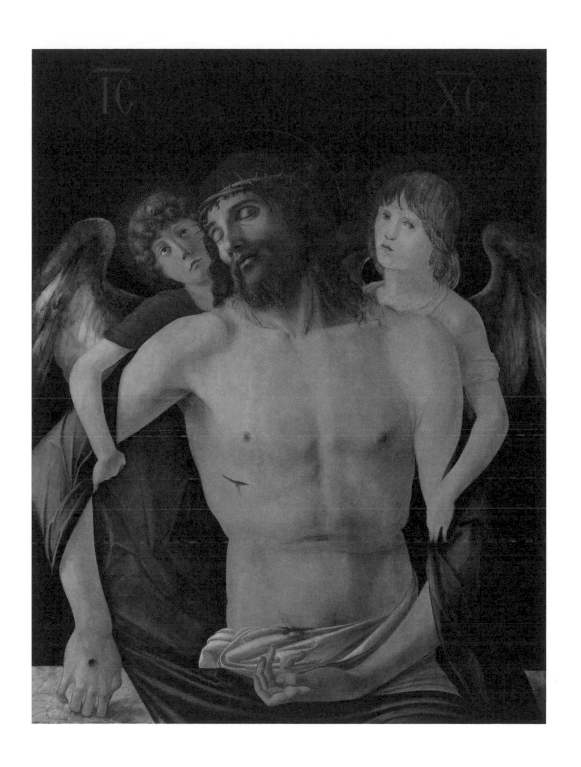

BILL VIOLA

Emergence
2002
Colour high-definition video
rear projection mounted on wall
in dark room
Projected image size 200 × 200 cm
(78 ¾ × 78 ¾ in); room dimensions
variable

There is a deeply embedded human longing to seek comfort in the arms of another, and an equally deep reciprocal desire to help bear the burden for others. The angels remind us of the sacred character of both of these acts.

As anyone who tries to lift the limp body of an adult discovers, the human body becomes heavier when conscious awareness is not present. From this observation arise both the term 'dead weight' and the idea of the inherent lightness of being. Consciousness, or sentience, cannot be empirically measured, nor can it be wholly contained within the body. Bellini's image depicts the delicate, most precious moment when the dark inertia of the human body is about to be uplifted to the light, 'enlightened', and transported towards transcendence and resurrection.

Once the divine nature of the human being is fully realized, the body is no longer required. The thirteenth-century Sufi poet and mystic Rumi compared the inner development of a human life to a bowl floating on a great ocean: empty at first, over a lifetime the bowl is gradually filled with the ocean's water of knowledge and experience. When it is finally full, the water held inside merges with the water outside, returning to its source. The bowl is rendered meaningless and silently drops away.

In 2008 I presented a large exhibition of my work in Rome at the Pallazzo delle Esposizione. At the same time, there was a Bellini exhibition nearby. After I saw the exhibition, I wrote the following letter to Giovanni Bellini at the invitation of the newspaper *La Republica*:

Dear Giovanni Bellini,

I saw your paintings at the Scuderie today and I was deeply moved and inspired. You bring figures to life with such delicate and sensual light. Your subtle colors awaken our emotions. Your eye has a compassionate, almost feminine gaze, gently caressing flesh and stone alike. Five hundred years after you made these pieces, I stand here humbled and in awe. As an artist I have many questions for you about your work.

In the faces of some of your Madonnas I have seen the softest play of light and shadow, yet the trees behind her remain sharp and clear. How could you have anticipated these same techniques in the cinema of today – soft filters for close ups of the face, and sharp focus for trees and landscapes. The distance in time between us suddenly disappeared.

How do you manage to paint the physical world so accurately and realistically and yet have it invested with such spiritual power? Is this just a challenge for your artistic abilities or is it the expression of your belief that in the eye of God everything is sacred? I would like to know, when you were painting the wounds of Christ, did the red liquid paint ever spill onto your hands or feet? Did you ever cry when you painted the tears of Mary or of Saint John? One of your last paintings was a portrait of Christ looking directly into our eyes. As you were making these last images in your studio did you feel that God was with you, that you were seeing and being seen by God?

Now that you are gone from this earth what images are you seeing now?

With deepest respect,
Bill Viola

Bill Viola lives and works in Long Beach, California. I am still waiting for a reply.

WOLS

Untitled (Kidneys)
c. 1938–39
Vintage gelatin silver print
23.3 × 18.2 cm (9 ¼ × 7 ¼ in.)
Galerie Berinson, Berlin

The first thing you recognize in Wols's photographs is his unpressured technique. It is so distinct from other photographic tendencies of his time, such as the technical emphasis of the Bauhaus photographers or the *pompier* perfectionism of Man Ray. There is, however, a refinement in Wols's roughness – a kind of elegant and knowing rusticity. I take that as a sign of emancipation, and I see it in the work of one of his precursors, Heinrich Zille, and then in the important and under-appreciated photographs Raoul Hausmann made in Ibiza in the early 1930s. Wols's style, like Hausmann's, expresses a dissent from some of the new conventions of avant-garde photography, as they were articulated in the 1920s and 1930s.

Stylistically, Wols's pictures have connections to the intensified apperception of the object by surrealist photographers like Raoul Ubac and Jacques-André Boiffard, and the emerging neo-realism of the contemporary French cinema in the work of Jean Renoir and Jean Vigo. The casualness of the picture is fused with an urgency, a caustic angry feeling that relates also to the new social and cultural mood identified with the writings of Antonin Artaud and Georges Bataille in the 1930s and 1940s, and then Jean Genet's work in the 1940s and 1950s. The images are connected also to the tone of Heidegger's writing of the inter-war period, philosophies that influenced Jean-Paul Sartre, a protector of Wols, and others during the Second World War.

To me, Wols's work feels seeped in the atmosphere of defeat, occupation, resistance and collaboration that dominated culture in France after 1940, but which Wols anticipated during the era of the Popular Front and the salad days of Fascism both in France and Germany. The pictures are emblems of that period, when all basic relationships were at stake and had to be microscopically re-examined.

The freedom of Wols's work from generic identities of photography of the 1920s and 1930s is evident in the scientific, almost forensic, nature of his pictures of foodstuffs, which are no longer 'still lifes'. This is an extension or intensification of the avant-garde idea of 'making strange' through the viewing of the 'near at hand', a concept important to the philosophies of Heidegger and Ernst Bloch. Wols reduces the necessities of photography to a space, a light, a camera and a subject, and frequently that subject is the thing that Wols, as predator, as ruler of the food chain, is obliged to consume: beans, sausages, sardines, bread, rabbits. The pictures are a study of his own inextinguishable needs as a member of the dominant species. They are Heideggerian also in that they are shaped by Wols's interest in the Tao: the enigma of the Way, of Desire, and of the All, which can be an expression of either humility or unconstrained cruelty, or both at the

same moment, and which must flicker in the consciousness of the dominant animal being.

Wols consciously cultivated his identity as sacrificial victim, but his acceptance and elaboration of this role is morally free of simple identification with the humble, the humiliated or the victimized, as the photographs' own propensity to harshness – which can be felt in the style and technique – recognizes itself as an inevitable identification with the aggressor, the predator. We see this in the images themselves, but also in the scratches and marks on Wols's prints, which seem to have been clawed by an animal.

Wols's famous self-image as a *photographe maudit* indicates that he made, or remade, himself as an 'exemplary victim' in the spirit of Artaud, in order to see things and people as if he were too weak to make any use of them. This is expressed in his aphorism:

> Man sees all things in terms of man's own interest
> this is why he does not understand things in themselves
> he is useless to nature
> he makes use of it and is unable
> to be of the slightest use to her

But Wols was also a bad-tempered and raging lawbreaker in the spirit of Rimbaud, Lautréaumont and Genet: the 'hero' who steps away from the crowd, searching for what he called a 'zero rating'. But even as he plays the hero, Wols recognizes that he cannot absolutely step outside the human drive for dominance; he remains a destroyer, an eater, and a member of the crowd, all the while longing for isolation from all forms of instrumentalism, all means of devouring and dominating. As he says in his aphorism of the rocks:

> The rocks, despite their fragility
> can teach us
> how fragile we are

The two stones in this exquisite composition, comparable to sixteenth-century Zen painting or to the rock garden at Ryoanji in Kyoto, could have once been thrown at Wols – or he could be saving them for a moment when he might need to throw them.

Jeff Wall lives and works
in Vancouver, British Columbia.

MARK WALLINGER

British, b. 1959

ON

DIEGO VELÁZQUEZ

Spanish, 1599–1660

DIEGO VELÁZQUEZ

Triumph of Bacchus
1628–29
Oil on canvas
165 × 225 cm (65 × 88 ½ in.)
Museo Nacional del Prado,
Madrid

*Mark Wallinger lives and
works in London.*

Velázquez is the greatest of all painters and this picture – prefiguring *Las Meninas* by nearly thirty years – is a wonderful example of the sophistication and modernity of his vision.

As in *Las Meninas*, Velázquez presents us with a complexity of focal points. There are the figures paying sardonic homage to Bacchus, including what appears to be one other deity. The figure doffing his hat on the right I would guess was a latecomer to the painting, included to break up the horizontal row of heads. Bacchus himself, pudgily androgynous, appears illuminated by a different kind of light. He gazes out of frame into a space from which we are forever denied access. As a god, he is abstracted from the scene, which only goes to place the two liggers on his left in even sharper relief. The look they direct at the viewer slices clean through 350 years in the most disconcerting way. It is a look familiar to anyone who has enjoyed the glorious puerility of piling into a photo booth after a good session. We are welcome to join them for a drink as long as we can stomach their blue jokes. However one might describe them, we are made complicit in the meaning of the work.

This direct importuning of the viewer is one aspect of Velázquez's modernity. The king looks at Diego and he (we) look back. He sees the Hapsburg chin as a spade and paints it as a spade.

There is an extraordinary consistency to this gaze which can find a king so ordinary. It can place the spiritual or mythological among the everyday or make an old woman frying eggs seem a matter of life or death. I think the key to this magic lies in Velázquez's determination to reveal the materiality of the paint. What we might now perceive as a sort of truth to materials was in a religious age more akin to the transubstantiation of the bread and wine in the Eucharist. Beyond verisimilitude, objects are not so much described, as inscribed with meaning. (Or is that the drink talking?)

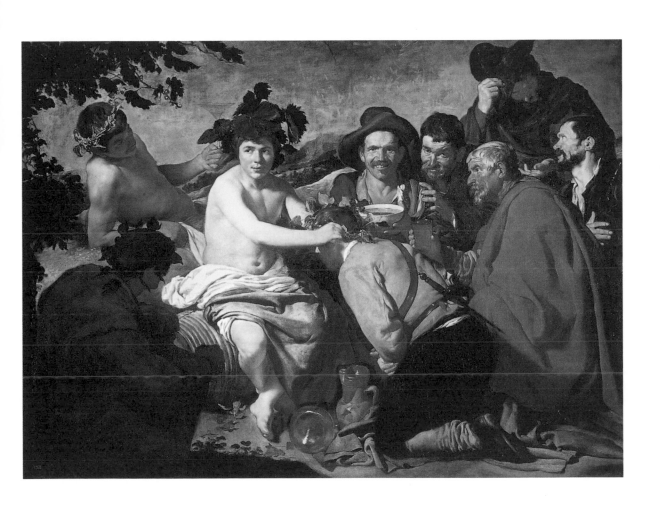

GILLIAN WEARING

British, b. 1963

ON

JAMES ENSOR

Belgian, 1860–1949

JAMES ENSOR (ABOVE)

The Great Judge
1898
Oil on canvas
63 × 77 cm (24 ¾ × 30 ¼ in.)
Private collection

GILLIAN WEARING
(BELOW LEFT)

Me as Warhol in Drag with Scar
2010
Framed bromide print
147 × 124 cm (57 ⅞ × 48 ¾ in.)

GILLIAN WEARING
(BELOW RIGHT)

Me as Arbus
2010
Framed bromide print
147 × 124 cm (57 ⅞ × 48 ¾ in.)

*Gillian Wearing lives and
works in London.*

I love James Ensor because he was obsessed with masks. I too have the same passion for disguise and changes of identity. In my work I conceal in order to reveal depths of the self, whereas Ensor showed how we are all but masks hiding our real selves under a façade. It is the opposite of what the sociologist Erving Goffman would have called the 'front stage' personality, when we perform to an audience, as opposed to 'back stage' behaviour when no one is watching and we drop our guard. Ensor showed the back stage as the mask, hiding the more banal centre inside. What you saw was the satirized individual who could not help but show their true colours.

The Great Judge, painted in 1898, shows a group of masks. The bodies are awkward and ill-fitting with the masks; some of the heads seem to rest on top of a body as if the body was a shelf and this was a still-life painting. Carnival masks sit alongside masks from Noh theatre and the Commedia dell'Arte, which are particularly fitting as there is a sense of grim humour hanging over the work. A scared-looking skeleton (who represents the judge) looks like he is being mocked and cornered by the other masks. Are they trying to confront death, the final judgment for everyone, or are they laughing in the face of it? But that laugh would be hollow, since death is the ultimate judge and always wins.

When I use a mask I see it as a layer waiting to be peeled back to reveal meaning. I see the masks we create for ourselves as being another self or selves, and believe that these personas are necessary for the different social environments we occupy. Ensor painted masks before psychoanalysis would have become widely understood and available as source material. His use of disguise could be traced back to his early life. Ensor's grandmother owned a souvenir shop, which, among other things, sold bric-a-brac, dolls, vases and carnival masks, and he would often be confronted by his grandmother wearing a 'frightful mask' before a carnival – a woman in her sixties trying to scare and entertain a five-year-old boy.

One of the reasons I chose this painting instead of many similar works by Ensor is that *The Great Judge* has a plain background. I prefer such backgrounds in my own disguise work, reducing everything to what is necessary to capture the essence of the sitter or sitters. It makes the portraits more powerful and arresting.

Ensor is an artist who I would place within my spiritual family. Within that family I would also include Cindy Sherman for her disguises and Diane Arbus, who seemed to evoke a mask-like face from every person she photographed, although their eyes would tell you that there were secrets to unfold. Ensor is the grandfather in this family tree – a kindred spirit.

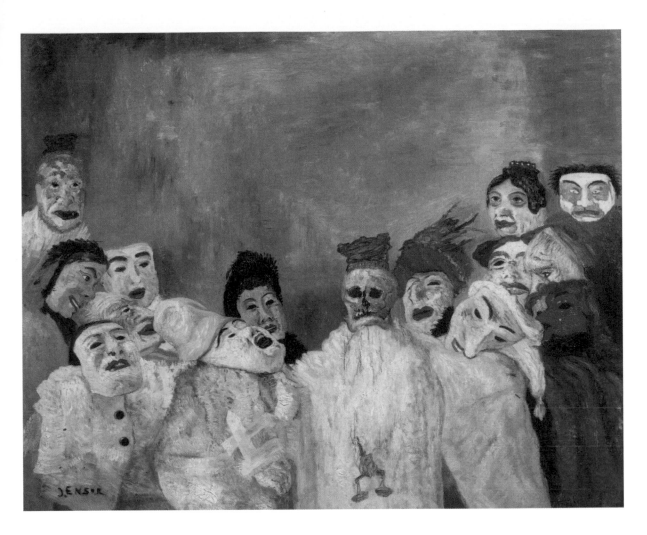

LAWRENCE WEINER
American, b. 1942

ON

WILLEM DE KOONING
American, 1904–1997

WILLEM DE KOONING (ABOVE)

Door to the River
1960
Oil on canvas
203.2 × 177.8 cm (80 × 70 in.)
Whitney Museum of American Art,
New York

LAWRENCE WEINER (BELOW)

STONE UPON STONE
UPON FALLEN STONE
1984
Enamel on brick
Dimensions of installation variable
Installation at The Guinness Hop
Store, Dublin, 1984

BACK │ DOOR TO THE RIVER │

& THERE
PLACED BY THE STAIRCASE LEADING FROM THE MUSEUM OF
MODERN ART TO THE TEMPORARY QUARTERS OF THE WHITNEY
MUSEUM OF AMERICAN ART
[THE INTERNATIONAL CULTURE I ASPIRED TO IN THE 60'S
ENTERING INTO WHERE I CAME FROM]
WAS A PAINTING
NOT JUST A PAINTING
BUT A REPRIMAND TO ME

ALL THAT HAD LED ME TO ATTEMPT TO FLEE TO THE
WEST COAST TO AVOID WAS IN FRONT OF ME
THE EXUBERANCE OF AN AMERICAN EXPRESSIONISM
TEMPERED WITH THE LOGIC OF A WORLD THAT WAS

│ STONE UPON STONE UPON FALLEN STONE │ *

TO SUCH AN EXTENT THAT 50 YEARS LATER I STILL
REFERRED TO IT AS BACK DOOR TO THE RIVER
THE WORK IN FACT WAS │ DOOR TO THE RIVER │ (1960)
BY WILLEM DE KOONING RECENTLY ACQUIRED BY
THE WHITNEY MUSEUM

THE STRUCTURE PRESENTED A REALITY (ALMOST
A CARTOON) WITHOUT ANY TRACE OF METAPHOR
WHERE THAT WHICH WAS OBVIOUS COULD BE USED TO
CONSTRUCT A STRUCTURE WITH A LOGIC NOT
INHERENT IN THE COMPONENTS

WITHOUT THE NECESSITY OF REDUCING OR ELEVATING THE
COMPONENTS THEMSELVES IT WAS POSSIBLE TO EXPECT THE
AFFECTION OF WHAT PRECEEDED YOU WITH NO ATTEMPT TO
FULFILL THEIR EXPECTATIONS

 ERGO:

IF I COULD MAKE A WORK THAT EMBODIED &
MADE SO CLEAR THIS UNDERSTANDING OF
MULTIPLE REALITIES WITHOUT THE NEED OF
REFERENCE OR HIERARCHY THERE WAS A
HOPE THAT I COULD BE AN ARTIST

LAWRENCE WEINER NYC 2010

Lawrence Weiner lives and
works in New York.

* LAWRENCE WEINER CAT# 498 (1983)
 COLLECTION BERNARD STARKMANN LONDON

FRANZ WEST
Austrian, b. 1947

ON

MICHELANGELO MERISI DA CARAVAGGIO
Italian, 1571–1610

CARAVAGGIO

Judith Beheading Holofernes
c. 1599
Oil on canvas
145 × 195 cm (57 × 76 ¾ in.)
Galleria Nazionale d'Arte Antica di
Palazzo Barberini, Rome

I spent some time looking at the Old Masters because we were required to know about them as art students, for reasons of prestige. Many people thought that older art had nothing in common with modern or contemporary art and this was not so far from my own point of view. Nevertheless, I got hold of a book on Caravaggio and true enough, I suddenly noticed details I had not previously been aware of.

I had loathed the popular veneration of the Old Masters, generally fomented by artist-priests who use their respect for, and therefore proximity to, the Old Masters to command the same veneration and respect for themselves. From a young age, I found idolatry repugnant, possibly as an after-effect of the Third Reich and the adulation of the pop stars of the 1960s.

I became interested in the Old Masters, and specifically those in the Kunsthistorisches Museum in Vienna, for social reasons. I was initially captivated by Velázquez's late portraits of King Philip's young children, the infantas. I was taken with the fashionable colours and the casual handling of their clothes and the backgrounds, which contrasted with the precise execution of the portraits – but I didn't need to pore over these paintings for entire evenings, nor did I want to spend the next forty years looking at them. But then in the Prado in Madrid, I came across Velázquez's paintings of the court dwarves, which became my next favourite Old Master works. I didn't need to spend all day and all night thinking about them either, but then they do have a connection with Caravaggio. I don't know who came first, Velázquez or Caravaggio, and I don't really want to know either.

Here are some things about Caravaggio's paintings that appeal to me:

Judith Beheading Holofernes (1599): This is really a spine-chilling crowd-pleaser featuring a beautiful woman.

Crucifixion of Saint Peter (1601): The saint is depicted in a helpless and painful posture that results in something inhuman and unbearable. Peter's gaze makes one feel partly responsible.

The Deposition from the Cross (*c.* 1600): The awful depiction of Christ's hand, with its greyish skin. His face reminds me of a curator at a Vienna museum.

The Cardsharps (*c.* 1595): The jolly face of the older cardsharp, who was apparently used as a model a number of times.

The Death of the Virgin (1601–1605/6): This is the best picture known to me at the moment.

Flagellation of Christ (1607–09): The beauty of Christ's face and upper body.

Beheading of Saint John the Baptist (1608): What I have always seen as merely a dark area in the background above the figures has revealed itself in bright light to be a room or even a landscape whose indeterminate nature is reminiscent of more recent painting, such as those by Cy Twombly.

Franz West lives and works in Vienna.

CARAVAGGIO (ABOVE)

The Cardsharps
c. 1595
Oil on canvas
94.2 × 130.9 cm (37 × 51 ½ in.)
Kimbell Art Museum,
Fort Worth, Texas

CARAVAGGIO (OPPOSITE)

The Death of the Virgin
1601–1605/6
Oil on canvas
369 × 245 cm (145 ¼ × 96 ½ in.)
Musée du Louvre, Paris

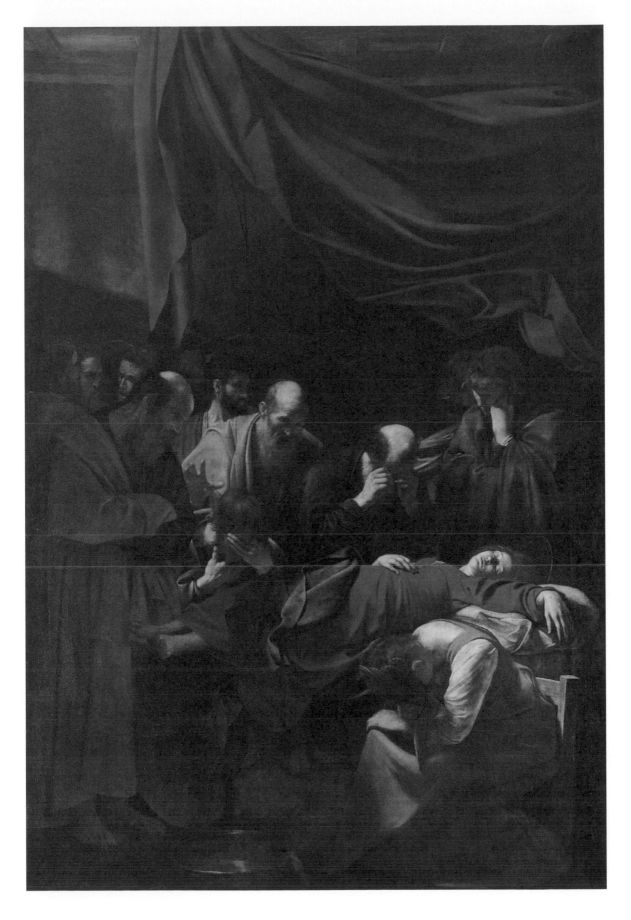

RACHEL WHITEREAD

British, b. 1963

ON

PIERO DELLA FRANCESCA

Florentine, c. 1415–1492

PIERO DELLA FRANCESCA

The Baptism of Christ
1450s
Egg tempera on poplar
167 × 116 cm (65 ¾ × 45 ¾ in.)
The National Gallery, London

This is one of the few paintings that I can conjure up in my mind's eye because I have had an intimate relationship with it for many years. I first saw it with my parents at the National Gallery in London when I was nine or ten years old. I remember seeing it again as a teenager, and later in my first year at Brighton College. A boyfriend took me to see his favourite painting, which happened to be this one.

When I look at *The Baptism of Christ* I see a quiet symmetry in it, which is one of the things that makes it feel like a silent painting. By symmetry, I mean the way that Piero has constructed four 'pillars' across the canvas. There are the angels on the left, the tree, the figure of Jesus, and then the partially clothed figure in the background. Together they give the painting a sculptural and vertical strength. It is almost like a building. To emphasize this verticality, the blue cords on the robes of the garments, about a third of the way up the painting, hold the image together horizontally. This is what draws me in. I can see why this painting was considered a masterpiece in early perspective.

The architectural quality of Piero's work has certainly appealed to me – and it exists in other works of his, such as the *Flagellation* and the *Portrait of Sigismondo Pandolfo Malatesta*. When I was making *Ghost*, I had a postcard of *The Baptism of Christ* on the wall of the room I was casting. (*Ghost* is a negative cast of an entire room, stripped down to its bare architecture.) The composition of *Ghost* had to feel right, so I made a drawing of what it might be. I was following some notion of solidity that existed in Piero's picture. This was an intuitive reaction rather than an intellectual one.

The Baptism of Christ has a very grand, gold, but rather heavy frame on it, while the image in the Piero della Francesca book that I've had for many years is cropped. My book reproduces the painting with two gold crescents on either side of the arch. The effect it creates is to make you think you are looking through a window. Again, there is a sense of participating in an architectural space.

Painted in the 1450s, when Piero was in his thirties, the painting was originally made as the centre section of an altarpiece for the chapel of Saint John the Baptist in the artist's hometown of Borgo Sansepolcro. I always imagine the painting to be smaller than it is. In fact it is quite large – 167 by 116 centimetres – which surprises me each time that I see it in person. I wonder about its scale. I don't think in this case the sense of intimacy that I get from the work, or the way in which a painting can draw you in, is to do with having gotten to know it as a book-sized reproduction. Some things just are the right scale in your imagination.

There is a harmonious relationship between nature and man in Piero's beautiful, naturalistic, dusky Tuscan landscape. You can just make out the town in the background, which certainly seems to relate to Sansepolcro,

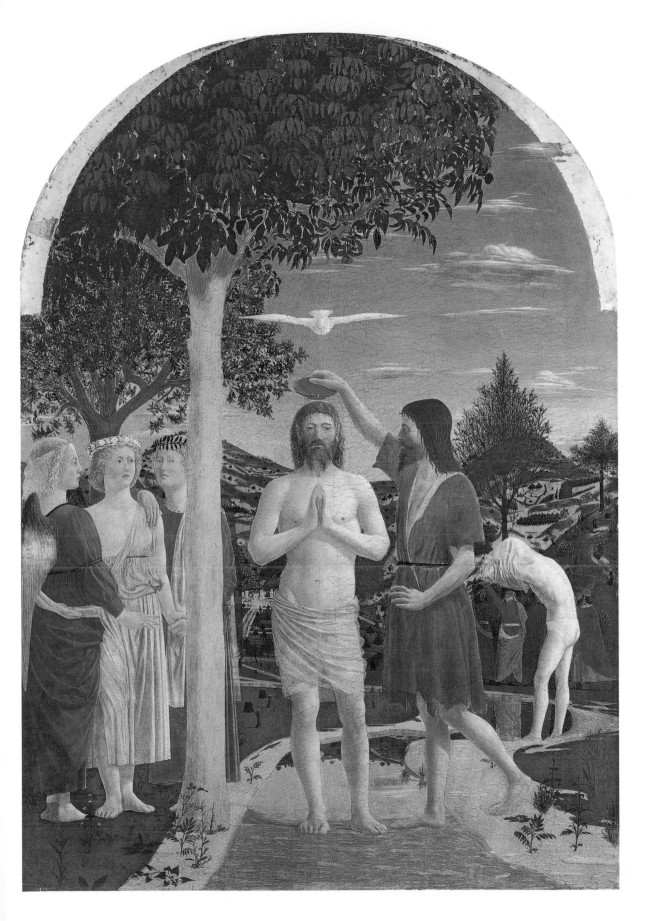

RACHEL WHITEREAD

Ghost
1990
Plaster on steel frame
269 × 355.5 × 317.5 cm (105 ⅞ ×
140 × 125 in.)
National Gallery of Art,
Washington, DC

*Rachel Whiteread lives and
works in London.*

but is obviously not a realistic view of where the baptism would have originally taken place. There are parts of this composition that are a bit odd. For example, the three kings in the background are comparatively crudely painted. Their reflection is actually more prominent than they are.

The colours have dulled over five centuries but they are still soft and alluring, rich and translucent. The angels' wings are almost like butterfly wings. The rich and sensual way the cloth has been painted evokes materials such as velvet and silk. And there is a sumptuous quality to these materials. The blues and pinks really shine out.

I feel that there is peacefulness to this painting, as well as a sense of piety – the bowl used to baptise Christ resembles a halo. There is eroticism too. Jesus' loincloth is transparent, and then there is a figure in the background who is undressing and looks very vulnerable.

This painting may tell a very particular story, but Piero's translation of it into a series of lines, colours and shapes has transfixed me for over thirty-five years. Surely that must be the testament of a truly great artwork?

ERWIN WURM

Austrian, b. 1954

ON

POUL GERNES

Danish, 1925–1996

POUL GERNES

Decoration of the Herlev Hospital,
University of Copenhagen, Herlev,
Denmark
1968–76

The Danish artist Poul Gernes was a fascinating man. He had the appearance of a hippie, with his long hair, big beard and brightly coloured clothes. He made amazing abstract 'target' paintings that consisted of concentric rings of bright colours. He also created striped paintings that spell out the letters of the alphabet. The first time that I saw Gernes's work was in 2007 at Documenta 12 in Kassel, Germany. Some of his target paintings and striped paintings, originally created in the 1960s, were reconstructed posthumously for the exhibition.

Gernes had little interest in selling his art, and many works ended up being stored in a large, damp barn for years. Those that have survived are in quite bad condition and smell of rotten wood. Despite all that, he was extremely disciplined about his art. In 1961 Gernes and the art historian Troels Andersen co-founded an art school in Copenhagen called Eks-Skolen (Experimental Art School), which was a reaction to the more traditional Royal Danish Academy of Fine Arts. Gernes strongly believed that artists could play an important role in society, and felt that the most essential thing was for them to discover their own ideas. However, his intention was for

Decoration of the Herlev Hospital,
University of Copenhagen, Herlev,
Denmark
1968–76

*Erwin Wurm lives and
works in Vienna.*

artists to create art that had a public purpose, rather than creating work for
their own subjective ends.

In Gernes's case this is best seen in the extraordinary buildings that he
painted, both inside and outside, in Denmark. He decorated almost twenty
public buildings, including schools, retirement homes, office buildings and
factories. It is great that so many of them still exist.

A few years ago I went to see some of them, including the Rebæk
Søpark student hall of residence at the University of Copenhagen, which
Gernes painted in the 1970s, and the University of Copenhagen Hospital
in Herlev, where he began work in 1968. I find it interesting that he created
his own colour system for these projects. The colours are strong and
vibrant – orange, yellow, bright green. I like the relation he made between
these colours, the patterns and the architecture in which they exist. The
combination creates an incredible atmosphere. The decoration of the
Herlev Hospital is extraordinary. You enter the building and you can see that
he has painted everything – the door handles, the walls, the doorframes, the
corridors. He also hung his own paintings on the walls.

For Gernes, this work was not just about decoration: there was a point
to these colours. He believed that the organization of colours in his system
could help to heal people or make them feel better, both physically and
mentally. Gernes passionately felt that colour could have a positive influence
on human psychology. I think that this idea is relevant to everybody's work,
and what I find so wonderful about Gernes is that he truly believed in what
he was doing.

YANG FUDONG

Chinese, b. 1971

ON

LANG JINGSHAN

Chinese, 1892–1995

LANG JINGSHAN

Composition with Twelve Photographs
1933; 1934; 1950; 1955
Gelatin silver prints
Variable dimensions from 19 × 25
cm to 34 × 29 cm (7 ½ × 9 ¾ in. to
13 ⅜ × 11 ½ in.)
Private collection

In the 1990s I attended the China Academy of Fine Art in Hangzhou. As I had grown up in Beijing, in the north, living in the southern city of Hangzhou was a brand new experience for me. Often called an earthly paradise, the beauty of Hangzhou is enchanting.

I primarily studied oil painting, but as the Academy of Fine Art was quite open-minded, we were influenced by contemporary artistic movements as well. I initially focused on more realistic, Russian-style paintings, or classical European paintings, hoping to practise such realism myself through mastering the techniques. But as I began to encounter modern conceptual artworks, such as videos, installations and conceptual photography, I felt dramatically inspired and changed. I began to realise that I could express myself artistically in so many ways other than purely through realistic paintings.

YANG FUDONG

No Snow on the Broken Bridge
2006
35mm black-and-white film,
transferred to DVD
11 minutes

*Yang Fudong lives and
works in Shanghai.*

Eventually I fell in love with photography and film, and harboured hopes of making my own film one day. At that time, I loved to loiter in the university library and archives, which was wonderfully stocked with books on contemporary art, to enrich my own knowledge. And at one point I came across the works of Lang Jingshan. His black-and-white photographs of landscapes, capturing people and animals, strike me as very impressive – they are tranquil and peaceful, and yet very modern. Lang Jingshan's work conveys an unspeakable feeling that is akin to Chinese landscape paintings, and yet his work has a very unique quality of its own, something that is highly poetic and profound.

Lang said that he wished to make use of photography as a realistic and expressive medium and to combine it with the country's philosophical ideas to create truly beautiful artworks. His work has greatly impressed me, and has helped make it clear to me that each country has its own artistic culture, which deserves to be treated with respect.

ZHANG HUAN

Chinese, b. 1965

ON

LEONARDO DA VINCI

Florentine, 1452–1519

LEONARDO DA VINCI (ABOVE)

The Last Supper
1492–7/8
Tempera and oil on plaster
460 × 880 cm (181 ⅛ × 346 ½ in.)
Convent of Santa Maria delle
Grazie, Milan

ZHANG HUAN (BELOW)

Ash Banquet
2011
Ash on linen
133 × 300 cm (181 ⅛ × 346 ½ in.)

*Zhang Huan lives and
works in Shanghai and New York.*

I first encountered da Vinci's *Last Supper* when I was studying Western art history in college. The reproduction in the book I had was very small and the printing technology at that time in China was not good at all. So I was full of curiosity, which added to the mystery of the work. I first saw it in the flesh in 2005. At the time, there were limitations on the number of visitors allowed into the church, probably fewer than thirty people inside at one time. We were all waiting in lines and entered the small rectangular space in groups. It was done in a peaceful atmosphere, and indeed I got the feeling I was on a pilgrimage.

I once read somewhere that da Vinci is like a deep ocean, Michelangelo like a towering mountain, and Raphael like a boundless plain. On my last trip to Milan I was again on a journey to find the three 'greats' of the Renaissance, and again I felt that strength – like waves crashing in unison, but unable to move the great rock – from da Vinci's *Last Supper*. The painting is an immovable force within art history.

I have used incense ash to remake da Vinci's painting. In Buddhist temples we burn incense ash in our worship to pray and commune with Buddha. For me, the ash is the collective memories, souls and wishes of the multitudes; it is a material with a spirit. It listens to the feeble voices of the living, and sustains the last wisp of hope. It sees the destination of the desirous, and records the confessions of human nature. It is witness to all of the joys and sorrows of life, and is the culmination of the human soul. As such, it speaks with different voices, presenting all the faces of life. It is precisely because the incense ash carries the most wonderful hopes and restless desires of mankind that I have gathered it together to recreate da Vinci's work.

The Last Supper captures the different facets of human nature in one instant. I'm not sure if in using the ash I have evoked the souls of mankind, or presented the destruction of innumerable souls. Today people wish to live a good life, but their desires continue to harm the world. The environment continues to deteriorate under the unceasing pace of man's development. How can people find balance in development, how can we avert a coming crisis? Those things in his nature that man cannot overcome are the greatest sorrows and unending cycles in his confrontation with himself. If our requirements of nature continue to exceed what it can provide, if we cannot find a balance in what we can keep and what we must give up, then the incense may as well represent the culmination of mankind's 'Last Supper'.

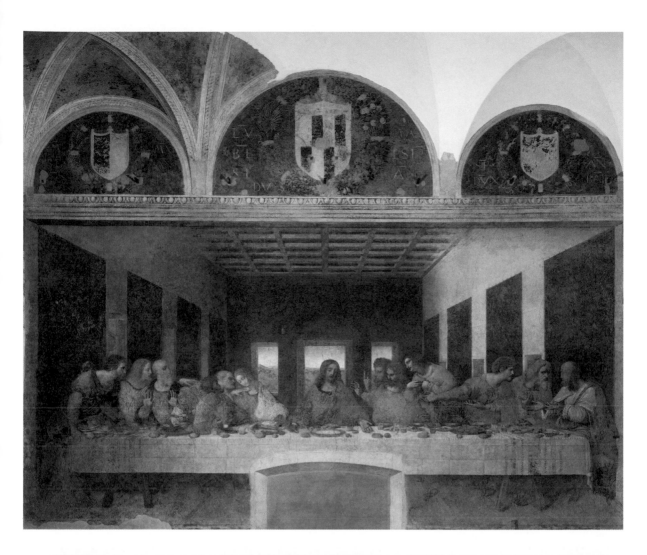

ZHANG XIAOGANG

Chinese, b. 1958

ON

CHEN HONGSHOU

Chinese, 1599–1652

CHEN HONGSHOU (OPPOSITE)

*Su Wu and Li Ling with Attendants
(Farewell of Su Wu and Li Ling)*
Seventeenth century
Hanging scroll, ink and
colour on silk
127 × 48 cm (50 × 18 ⅞ in.)
University of California, Berkeley
Art Museum

ZHANG XIAOGANG (PAGE 202)

Women of Daliang Mountain
1987
Pen on paper
18.5 × 16.5 cm (7 ¼ × 8 ½ in.)

I do not know when we, the Chinese, began to lose awareness of our traditions. Chinese education in the twentieth century closely revolved around the Soviet model of culture. Traditional culture, and Chinese scholarly painting in particular, was seen to represent backwardness and decadence. When I studied at university, I specifically chose courses in Chinese traditional art and culture. Only then did I realize that no matter what, we couldn't change the five thousand years of civilization that was deeply rooted in our blood. However, when our professor would stand in front of us and recite from memory teachings on Song Dynasty painters Mi Fu (1051–1107) or Ma Yuan (*c.* 1160–1225), my mind would be full of doubt. For at the time, we had just gone through a long period of isolation. We felt an urgent need to understand the world around us and to move forward. For me, as a kid barely twenty years old, modern Western culture far surpassed the Four Great Yuan Masters (Huang Gongwang, Wang Meng, Wu Zhen and Ni Zan), active in the Yuan Dynasty (1271–1368), and a couple of Song landscapists. Western art seemed more truthful, more passionate.

So it was that I struggled through the first few years of the 1980s, lost and alone. I looked at the work of El Greco, Van Gogh, Magritte, de Chirico and the German New Expressionists. I read Kierkegaard, Kafka, Nietzsche, Freud, Hermann Hesse and Henri Bergson. I would seek out those masters who sat atop the world, persistently looking for the true meaning of art and life. Meanwhile, my books on traditional Chinese art and culture remained unread on the top shelf of my bookcase. Eventually I returned to them, and the artists and artworks that began to hold sway over me included Gu Kaizhi's *The Goddess of the Luo* (Fourth century), Wang Ximeng's (1096–1119) *Shanshui*, and the late Ming Dynasty (1368–1644) painter Chen Hongshou.

Chen Hongshou lived in a period when the Ming Dynasty was verging on destruction. At the same time, Europe was experiencing a Golden Age, a heyday of those artists I admire, such as Velázquez, Vermeer and Rembrandt. During this period in China, however, intellectuals suffered tremendously. The case was especially true, I imagine, for such a hopelessly talented scholar as Chen, who repeatedly failed the civil service examinations. Once upon a time I thought that scholars like Chen were similar to the German Expressionists, full of anger and desperation, resisting through poetry and painting, and establishing new value systems.

But Chen Hongshou was not like that. He specialized in painting human figures, many of whom appear in exaggerated form, in a lucid yet delicate style, painted with unsophisticated brushstrokes that, nevertheless, did not undermine his scholarly refinement. (I don't understand why he chose figure painting, as figurative work has long been considered inferior to landscape

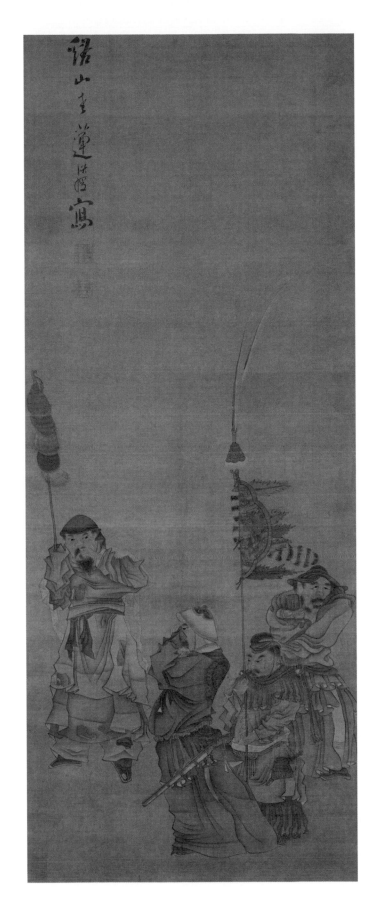

painting in China.) He painted reputable scholars as well as beautiful women. He also made incomparably exquisite woodblock prints, such as those that illustrated famous novels and dramas. I particularly like the works Chen made later on in his life, especially *Farewell of Su Wu and Li Ling*. Despite its apparent simplicity, it is a well-conceived and composed painting. Chen's style of line reveals a flawless charm that leaves me utterly fixated.

Chen lived in the period when the Ming Dynasty was transitioning into the Qing Dynasty, amid much violence and destruction. It is hard to imagine how, as soldiers carried out massacres in the streets, Chen could remain at home making his gracefully arranged compositions, such as *Tasting Tea* and *Five Old People at Mount Hua*. His teacher Liu Zongzhou protested against the invasion by fasting, subsequently dying of starvation. Some of Chen's friends committed suicide. Chen vented his frustrations through alcohol. It was told that he cried so much that he was considered insane.

In recent years I have come to the conclusion that as a Chinese artist I have been influenced by three different historic strains: the Western, modern influence; the legacy of the Soviet Union's socialist culture, encompassing the Cultural Revolution; and traditional Chinese aesthetics stretching back thousands of years. In light of this conclusion, I have taken another look at Song, Yuan and Ming Dynasty paintings, and I have discovered that in their work those before me experienced a profound and mysterious journey that is distant, yet unexpectedly familiar. The thread that once connected Chen Hongshou to perspectives of Western modernism in my mind seems to have undergone another transformation over the last twenty years. The two ends of this thread no longer represent two opposing value systems, but instead they have melted into a longing for, and a rumination on, a new culture. I hereby make a genuine attempt at making my own personal journey in order to draw myself nearer to the artistic masters of an older generation.

Zhang Xiaogang lives and works in Beijing.

SELECTED MONOGRAPHS AND CATALOGUES

Abts, Tomma
Hainley, Bruce, Laura Hoptman and Jan Verwoert, *Tomma Abts* (London and New York: Phaidon, 2008)
Szymczyk, Adam, *Tomma Abts* (Basel: Kunsthalle Basel, 2005)

Ahtila, Eija-Liisa
Ardalan, Ziba de Weck (ed.), *Eija-Liisa Ahtila: Where is Where?* (Cologne: Walther König, 2010)
Bronfen, Elisabeth, Regis Durand and Doris Krystof, *Eija-Liisa Ahtila* (Ostfildern: Hatje Cantz, 2008)
Hirvi, Maria (ed.), *Ahtila Eija-Liisa: Fantasized Persons and Taped Conversations* (Helsinki: Crystal Eye, 2002)

Allora & Calzadilla
Freiman, Lisa D., Carrie Lambert-Beatty and Yates McKee, *Gloria: Allora & Calzadilla* (London and New York: Prestel, 2011)
Hernández Chong Cuy, Sofía (ed.), *Allora & Calzadilla* (New York: Americas Society, 2005)
Ruf, Beatrix (ed.), *Allora & Calzadilla* (Zurich: JRP|Ringier, 2009)

Althamer, Pawel
Bosch, Paula van den et al., *Pawel Althamer: The Vincent Award* (Ostfildern: Hatje Cantz, 2004)
Cotter, Suzanne, Roman Kurzmeyer and Adam Szymczyk, *Paweł Althamer* (London and New York: Phaidon, 2011)

Antin, Eleanor
Bloom, Lisa E. and Howard N. Fox, *Eleanor Antin* (Los Angeles: LACMA, 1999)
Hertz, Betti-Sue, *Eleanor Antin: Historical Takes* (London and New York: Prestel, 2008)

Araeen, Rasheed
Araeen, Rasheed, Angela Kingston and Antonia Payne (eds), *From Modernism to Postmodernism: Rasheed Araeen: a Retrospective: 1959–1987* (Birmingham: Ikon Gallery, 1987)
Malik, Amna, *Rasheed Araeen: Before and After Minimalism, 1959–1974* (London: Aicon Gallery, 2010)

Attia, Kader
Aupetitallot, Yves (ed.), *Kader Attia* (Zurich: JRP|Ringier, 2006)
Durand, Régis, Hannah Feldman and Octavio Zaya, *Kader Attia* (Huarte: Centro Huarte de Arte Contemporáneo, 2008)

Auerbach, Frank
Carlisle, Isabel, Catherine Lampert and Norman Rosenthal, *Frank Auerbach: Paintings and Drawings, 1954–2001* (London: Royal Academy of Arts, 2001)
Feaver, William, *Frank Auerbach* (New York: Rizzoli, 2009)
Hughes, Robert, *Frank Auerbach* (London and New York: Thames & Hudson, 1992)

Baldessari, John
Baldessari, John and Hans Ulrich Obrist, *John Baldessari/Hans Ulrich Obrist (Conversation Series)* (Cologne: Walther König, 2009)
Dean, Robert and Patrick Pardo (eds), *John Baldessari: Catalogue Raisonné Volume 1: 1956–1974* (New Haven: Yale, 2012)
Jones, Leslie and Jessica Morgan (eds), *John Baldessari: Pure Beauty* (London: Tate, 2009)

Balka, Miroslaw
Archer, Michael and Zygmunt Bauman, *Miroslaw Balka: 17 x 23,5 x 1,6* (London: White Cube, 2008)
Cotter, Suzanne (ed.), *Miroslaw Balka: Topography* (Manchester: Cornerhouse, 2010)
Sainsbury, Helen (ed.), *Miroslaw Balka: How It Is* (London: Tate, 2009)

Batchelor, David
Batchelor, David, *David Batchelor: Unplugged* (Edinburgh: Talbot Rice Gallery, 2007)
Ree, Jonathan, *David Batchelor: Volume 1, No. 1–250: Found Monochromes* (London: Ridinghouse, 2010)

Bock, John
Hoffmann, Jens, *John Bock: Koppel* (Cologne: Walther König, 2004)
Hollein, Max and Esther Schlicht (eds), *John Bock: Films* (Cologne: Walther König, 2007)

Buren, Daniel
Cotter, Suzanne (ed.), *Daniel Buren: Interventions II* (Oxford: Modern Art Oxford, 2006)
Lelong, Guy, *Daniel Buren* (Paris: Flammarion, 2002)

Bustamante, Jean-Marc
Bustamante, Jean-Marc, *Jean-Marc Bustamante: L.P.* (Lucerne: New Museum of Art, 2001)
Bustamante, Jean-Marc and Alfred Pacquement, *Jean-Marc Bustamante* (Paris: Gallimard, 2003)
Lageira, Jacinto and Ulrich Loock, *Jean-Marc Bustamante* (Paris: Flammarion, 2006)

Campus, Peter
Nierhoff, Barbara and Wulf Herzogenrath, *Peter Campus: Analog + Digital Video + Foto 1970–2003* (Cologne: Walther König, 2003)
Pohlen, Annelie and Alexander Tolnay (eds), *Rewind to the Future* (Bonn: Bonner Kunstverein, 1999)

Celmins, Vija
Celmins, Vija, *Vija Celmins: Dessins* (Paris: Centre Pompidou, 2006)
Fer, Briony, Robert Gober and Lane Relyea, *Vija Celmins* (London and New York: Phaidon, 2004)
Friedrich, Julia (ed.), *Vija Celmins: Desert, Sea & Stars* (Cologne: Museum Ludwig, 2011)

Chetwynd, Spartacus
Gygax, Raphael and Heike Munder (eds), *Spartacus Chetwynd* (Zurich: JRP|Ringier, 2007)

Clemente, Francesco
Babini, Luca and Rene Ricard, *Francesco Clemente: A Portrait* (New York: Aperture, 1999)
Dennison, Lisa, *Clemente: A Retrospective* (New York: Guggenheim Museum, 2003)
Hollein, Max (ed.), *Francesco Clemente: Palimpsest* (Nürnberg: Verlag für moderne Kunst, 2011)

Close, Chuck
Finch, Christopher, *Chuck Close: Life* (London and New York: Prestel, 2010)
Finch, Christopher, *Chuck Close: Work* (London and New York: Prestel, 2010)
Storr, Robert et al., *Chuck Close* (New York: MoMA, 1998)

Condo, George
Hoptman, Laura (et al.), *George Condo: Mental States* (London: Hayward Gallery, 2011)
Kellein, Thomas, *George Condo: Sculpture* (Zürich: Galerie Bruno Bischofberger, 2003)

Craig-Martin, Michael
Cork, Richard, *Michael Craig-Martin* (London: Thames & Hudson, 2006)

Thomas, Rachael, *Rachael Thomas Interviews Michael Craig-Martin* (Milan: Charta, 2006)

Crewdson, Gregory
Berg, Stephan, *Gregory Crewdson 1985–2005* (Ostfildern: Hatje Cantz, 2005)
Burnett, Craig, *Gregory Crewdson: In a Lonely Place* (Ostfildern: Hatje Cantz, 2011)
Moody, Rick, *Twilight* (London and New York: Abrams, 2002)

Dalwood, Dexter
Crow, Thomas, *Dexter Dalwood: Recent History* (London: Gagosian Gallery, 2006)
Derieux, Florence (ed.), *Dexter Dalwood* (London: Tate, 2010)

Dean, Tacita
Dean, Tacita, *Seven Books Grey* (Göttingen: Steidl, 2011)
Dean, Tacita, *Tacita Dean* (London: Tate, 2001)
Greer, Germaine, Jean-Christophe Royoux and Marina Warner, *Tacita Dean* (London and New York: Phaidon, 2006)
Vischer, Theodora and Isabel Friedli, *Tacita Dean: Analogue* (Göttingen: Steidl, 2001)

Deller, Jeremy
Higgs, Matthew (ed.), *Jeremy Deller: Joy in People* (London: Hayward Gallery, 2012)
Young, Lesley (ed.), *Jeremy Deller: Procession* (Manchester: Cornerhouse, 2010)

Demand, Thomas
Marcoci, Roxana, *Thomas Demand* (New York: MoMA, 2005)
Obrist, Hans Ulrich, *Thomas Demand* (Cologne: Walther König, 2007)

Dr Lakra
Cruzvillegas, Abraham, *Dr. Lakra: Health and Efficiency* (Barcelona: Editorial RM, 2009)
Orozco, Gabriel and Dr Lakra, *Dr. Lakra* (Barcelona: Editorial RM, 2010)

Dumas, Marlene
Bloom, Barbara et al., *Marlene Dumas* (London and New York: Phaidon, 2009)
Butler, Cornelia et al., *Marlene Dumas: Measuring Your Own Grave* (Los Angeles: MOCA, 2008)

Elmgreen & Dragset
Beitin, Andreas F. and Peter Weibel, *Elmgreen & Dragset: Trilogy* (London: Thames & Hudson, 2011)
Benn, Tony, Massimiliano Gioni and Amelia Saul, *Elmgreen & Dragset: This is the First Day of My Life* (Ostfildern: Hatje Cantz, 2008)

Fischer, Urs
Gioni, Massimiliano (ed.), *Urs Fischer: Shovel in a Hole* (Zurich: JRP|Ringier, 2009)
Ruf, Beatrix, *Good Smell Make-up Tree* (Geneva: JRP Editions, 2004)

Fontcuberta, Joan
Batchen, Geoffrey and Joan Fontcuberta, *Joan Fontcuberta: Landscapes Without Memory* (New York: Aperture, 2005)
Caujolle, Christian, *Joan Fontcuberta* (London and New York: Phaidon, 2001)
Fontcuberta, Joan, *Contranatura* (Alicante: MUA, 2001)

Fritsch, Katharina
Blazwick, Iwona, *Katharina Fritsch* (London: Tate, 2002)
Curiger, Bice, *Katharina Fritsch* (Ostfildern: Hatje Cantz, 2009)

Gander, Ryan
Åbäke, Ryan Gander and Dorothea Strauss (eds),
Ryan Gander: Catalogue Raisonnable Vol. 1 (Zurich:
JRP | Ringier, 2010)
Gander, Ryan, *Ryan Gander: Heralded as the New Black*
(Birmingham: Ikon Gallery, 2008)

Gormley, Antony
Caiger-Smith, Martin, *Antony Gormley* (London:
Tate, 2010)
Hutchinson, John et al., *Antony Gormley* (London
and New York: Phaidon, 2000)
Noble, Richard, *Antony Gormley* (Göttingen:
SteidlMack, 2007)

Graham, Dan
Brouwer, Marianne (ed.), *Dan Graham: Works
1965–2000* (Düsseldorf: Richter Verlag, 2001)
Kitnick, Alex (ed.), *Dan Graham* (Cambridge, MA:
MIT Press, 2011)
Moure, Gloria, *Dan Graham: Works and Collected
Writings* (Barcelona: Polígrafa, 2009)

Hein, Jeppe
Gauthier, Michel, *Jeppe Hein: Objects in the Mirror are
Closer than they Appear* (Nîmes: Carré d'Art, Musée
d'art Contemporain, 2007)
Hein, Jeppe (ed.), *Jeppe Hein: Until Now* (London:
König Books, 2006)

Hiller, Susan
Einzig, Barbara (ed.), *Thinking About Art:
Conversations with Susan Hiller* (Manchester:
Manchester University Press, 1996)
Gallagher, Ann (ed.), *Susan Hiller* (London: Tate, 2011)
Kokoli, Alexandra M. (ed.), *Susan Hiller: The
Provisional Texture of Reality: Selected Texts and
Talks 1977–2007* (Zurich: JRP | Ringier, 2008)

Hirschhorn, Thomas
Basualdo, Carlos, Benjamin Buchloh and Alison M.
Gingeras, *Thomas Hirschhorn* (London and New
York: Phaidon, 2004)
Bizzarri, Thomas (ed.), *Thomas Hirschhorn: Establishing
a Critical Corpus* (Zurich: JRP | Ringier, 2011)
Lorenz, Ulrike (ed.), *Thomas Hirschhorn: It's Burning
Everywhere* (Heidelberg: Kehrer, 2011)

Höfer, Candida
Glenn, Constance, Virginia Heckert and Mary-Kay
Lombino, *Candida Höfer: Architecture of Absence*
(New York: Aperture, 2004)
Heinzelmann, Markus and Doreen Mende (eds),
Candida Höfer: Projects: Done (Cologne: Walther
König, 2009)
Krüger, Michael, *Candida Höfer: A Monograph*
(London: Thames & Hudson, 2003)

Iglesias, Cristina
Blazwick, Iwona (ed.), *Cristina Iglesias* (Barcelona:
Polígrafa, 2002)
Moure, Gloria, *Cristina Iglesias* (Barcelona:
Polígrafa, 2009)

Kabakov, Ilya
Egging, Bjoern and Thomas Kellein (eds),
*Ilya and Emilia Kabakov: An Alternative History
of Art* (Bielefeld: Kunsthalle Bielefeld, 2005)
Kabakov, Emilia and Renate Petzinger (eds),
Ilya Kabakov: Paintings 1957–2008 (Berlin:
Kerber Verlag, 2008)
Siben, Isabel (ed.), *Ilya & Emilia Kabakov:
Installation & Theater* (London and New York:
Prestel, 2006)

Messager, Annette
Bernadac, Marie-Laure (ed.), *Annette Messager: Word
for Word: Texts, Writings and Interviews* (London:
Violette Editions, 2006)

Messager, Annette, *Annette Messager: The Messengers*
(London and New York: Prestel, 2007)

Milhazes, Beatriz
Herkenhoff, Paulo, *Beatriz Milhazes* (Rio de Janeiro:
UBS Pactual, 2006)
Kono, Michiko and Delfim Sardo, *Beatriz Milhazes*
(Ostfildern: Hatje Cantz, 2012)

Muniz, Vik
Celant, Germano (ed.), *Vik Muniz* (Milan:
Mondadori Electa, 2004)
Durant, Mark Alice, Charles Stainback and Vik
Muniz, *Seeing is Believing* (Santa Fe: Arena, 1998)
Muniz, Vik, *Reflex: A Vik Muniz Primer* (New York:
Aperture, 2005)

Neto, Ernesto
Neto, Ernesto, *Ernesto Neto* (London: ICA, 2000)
Rugoff, Ralph et al., *Ernesto Neto: The Edges of the
World* (London: Hayward Gallery, 2010)

Noble, Paul
Kunzru, Hari and Paul Noble, *Paul Noble: Dot to Dot*
(New York: Gagosian Gallery, 2007)
Munder, Heike and Anthony Spira (eds), *Paul Noble*
(Zurich: JRP | Ringier, 2004)

Paci, Adrian
Paci, Adrian, *Adrian Paci: Per Speculum* (Milton
Keynes: Milton Keynes Gallery, 2007)
Vettese, Angela (ed.), *Adrian Paci* (Milan: Edizioni
Charta, 2006)

Pardo, Jorge
Coles, Alex, Barbara Steiner and Christina Végh,
Jorge Pardo (Düsseldorf: Richter Verlag, 2009)
Kraus, Chris, Lane Relyea and Christina Végh, *Jorge
Pardo* (London and New York: Phaidon, 2008)

Parker, Cornelia
Blazwick, Iwona and Ewa Lajer-Burcharth,
Cornelia Parker (Sightings 1999–2001) (Turin:
Hopefulmonster Editore, 2001)
Jahn, Andrea and Cornelia Parker, *Cornelia Parker:
Perpetual Canon* (Berlin: Kerber Verlag, 2005)
Morgan, Jessica and Cornelia Parker, *Cornelia Parker*
(New York: Independent Curators Inc., 2000)

Patterson, Simon
Archer, Michael, Patricia Bickers and Fiona
Bradley, *Simon Patterson: High Noon* (Edinburgh:
Fruitmarket Gallery, 2005)
Bickers, Patricia (ed.), *Simon Patterson* (Newcastle
upon Tyne: Locus+, 2002)

Penone, Giuseppe
Maraniello, Gianfranco, *Giuseppe Penone: Writings
1968–2008* (Birmingham: Ikon Gallery,
2009)
Penone, Giuseppe and Adachiara Zevi, *Giuseppe
Penone* (London: Haunch of Venison,
2011)

Periton, Simon
Bracewell, Michael, *Simon Periton* (London: Koenig
Books, 2008)
Bradley, Will and Simon Periton, *Simon Periton*
(London: Sadie Coles HQ, 2003)

Pettibon, Raymond
Cooper, Dennis, Ulrich Loock and Robert Storr,
Raymond Pettibon (London and New York:
Phaidon, 2001)
Dávila, Mela and Roland Groenenboom (eds),
Raymond Pettibon: Plots Laid Thick (Barcelona:
Museu d'Art Contemporani de Barcelona, 2002)
Rugoff, Ralph, *Raymond Pettibon* (New York:
Rizzoli, 2012)

Ristelhueber, Sophie
Latour, Bruno, David Mellor and Thomas
Schlesser, *Sophie Ristelhueber: Operations* (London:
Thames & Hudson, 2009)
Ristelhueber, Sophie, *Sophie Ristelhueber: Details of
the World* (Boston: MFA Publications, 2001)

Ruscha, Ed
Ellroy, James et al., *Ed Ruscha: Fifty Years of Painting*
(London: Hayward Gallery, 2009)
Marshall, Richard D., *Ed Ruscha* (London and New
York: Phaidon, 2003)
Schwartz, Alexandra (ed.), *Leave Any Information at
the Signal: Writings, Interviews, Bits, Pages* (Cambridge,
MA: MIT Press, 2002)

Salle, David
Mignot, Dorine, *David Salle* (Ghent: Ludion, 1999)
Whitney, David, *David Salle* (New York: Rizzoli, 1994)

Sarmento, Julião
Lingwood, James, *Julião Sarmento: Withholding*
(Santander: Fundación Marcelino Botín, 2006)
Meyer-Hermann, Eva, *Julião Sarmento: Echo*
(Eindhoven: Van Abbemuseum, 2004)
Neri, Louise (ed.), *Julião Sarmento* (Barcelona:
Polígrafa, 2003)

Sasnal, Wilhelm
Borchardt-Hume, Achim, *Wilhelm Sasnal* (London:
Whitechapel, 2012)
Eichler, Dominic, Joerg Heiser and Andrzej
Przywara, *Wilhelm Sasnal* (London and New York:
Phaidon, 2011)
Heynen, Julian, *Wilhelm Sasnal* (London and New
York: Prestel, 2009)

Scheibitz, Thomas
Heynen, Julian (ed.), *Thomas Scheibitz: La Biennale di
Venezia 2005, German Pavilion* (Cologne: Snoeck
Verlagsgesellschaft, 2005)
Scheibitz, Thomas, *Thomas Scheibitz: About 90
Elements / Tod im Dschungel* (Düsseldorf:
Richter, 2007)

Signer, Roman
Mack, Gerhard, Jeremy Millar and Paula van den
Bosch, *Roman Signer* (London and New York:
Phaidon, 2006)
Signer Aleksandra and Peter Zimmermann,
*Roman Signer: Projections: Super-8 Films and Videos
1975–2008* (Göttingen: Steidl, 2009)
Withers, Rachel, *Roman Signer* (Cologne:
DuMont, 2008)

Stezaker, John
Ades, Dawn and Michael Bracewell, *John Stezaker*
(London: Ridinghouse, 2011)
Stezaker, John, *John Stezaker: Silkscreens* (London:
The Approach, 2010)

Sugimoto, Hiroshi
Bonami, Francesco, *Hiroshi Sugimoto: Architecture*
(Ostfildern: Hatje Cantz, 2007)
Brougher, Kerry and Pia Müller-Tamm, *Hiroshi
Sugimoto* (Ostfildern: Hatje Cantz, 2010)
Kellein, Thomas, *Hiroshi Sugimoto: Time Exposed* (London
and New York: Thames and Hudson, 1995)

Suh, Do Ho
Corrin, Lisa G. and Miwon Kwon, *Do Ho Suh*
(London: Serpentine Gallery, 2002)
Suh, Do Ho, *Do Ho Suh* (Seoul: Artsonje Center, 2003)

Taaffe, Philip
Adams, Brooks and Holger Broeker, *The Life of
Forms* (Ostfildern: Hatje Cantz, 2008)
O' Raw, Eimear (ed.), *Philip Taaffe: Anima Mundi*
(Dublin: Irish Museum of Modern Art, 2011)

Rosenblum, Robert, Robert Creeley and Philip Taaffe, *Philip Taaffe* (Valencia : IVAM Institut Valencia d'Art Modern, 2000)

Tal R
Grosenick, Uta, Jutta Koether and Ferdinand Ahm Krag, *Tal R: Adieu Interessant* (Cologne: Walther König, 2008)
Hellmold, Martin and Dirk Luckow (eds), *Tal R: You Laugh an Ugly Laugh* (Cologne: DuMont, 2009)

Tiravanija, Rirkrit
Grassi, Francesca (ed.), *Rirkrit Tiravanija: A Retrospective (Tomorrow is Another Fine Day)* (Zurich: JRP | Ringier, 2007)
Obrist, Hans Ulrich, *Rirkrit Tiravanija / Hans Ulrich Obrist* (Cologne: Walther König, 2010)

Tomaselli, Fred
Berry, Ian and Heidi Zucherman Jacobson, *Fred Tomaselli* (London and New York: Prestel, 2009)
Siegel, Katy and Fred Tomaselli, *Fred Tomaselli* (London: White Cube, 2009)
Tomaselli, Fred, *Fred Tomaselli: Monsters of Paradise* (Edinburgh: Fruitmarket Gallery, 2004)

Viola, Bill
Townsend, Chris (ed.), *The Art of Bill Viola* (London: Thames & Hudson, 2004)
Violette, Robert (ed.), *Bill Viola: Reasons for Knocking at an Empty House: Writings 1973–1994* (London: Thames & Hudson, 1995)
Walsh, John, (ed.), *Bill Viola: The Passions* (Los Angeles: J. Paul Getty Museum, 2003)

Wall, Jeff
de Duve, Thierry (et al.), *Jeff Wall* (London and New York: Phaidon, 2009)
Galassi, Peter, *Jeff Wall* (New York: MoMA, 2007)
Vischer, Theodora and Heidi Naef, *Jeff Wall: Catalogue Raisonné 1978-2004* (Göttingen: Steidl, 2005)

Wallinger, Mark
Grayson, Richard et al., *Mark Wallinger* (Zurich: JRP Ringier, 2008)
Herbert, Martin, *Mark Wallinger* (London and New York: Thames & Hudson, 2011)
Wallinger, Mark, *The Russian Linesman: Frontiers, Borders and Thresholds* (London: Hayward Gallery, 2009)

Wearing, Gillian
Ferguson, Russell, Donna De Salvo and John Slyce, *Gillian Wearing* (London and New York: Phaidon, 1999)
Molon, Dominic and Barry Schwabsky, *Gillian Wearing: Mass Observation* (London: Merrell, 2002)

Weiner, Lawrence
De Salvo, Donna and Ann Goldstein (eds), *Lawrence Weiner: As Far As the Eye Can See* (New Haven: Yale, 2007)
Fietzek, Gerti and Gregor Stemmrich (eds), *Having Been Said: Writings and Interviews of Lawrence Weiner 1968–2003* (Ostfildern: Hatje Cantz, 2004)

West, Franz
Alexander, Darsie (ed.), *Franz West: To Build a House You Start With the Roof (Work 1972–2008)* (Cambridge, MA: MIT Press, 2008)
Fleck, Robert, Bice Curiger and Neal Benezra, *Franz West* (London and New York: Phaidon, 1999)
Storr, Robert et al., *West: Pensées, Features, Interviews, Anthology* (London: Whitechapel Art Gallery, 2003)

Whiteread, Rachel
Chris Townsend (ed.), *The Art of Rachel Whiteread* (London: Thames & Hudson, 2004)
Mullins, Charlotte, *RW: Rachel Whiteread* (London: Tate, 2004)
Whiteread, Rachel, *Ghost* (London: Chisenhale Gallery, 1990)

Wurm, Erwin
Bush, Kate and Michael Newman, *Erwin Wurm* (London: Photographers' Gallery, 2000)
Davila, Thierry et al., *Erwin Wurm: The Artist Who Swallowed the World* (Ostfildern: Hatje Cantz, 2006)
Golonu, Berin (ed.), *Erwin Wurm: I Love my Time, I don't Like my Time* (Ostfildern: Hatje Cantz, 2004)

Yang Fudong
Baecker, Angie (ed.), *Yang Fudong: Seven Intellectuals in Bamboo Forest* (Stockholm: Jarla Partilager, 2008)
Beccaria, Marcella, *Yang Fudong* (Milan: Skira, 2006)
Yang Fudong, *No Snow on the Broken Bridge: Film and Video Installations by Yang Fudong* (Zurich: Ringier, 2006)

Zhang Huan
Chiu, Melissa (ed.), *Zhang Huan: Altered States* (New York: Asia Society, 2007)
Dziewior, Yilmaz, RoseLee Goldberg and Robert Storr, *Zhang Huan* (London and New York: Phaidon, 2009)
Hu, Jun Jun, Mafalda Rodríguez and Zhang Huan, *Zhang Huan* (Madrid: La Fabricá y Fundación Telefónica, 2007)

Zhang Xiaogang
Colman, Julia and Lu Peng, *Zhang Xiaogang* (Tampere: Sara Hildén Art Museum, 2007)
Zhang Xiaogang, *Revision*, (New York: PaceWildenstein, 2008)
Zhang Xiaogang, *Zhang Xiaogang* (Milan: Mondadori Electa, 2008)

MUSEUMS AND PUBLIC COLLECTIONS

Europe
Austria
Liechtenstein Museum, Vienna
Belgium
Musées Royaux des Beaux-Arts de Belgique, Brussels
Museum of Fine Arts, Ghent
Denmark
David Collection, Copenhagen
Museum Jorn, Silkeborg
France
Bibliothèque Nationale de France, Paris
FRAC Basse Normandie, Caen
Musée de l'Orangerie, Paris
Musée d'Orsay, Paris
Musée du Louvre, Paris
Musée National d'Art Moderne, Centre Georges Pompidou, Paris
Musée National Picasso, Paris
Germany
Bayerisches Nationalmuseum, Munich
Gemäldegalerie, Berlin
Hamburger Kunsthalle, Hamburg
Museum Ludwig, Cologne
Neue Nationalgalerie, Berlin
Hungary
Museum of Fine Arts, Budapest
Italy
Brancacci Chapel, Church of Santa Maria del Carmine, Florence
Castello Sforzesco, Milan
Convent of Santa Maria delle Grazie, Milan
Galleria Nazionale d'Arte Antica di Palazzo Barberini, Rome
Museo di Capodimonte, Naples

The Netherlands
Museum Boijmans Van Beuningen, Rotterdam
Rijksmuseum, Amsterdam
Poland
National Museum, Warsaw
Museum Sztuki, Lodz
Russia
The State Russian Museum, St. Petersburg
Spain
Museo Nacional del Prado, Madrid
Museo Thyssen-Bornemisza, Madrid
Museu Nacional d'Art de Catalunya, Museu Cau Ferrat, Sitges
United Kingdom
British Museum, London
Government Art Collection
Hatton Gallery, Newcastle University, Newcastle upon Tyne
National Gallery, London
Tate Collection, London
New Art Gallery, Walsall

North America
California
Berkeley Art Museum, University of California
J. Paul Getty Museum, Los Angeles
Museum of Contemporary Art, Los Angeles
San Diego Museum of Art
San Francisco Museum of Modern Art
Connecticut
Yale University Art Gallery, New Haven
Illinois
Art Institute of Chicago
Massachusetts
Worcester Art Museum
New York
Albright-Knox Art Gallery, Buffalo
Frick Collection
Grey Art Gallery, New York University Art Collection
Metropolitan Museum of Art
Museum of Modern Art
Pierpont Morgan Library
Whitney Museum of American Art
Ohio
Cleveland Museum of Art
Texas
Chinati Foundation, Marfa
Kimbell Art Museum, Fort Worth
Museum of Fine Art, Houston
Washington, DC
Hirshhorn Museum and Sculpture Garden, Smithsonian Institution
Library of Congress
National Gallery of Art

Asia Pacific
Australia
National Gallery of Australia, Canberra

ACKNOWLEDGMENTS

I would like to thank all the artists who have written for this book for their generosity in agreeing to take part. I have been humbled by the quality and originality of their texts, and many have introduced me to new artists along the way. I would also like to thank the many gallerists and others across the globe who have been incredibly helpful, including:

Cornelia Grassi
Piritta Puhto and Sarah Supply at Eija-Liisa Ahtila studio
Joanna Diem at Foksal Gallery Foundation
Krzysztof Kosciuczuk at Pawel Althamer studio
Niru Ratnam
Jessica Morgan
Catherine Lampert
Rashell George at John Baldessari studio

Martin Klosterfelde
Ina Meier and Lotte Møller at John Bock studio
Hans-Ulrich Schlumpf
Carla Borel and Megan O'Shea at Timothy Taylor
 Gallery
James Cahill at Sadie Coles HQ
Ricardo O. Kugelmas at Francesco Clemente studio
Susan May and Craig Burnett at White Cube
Beth Zopf at Chuck Close studio
Susanna Beaumont and Dale McFarland at Frith
 Street Gallery
Kathy Stephenson and Erin Manns at Victoria Miro
 Gallery
Priya Bhatnagar at Urs Fischer studio
Laura McNamara at Antony Gormley studio
Stephen Friedman and Alice Walters at Stephen
 Friedman Gallery
Sidney Norberg at Sprovieri Gallery
Kate McGarry
Linda Pelligrini and Catherine Belloy at Marian
 Goodman Gallery
Tatiana Dager at Ernesto Neto studio
Brian Armbruster and Jody Asano at Jorge Pardo
 studio
Stacy Bengston at Regen Projects
Mary Dean at Ed Ruscha studio
Karin Seinsoth and Rowena Chiu at Hauser & Wirth
Kristina McLean at Calum Sutton PR
Glorimarta Linares at Rirkrit Tiravanija studio
Ines Turian at Franz West studio
Hazel Willis at Rachel Whiteread studio
Maggie Ying at Zhang Huan studio
Andrea Niederbuchner and Hannes Schroeder-
 Finckh at Thomas Scheibitz studio
Wiebke Petersen at Jeppe Hein studio
Benjamin Provo at George Condo studio
McLean Fahnestock at Bill Viola studio
Kira Perov
Maureen Paley
Leni Michl and Claudia Salzer at Erwin Wurm studio
Simone Battisti at Bortolami Gallery
Gregg Stanger at Hiroshi Sugimoto studio
Rosemary Suh
Raymond Foye at Philip Taaffe studio
Kirsten Thueson at Lawrence Weiner studio
Robert Stoppenbach
Ann Gallagher
Bice Curiger
Erika Benincasa at Vik Muniz studio
Charles Asprey

PICTURE CREDITS

a = above, b = below, l = left, r = right

2 Courtesy the artist. © Thomas Struth; **9** Photo
Ken Adlard. © Ryan Gander; **10** Photo © Lucy
Skaer; **11** Photo of the studio. © Beatriz Milhazes;
13 Photo © Thomas Scheibitz. Clockwise from
top left: *El Greco und Toledo*, Jonathan Brown, et al.,
Fröhlich und Kaufmann, 1983, p. 173; *El Greco.
Identity and Transformation*, José Álvarez Lopera (ed.),
Skira editore, 1999, p.291; Royal College Magazine,
2010; *El Greco*, National Gallery Company London,
2003, p. 137; *El Greco*, Kurt Pfister, Scientia A G
Zürich, 1941; **15 a, b** Courtesy the Etsuko and
Joe Price Collection; **17** Musée National Picasso,
Paris. © Succession Picasso/DACS, London 2012;
18 Private collection. Armando Reverón © 2012
Bolivarian Republic of Venezuela; **21** Jerzy Stajuda
© Ligier Piotr/National Museum in Warsaw; **23**
Museum of Modern Art, New York. Purchase, inv.
256.1937. Max Ernst © ADAGP, Paris and DACS,
London 2012; **24** Photo John Riddy. © Barford
Sculptures Ltd; **26** Musée royaux des Beaux-Arts de
Belgique, Brussels; **27 a, b, l, r** Photo Kader Attia.
© Kader Attia; **28** Centre Pompidou, MNAM-CCI,
Dist. RMN-GP, Paris/Photo Philippe Migeat. ©
Succession H. Matisse/DACS 2012; **31** Private

collection. © The Estate of Sigmar Polke, Cologne,
DACS 2012; **32** Froehlich Foundation, Stuttgart.
© The Estate of Sigmar Polke, Cologne, DACS
2012; **33** Speck Collection, Cologne. © The Estate
of Sigmar Polke, Cologne, DACS 2012; **34** Castello
Sforzesco, Milan; **37 a, b** Bibliothèque nationale
de France, Paris; **38–40** Photo © Hans-Ulrich
Schlumpf, CH–8044 Zurich; **42** Photo Bulloz;
43 Photo Susan Jellicoe; **45** Museum Boymans
van Beuningen, Rotterdam, The Netherlands/
Bridgeman Art Library; **47** Grey Art Gallery, New
York University Art Collection. Milton Avery ©
ARS, NY and DACS, London 2012; **49** Museum
of Modern Art, New York. Gift of Edward R.
Broida, inv. 708.2005. © 2011 The Estate of Philip
Guston; **50** Courtesy Sadie Coles HQ, London,
and Migros Museum für Gegenwartskunst, Zürich.
Stefan Altenburger Photography. © Spartacus
Chetwynd; **51** © Herbert List/Magnum Photos;
53 Collection of Alba and Francesco Clemente;
55, 56 Rijksmuseum, Amsterdam; **58 a** Courtesy
the artist and Sprüth Magers, Berlin. © George
Condo 2011; **58 b** the artist and Skarstedt
Gallery, New York. © George Condo 2011; **59** The
Frick Collection, New York; **60–61** Yale University
Art Gallery, New Haven. Gift from the Estate of
Katherine S. Drier, inv. 1953.6.4. © Succession
Marcel Duchamp/ADAGP, Paris and DACS,
London 2012; **62, 63** Courtesy Gagosian Gallery,
London. © Michael Craig-Martin; **64** Hirshhorn
Museum and Sculpture Garden, Smithsonian
Insitution, Washington, D.C. Gift of the Joseph
H. Hirshhorn Foundation, 1966, inv. 66.2504; **65**
Courtesy the artist, Luhring Augustine, New York
and White Cube, London. © Gregory Crewdson;
66 Courtesy White Cube, London. © Gregory
Crewdson; **67** Yale University Art Gallery, New
Haven. Bequest of Stephen Carlton Clark, B.A.
1903, inv. 1961.18.30; **69** Museum of Modern
Art, New York. Partial and promised gift of Jo
Carole and Ronald S. Lauder and purchase, inv.
243.2005.a-c. © Estate of Robert Rauschenberg.
DACS, London/VAGA, New York 2012; **70**
Government Art Collection, UK. Paul Nash ©
Tate, London 2012; **73, 75 a** National Gallery,
London; **75 b** Courtesy the artist. Thomas Demand
© DACS 2012; **77** Museo del Prado, Madrid;
78 Museum voor Schone Kunsten, Ghent; **79**
Metropolitan Museum of Art, New York. Robert
Lehman Collection, 1975, inv. 1975.1.186/Art
Resource/Scala, Florence; **81** The David Collection,
Copenhagen; **82** Photo Anders Sunde Berg. ©
Elmgreen & Dragset; **83** Courtesy Galleri Nicolai
Wallner, Copenhagen. Photo Neugerriemschneider.
© Elmgreen & Dragset; **84** Photo Archive, Museo
Medardo Rosso, Barzio, Italy; **86, 87** Bayerisches
Nationalmuseum, Munich; **90** Tate, London 2011;
92 Muzeum Sztuki, Lodz; **94** New Art Gallery,
Walsall. © The Estate of Sir Jacob Epstein/Tate,
London 2012; **95** Leeds Museums and Galleries.
Centre for the Study of Sculpture. © The Estate
of Sir Jacob Epstein/Tate, London 2012; **97 a**
Photo Geordy Pearson. John Chamberlain ©
ARS, NY and DACS, London 2012; **97 b** John
Chamberlain © ARS, NY and DACS, London 2012;
98 © Donation Jorn, Silkeborg/DACS 2012; **101**
Cleveland Museum of Art. Purchase through the
J.H. Wade Fund, inv. 28.8; **103** Museum Ludwig,
Cologne. © The Andy Warhol Foundation for the
Visual Arts/Artists Rights Society (ARS), New
York/DACS, London 2012; **105 a** Photo Klaus
Frahm/ARTUR IMAGES. Ludwig Mies van der
Rohe © DACS 2012; **105 b** Photo © Candida
Höfer/VG Bild-Kunst, Bonn 2009 (From: Candida
Höfer: Kuehn Malvezzi. Verlag der Buchhandlung
Walther König: Köln 2009, p.207); **107 a** Museo
del Prado, Madrid; **107 b** San Diego Museum of
Art; **108** State Russian Museum, St Petersburg; **110**
Photo Florian Kleinefenn. © Annette Messager;

111 British Museum, London; **112** Pierpont Morgan
Library, New York; **115** Lichtenstein Museum,
Vienna; **117 a** © Courtesy "The World of Lygia
Clark" Cultural Association; **117 b** Courtesy Galeria
Fortes Vilaça, São Paulo, Brasil and Tanya Bonakdar
Gallery, New York. Photo Rogério Faissal. ©
Ernesto Neto; **119** Hatton Gallery, University of
Newcastle Upon Tyne/Bridgeman Art Library. Kurt
Schwitters © DACS 2012; **121 l, r** Brancacci Chapel,
Church of Santa Maria del Carmine, Florence; **122**
Museo di Capodimonte, Naples; **124–125** Musée
d'Orsay, Paris; **127 a** Metropolitan Museum of Art.
Purchase, Photography in the Fine Arts Gift, 1969,
inv. 69.521/Art Resource/Scala, Florence. © Man
Ray Trust/ADAGP, Paris and DACS, London 2012.
© Succession Marcel Duchamp/ADAGP, Paris
and DACS, London 2012; **127 bl, br** Courtesy the
artist. © Cornelia Parker; **129** Photo Metropolitan
Museum of Art, New York. © John Baldessari;
131 Photo Archivio Penone; **132 l** From *Principles
of Decorative Design*, 1873. London: Cassell, Petter
& Galpin; **132 r** Celebrity Cruises Collection, mv
Millennium. Courtesy Sadie Coles HQ, London. ©
Simon Periton; **135, 136 a** Bibliothèque nationale
de France, Paris; **136 b** Photo akg-images; **137 a,
b** Courtesy Sadie Coles HQ, London. © Raymond
Pettibon; **138** Library of Congress, Washington,
D.C. Prints and Photographs Division, LC-USF342-
T01-008134-A; **139** Courtesy the artist. © Sophie
Ristelhueber; **140** Courtesy Gagosian Gallery,
London. © Ed Ruscha; **141** Tate, London 2011;
142 Art Institute of Chicago. Charles H.
and Mary F.S. Worcester Collection, inv. 1947.67.
Andre Derain © ADAGP, Paris and DACS, London
2012; **145** Photo Lefevre Fine Art Ltd. London/
Bridgeman Art Library;**147 a** National Gallery,
London; **147 b** Courtesy the artist and Sadie Coles
HQ, London. © Wilhem Sasnal; **149** Worcester
Art Museum, Massachusetts, inv. 1922.5; **150**
Photo White Images/Scala, Florence; **151** Museum
of Fine Arts, Budapest; **153** Courtesy Fraenkel
Gallery, San Francisco. © Lee Friedlander; **155 l**
Kupferstichkabinett, Kunsthalle, Hamburg; **155
r** Courtesy The Approach, London. Photo FXP
Photography, London. © John Stezaker; **157**
Gemäldegalerie, Staatliche Museen Berlin, inv. 532;
158, 159 Courtesy the artist and The Pace Gallery,
New York. © Hiroshi Sugimoto; **160** Private
collection; **161** Courtesy the artist. © Do Ho Suh,
1999; **163** Collection of Philip Taaffe, New York.
Raoul Dufy © ADAGP, Paris and DACS, London
2012; **165 a** Photo Scala, Florence; **165 b** Courtesy
Contemporary Fine Arts, Berlin and Victoria
Miro Gallery, London. Photo Jochen Littkemann,
Berlin. © Tal R; **166** Collection Mr and Mrs Kok-
Broodthaers. Marcel Broodthaers © DACS 2012;
169 Zimmerman Family Collection; **170 a, b**
Photo courtesy James Cohan Gallery, New York/
Shanghai. © Fred Tomaselli; **173** National Gallery,
London; **174** Performers: Weba Garretson, John
Hay, Sarah Steben. Photo: Kira Perov. © Bill Viola;
177 Galerie Berinson, Berlin. Wols © ADAGP,
Paris and DACS, London 2012; **179** The J. Paul Getty
Museum, Los Angeles. Wols © ADAGP, Paris and
DACS, London 2012; **181** Museo del Prado, Madrid;
183 a Private collection. James Ensor © DACS
2012; **183 bl, br** Courtesy Maureen Paley, London.
© Gillian Wearing; **185 a** Whitney Museum of
American Art, New York. Purchase with funds
from the Friends of the Whitney Museum of
American Art, inv. 60.63. © The Willem de Kooning
Foundation, New York/ARS, NY and DACS,
London 2012; **185 b** Courtesy Marian Goodman
Gallery, New York/Paris. Photo Sally Kerr Davis.
© Lawrence Weiner; **187** Galleria Nazionale d'Arte
Antica di Palazzo Barberini, Rome; **188** Kimbell
Art Museum, Fort Worth, Texas, inv. AP 1987.06;
189 Musée du Louvre, Paris; **191** National Gallery,
London; **192** Courtesy Gagosian Gallery, London.

INDEX